A RESTON BOOK
PRENTICE - HALL , INC.
ENGLEWOOD CLIFFS, NEW JERSEY

richard b. leinbach

tion techniques ∎

TO CLETA

ISBN 0-8359-8413-3

A RESTON BOOK
PUBLISHED BY PRENTICE-HALL, INC.
A DIVISION OF SIMON & SCHUSTER, INC.
ENGLEWOOD CLIFFS, NEW JERSEY 07632

10 9 8 7 6 5 4 3 2 1

PRINTED IN THE UNITED STATES OF AMERICA.

I AM ESPECIALLY GRATEFUL TO THE INTERIOR DESIGN STUDENTS AND STAFF AT EASTERN MICHIGAN UNIVERSITY WHO PROVIDED THE STIMULUS FOR THE BOOK AND WHO GAVE CONTINUED SUGGESTIONS AND ENCOURAGEMENT THROUGHOUT ALL STAGES OF ITS DEVELOPMENT; TO GENE GALLEY AND SHARON SHEMON FOR THEIR EDITORIAL COMMENTS AND SUGGESTIONS; TO DEAN ELIZABETH KING FOR FINDING RELEASE TIME; TO TIM SIEGEL FOR HIS GENEROUS GIFT; AND TO DIANNE WERDER FOR HER INSIGHT IN THE PROJECT.

contents

equipment
and materials

The technical and creative competencies needed by the interior designer for the completion and presentation of the design solutions demand the use of many of the identical materials and equipment employed by artists and architects.

It is for this reason that the basic drafting equipment and illustration materials most often utilized by interior designers for the creation of perspective illustrations, presentation boards and models originates in the specialized areas of art and architecture.

The quality of the presentations of the design solutions will depend on the illustrative and technical skills of the designer, and to a slightly lesser degree, on the quality of the materials and equipment used. The beginning interior design student will soon realize that the best, yet affordable, materials and equipment will help immeasurably. The purchase of the equipment items will entail the major outlay of funds. However, if these items are treated with respect and care, they will last indefinitely. They are investments for the future.

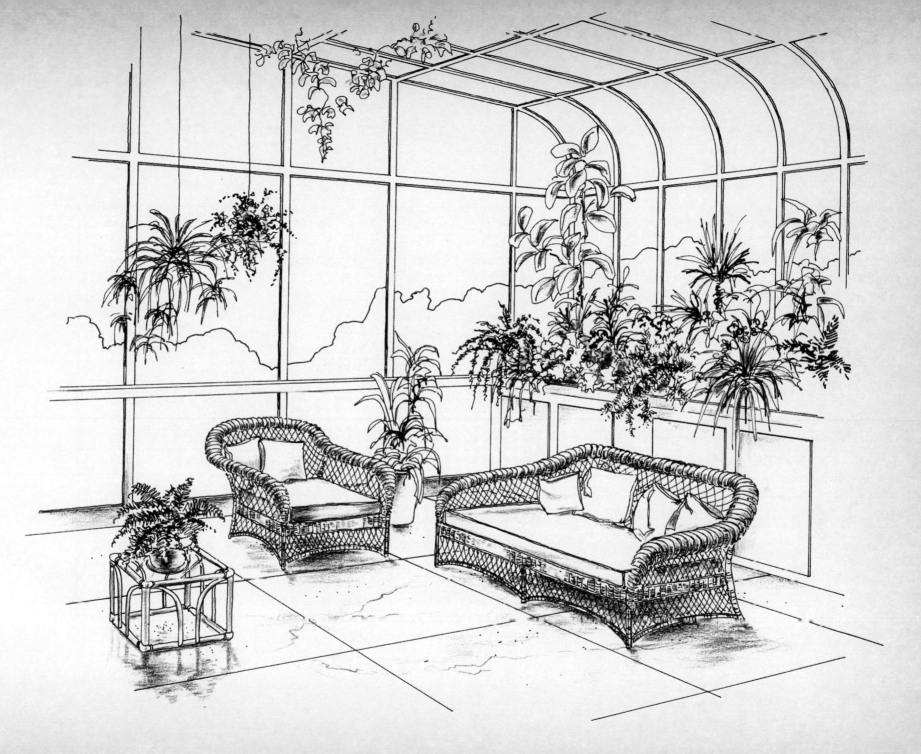

DRAFTING EQUIPMENT AND MATERIALS

DRAFTING SURFACE

AN ADJUSTABLE TOP DRAFTING TABLE OR A METAL EDGED DRAWING BOARD WITH A VINYLCOVER ADHERED TO ITS SURFACE WITH DOUBLE FACED TAPE IS DESIRED. THE COVER WILL PROVIDE A SMOOTH, EVEN DRAWING SURFACE THAT WILL ACCEPT MINOR PUNCTURES FROM A COMPASS POINT OR KNIFE BLADE AND HEAL ITSELF.

DRAFTING CHAIR OR STOOL

THE DRAFTING CHAIR SHOULD SWIVEL AND HAVE ADJUSTABLE SEAT HEIGHTS AND FIRM, ADJUSTABLE BACK SUPPORT MECHANISMS. THE DRAFTING STOOL SHOULD ALSO SWIVEL AND HAVE ADJUSTABLE SEAT HEIGHT MECHANISMS.

TRANSPARENT EDGED PARALLEL BAR OR T-SQUARE

THE T-SQUARE OR THE PARALLEL BAR WILL AID IN THE DRAWING OF PARALLEL LINES ACROSS A SURFACE. EACH WILL ALSO ACT AS A SUPPORT FOR TRIANGLES WHEN DRAWING VERTICAL OR DIAGONAL LINES. THE BEST PARALLEL BAR IS EQUIPPED WITH ROLLER BEARINGS TO KEEP THE RULE OFF THE DRAWING SURFACE. 36"/42" ARE PRACTICAL LENGTHS FOR THE T-SQUARE. BOTH RULES SHOULD FIT THE DRAFTING SURFACES. THE PARALLEL BAR IS MORE EXPENSIVE, BUT IS THE MORE ACCURATE OF THE TWO RULES.

LAMP

AN ADJUSTABLE FLUORESCENT OR INCANDESCENT LAMP NEAR OR OVER THE WORK SURFACE IS DESIRED. THE FLUORESCENT LAMP IS CONSIDERED THE BEST ALL-AROUND LIGHT FOR DRAFTING AS IT MINIMIZES EYE STRAIN AND SHADOWS CAST BY HANDS AND TOOLS.

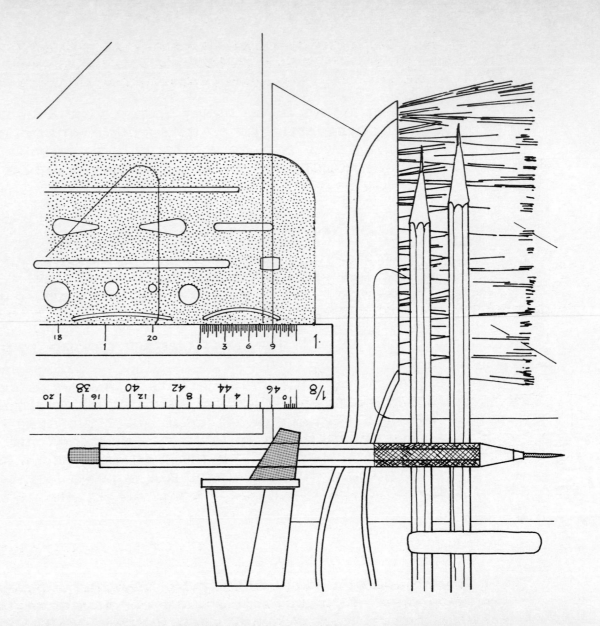

SCALE

The architect's scale has six sides, engraved with the following scales: 1/16"=1'0"; 1/8" or 1/4"=1'0"; 3/16" or 3/32"=1'0"; 3/8" or 3/4"=1'0"; 1/2" or 1"=1'0"; 1 1/2" or 3"=1'0". A scale is used only for measurements, never as a cutting edge.

TRIANGLES

Each triangle should be made from clear plastic: one 45°-45°; one 30°-60°. One triangle should be 12" along one side; one triangle could have an ink edge.

DRAWING PENCILS

Several common wood encased pencils and/or traditional lead holders will be satisfactory. Suggested lead weights: 2H, medium hard; F or H, medium.

PENCIL POINTER

The small, round, portable variety is the most practical pointer.

DRAFTING BRUSH

The conventional, wood-backed bristle brush will be satisfactory.

ERASERS / ERASING SHIELD

A soft, general eraser and/or a white plastic eraser is suggested. The erasing shield is a thin metal plate with a variety of shaped holes cut into it. The shield will protect the drawing while erasing a portion of a line no longer needed.

BOW COMPASS / CIRCLE TEMPLATE

A BOW COMPASS WITH CENTER ADJUSTING SCREW WILL MAINTAIN ITS SIZE WHEN DRAWING LARGE CIRCLES. A TEMPLATE WITH A GOOD RANGE OF OPENINGS IS BEST FOR DRAWING SMALLER CIRCLES.

MASKING OR DRAFTING TAPE

A MODERATE SIZED ROLL IS SUFFICIENT FOR ADHERING CORNERS OF PAPERS TO DRAWING SURFACES.

TECHNICAL PENS

A TYPE OF PEN THAT PRODUCES AN INK LINE OF EVEN THICKNESS FOR FREEHAND OR TECHNICAL DRAWING. TECHNICAL PENS ARE AVAILABLE INDIVIDUALLY, OR IN SETS OF THREE, FOUR, SEVEN OR NINE PENS. THE SET OF FOUR PENS WITH POINT SIZES 00, 0, 1 AND 2 WILL PROVIDE AN ADEQUATE VARIETY OF LINE WEIGHTS, BUT EXAMINE THE FULL RANGE OF POINT SIZES BEFORE MAKING A PURCHASE. CHOOSE THE ASSORTMENT THAT MEETS YOUR NEEDS.

TRACING TISSUE

A MOST CONVENIENT PAPER FOR WORKING DRAWINGS AND OVERLAYS. A ROLL OF YELLOW OR WHITE TISSUE, 18" WIDE, 20 YARDS LONG IS MOST ADEQUATE.

VELLUM

A WHITE, 100% RAG PAPER WITH AN EXCELLENT SURFACE FOR PEN OR PENCIL DRAWINGS WHICH MAY BE RUN WITH SENSITIZED PAPER THROUGH A WHITEPRINTER FOR FINE BLUE OR SEPIA PRINTS.

ILLUSTRATION MATERIALS AND EQUIPMENT

COLORED PENCILS

Colored pencils, particularly those that have soft, waxy leads, are excellent in strength of lead, color rendition and compatibility with permanent markers. The pencils may be purchased individually or in sets. For ease in replacement, sharpen the ends without the color's name or number.

PERMANENT MARKERS

Markers are pens with ultra-fine, pointed or wide hard felt tips, fast-drying ink and permanent colors. Assemble an assortment of several light values and/or one darker value in each color grouping. The assortment should also include several warm and cool grays. Color test each marker on a sample of board or paper before purchasing it. Don't rely on color names only. Suggestion: make a reference chart of the colors and their names just acquired. Take this chart along when purchasing additional markers.

WATERCOLOR

Transparent and opaque watercolors are traditional presentation media. Transparent watercolors are available in sets of pans of color or in a wide assortment of professional grade colors or student grade colors in tubes. Tempera, casein and gouche are opaque watercolors. Watercolor can be a difficult medium, but with practice, excellent illustrations are possible.

PEN and INK

One bottle of black waterproof drawing ink should be available for ink washes and free linework. A bottle of black drawing ink for technical pens is usually included in each pen set.

A 'crow-quill' pen will produce some exciting free-hand ink drawings. The pen is a flexible, fine-tip pen that will produce a wide range of line weights in direct response to hand pressures.

ILLUSTRATION and MATT BOARDS

Colored matt or white illustration boards are fine surfaces for ink, watercolor, marker or combinations of media as well as for collage or presentation boards and model building. White illustration boards are available in hot or cold press, single or double thicknesses. Hot press boards have a smooth, non-porus surface; cold press boards have a medium toothed surface. Colored matt boards are available in a variety of colors and surface textures; most colors in single thickness only.

'MARKER' PAPER

A new, 100% rag paper, often available in tablets, that has been created expressly for markers. It is great for fast, overlay renderings of perspectives.

BRUSHES

An assortment of soft hair brushes is needed for painting with any water-soluble medium. The hair in most bristle brushes is too stiff for extensive work with transparent or opaque watercolors or ink washes.
Suggested sizes:
ROUND FERRULE: medium and/or large oval wash brushes; pointed tip brushes: 0 or 1; 3 or 5; 7 or 8.
FLAT FERRULE: flat tip brushes: 1/8" or 1/4" or 3/8" or 1/2".

SELECTED OPTIONAL MATERIALS

DRY TRANSFER LETTERING SHEETS

DRY TRANSFER LETTERING SHEETS ARE ACETATE SHEETS PRINTED ON ONE SIDE WITH TRANSPOSABLE LETTERS, NUMBERS, SYMBOLS, ETC. PRESENTATION BOARD TITLES AND OTHER LABELS CAN BE CREATED BY RUBBING OVER THE AREA OF THE LETTER OR SYMBOL AND TRANSFERRING IT TO THE BOARD OR PAPER. DRY TRANSFER LETTERING SHEETS ARE PRODUCED BY SEVERAL COMPANIES IN AN EXTENSIVE COLLECTION OF TYPE FACES AND TYPE SIZES. MOST TRANSFER SHEETS ARE PRINTED IN MATTE BLACK, SOME IN MATTE WHITE, AND SOME STYLES IN COLOR.

SHADING FILMS / PATTERN FILMS

SHADING FILMS AND PATTERN FILMS ARE TONED OR PATTERNED ACETATE SHEETS WITH A LOW TACK ADHESIVE BACKING FOR EASY REPOSITIONING THAT CAN ADD TEXTURAL INTERESTS OR VALUES AND INTENSITIES OF GRAY RANGING FROM 10% TO 70% TO AN ILLUSTRATION. TO UTILIZE THESE FILMS, CUT A SHAPE INTO THE SURFACE FILM, LIFT THE CUT AREA FROM THE BACKING SHEET, LOCATE AND PRESS THE AREA INTO POSITION, CAREFULLY TRIM ANY EXCESS AWAY. MOST SHADING OR PATTERN FILMS ARE AVAILABLE IN MATTE BLACK FINISH, SOME ARE AVAILABLE IN COLOR.

MODELS

MODELS ARE THREE-DIMENSIONAL SOLUTIONS TO DESIGN PROBLEMS. SUCCESSFUL WORKING OR FINISHED MODELS DISPLAY IMAGINATION, DEXTERITY, TIME AND THE CREATIVE USE OF MATERIALS.

PAPERS, BOARDS AND ENRICHMENT MATERIALS

SINGLE OR DOUBLE THICK CARDBOARDS AND BALSA WOOD HAVE TRADITIONALLY BEEN THE MATERIALS USED MOST OFTEN FOR THE CONSTRUCTION OF MODELS. FOAM-CORE BOARD, A LAMINATE OF POLYSTYRENE FOAM AND TWO SURFACE LAYERS OF PAPERBOARD, IS NOW AVAILABLE IN SEVERAL THICKNESSES AND IS A SATISFACTORY NEW CONSTRUCTION MATERIAL. A LIST OF ENRICHMENT MATERIALS COULD INCLUDE: BRISTOL AND TAG BOARDS, WALLPAPERS AS WELL AS TISSUE, COLORED, METALLIC OR BROWN WRAPPING PAPERS, PHOTOGRAPHS, ACETATE, WOVEN AND NON-WOVEN, PRINTED OR TEXTURED TEXTILES, BEADS, SOLDER AND WIRE, PINS AND TACKS, ETC., ETC. ALL MATERIALS SELECTED FOR THE CONSTRUCTION AND ENRICHMENT OF A MODEL MUST BE APPROPRIATE FOR THE SCALE OF THE MODEL.

METAL STRAIGHT-EDGE

AN INVALUABLE AID WHEN CUTTING ANY CONSTRUCTION MATERIALS IS A 36" OR 42" METAL STRAIGHT-EDGE, WITH OR WITHOUT MEASUREMENT INCREMENTS OR NON-SKID BACKING.

KNIFE, SCISSORS AND GLUES

A SHARP UTILITY KNIFE WITH AN EXTRA PACK OF BLADES AND A GENERAL PURPOSE SCISSORS OF MEDIUM SIZE ARE NECESSITIES FOR MODEL BUILDING. ONE BOTTLE EACH OF WHITE GLUE AND RUBBER CEMENT WILL PROVIDE ALL ADHESIVE NEEDS FOR THE BONDING OF THE BOARDS, PAPERS AND FABRICS.

2

perspective

PERSPECTIVE ·
· A BRIEF HISTORY

When you were a child and wanted to draw a picture of someone or something, you did so spontaneously, directly, with little regard for scale, space or perspective, an illustration of the three-dimensional world on a two-dimensional surface. In your drawing you probably emphasized a house with its blue door because that was YOUR house, or the flowers and the hands of the child because that was YOU holding the just-picked yellow flowers in YOUR hands.

Like children, the artists who decorated the walls in tombs, or public buildings and private residences in Egypt or Crete adapted the wall space to meet their needs. The scenes they presented were conceived on the flat plane of the wall, unbroken by the objects painted on it. The primary figures were often drawn larger than the subordinates in the story, and depth was shown by overlapping the forms. There was little or no attempt at foreshortening or presenting objects in perspective.

There is recorded evidence that the Greeks in their early periods painted two-dimensional scenes on walls and that by the mid-fifth century B.C. were using a limited form of perspective. In the fourth century B.C. Greek painters were creating painted panels with figures modelled in light and shade and occasionally presented with receding backgrounds.

GREEK VASE PAINTINGS HAD A PARALLEL DEVELOPMENT. ON THE
VASES OF THE SIXTH CENTURY B.C., THE PAINTERS DEPICTED THE FIGURES
IN PROFILE AND OVERLAPPING FORMS. EARLY IN THE FIFTH CENTURY THE
FIGURES WERE BEGINNING TO TURN. BY THE SECOND HALF OF THE FIFTH
CENTURY THE FIGURES WERE BEING PAINTED IN THREE-QUARTER VIEW
AND/OR WITH FORESHORTENED PARTS OF THE BODY, WEARING FLOWING
GARMENTS OF MANY FOLDS AND PLACED NEXT TO FURNITURE AND
OTHER OBJECTS DRAWN WITH RECEDING SIDES.

MANY OF THE PRESERVED ROMAN FRESCOES WERE FREE COPIES OF
ORIGINAL GREEK PAINTINGS. IN THESE DECORATIVE COMPOSITIONS A
FORM OF PERSPECTIVE COULD SOMETIMES BE NOTED. PERSPECTIVE AS
CONCEIVED BY THE ROMANS WAS NOT A CONSISTENT METHODOLOGY.
PARALLEL OBJECTS OFTEN HAD DIFFERING VANISHING POINTS AND
FORESHORTENING COULD VARY THROUGHOUT THE FRESCO.

DURING THE MEDIEVAL PERIODS, ADVANCEMENTS IN PERSPECTIVE THAT
HAD BEEN MADE BY THE GREEKS AND THE ROMANS ALMOST DISAPPEARED.
TRACES OF FORESHORTENING CAN BE DETECTED IN PAINTINGS SUGGESTING
DEPTH FOR THE THRONES OF SAINTS AND MADONNAS. GIOTTO, IN THE
THIRTEENTH AND FOURTEENTH CENTURIES, SKILLFULLY PAINTED FRESCOES
OF FIGURES ARRANGED IN SPACE, IN NATURALISTIC SETTINGS THAT
SUGGESTED THE LOCAL COUNTRYSIDE.

The principles of linear perspective were developed in the early Renaissance by the architect Filippo Brunelleschi. Linear perspective refers to the changes in size of objects as they recede from the viewer. All parallel lines in the objects seem to converge at one point on the eyelevel. The architect/scholar Alberti elaborated on Brunelleschi's concepts, writing that the artist should not only master the technical skills of perspective, but should also master optics and mathematics, particularly geometry, as well. This mathematically based mastery of pictorial space can be seen in the paintings of DaVinci or Masaccio or the relief sculptures of Donatello or Ghiberti and the many Renaissance artists and sculptors that followed them.

A very unique adaptation of perspective can be found in the pictorial panels of intarsia created by Renaissance wood-workers. These very accurately conceived wainscot panels presented in contrasting colored woods, views of tables, cabinets with open doors, shelves filled with objects, musical instruments, etc., all in proper foreshortening and linear perspective.

IN THE CENTURIES THAT FOLLOWED, ELABORATIONS WERE MADE UPON THE TENETS OF BRUNELLESCHI. BY ADDING LINES THAT CONVERGED AT A SECOND VANISHING POINT, ARTISTS WERE ABLE TO PRESENT OBLIQUE VIEWS OF INTERIORS AND LANDSCAPES IN TWO-POINT PERSPECTIVE.

PERSPECTIVE NEVER RESTRICTED THE ARTIST. LINEAR PERSPECTIVE GAVE LEONARDO A WELL-STRUCTURED GRID ON WHICH TO COMPOSE HIS PAINTINGS. CEZANNE, ON THE OTHER HAND, REORGANIZED PERSPECTIVE, VARYING THE SIZE OF OBJECTS WITH THEIR IMPORTANCE AND PAINTED THEM IN COMPLEMENTARY PATTERNS OF COLOR. CUBISTS DISTORTED PERSPECTIVE EMPHASIZING AND REARRANGING THEIR SUBJECTS UNTIL ONLY THE GEOMETRIC QUALITIES EMERGED. THE CONTEMPORARY ARTIST MAY UTILIZE OR IGNORE PERSPECTIVE, AND, LIKE THE CHILD WITH HIS CRAYONS, CONTNUES TO EXPLORE THE WORLD AROUND HIM IN INDIVIDUAL MODES OF EXPRESSION.

PERSPECTIVE DRAWINGS CAN BE ILLUSTRATIONS OF NATURAL SCENES OR OF
EXTERIORS OR INTERIORS OF BUILDINGS. EACH ILLUSTRATION WILL CONTAIN
THE ILLUSION OF DEPTH AND/OR DISTANCES WITHIN ITS BOUNDARIES.
PERSPECTIVES CAN BE DRAWN IN A SCALE AND HAVE EITHER A ONE-POINT OR
TWO-POINT FORM DEPENDING ON WHAT THE ILLUSTRATOR WANTS TO INDICATE.

A ONE-POINT PERSPECTIVE DRAWING OF AN INTERIOR IS AN ILLUSTRATION IN
WHICH THE VIEWER IS DIRECTED TO FOCUS HIS ATTENTION ON AN INTERIOR
WALL, AS WELL AS ON THE FRONT OR SIDE SURFACES OF ALL PIECES OF
FURNITURE AND ACCESSORIES PLACED PARALLEL TO THE WALLS.

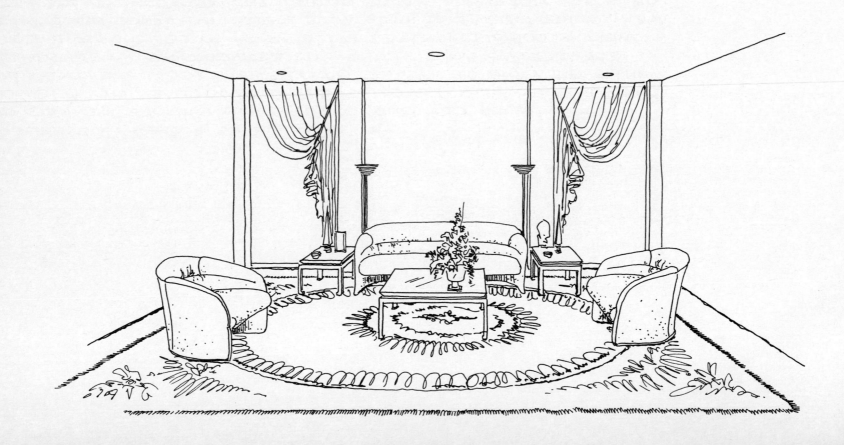

A TWO-POINT PERSPECTIVE DRAWING OF AN INTERIOR IS AN ILLUSTRATION IN WHICH THE VIEWER IS DIRECTED TO FOCUS HIS ATTENTION INTO THE CORNER OF THE INTERIOR, AS WELL AS ON THE CORNERS OF ALL PIECES OF FURNITURE AND ACCESSORIES WHOSE SIDES ARE PARALLEL TO THE WALLS.

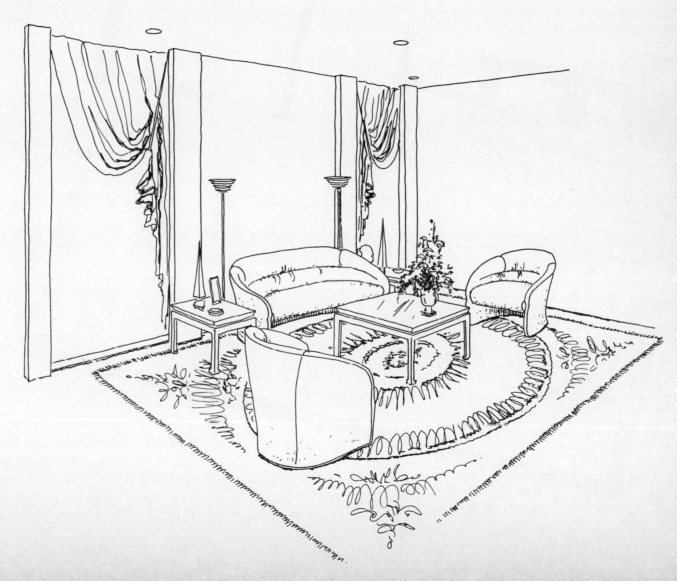

A FLOOR PLAN IS A LINEAR, SCALED DRAWING OF A COMPLETE FLOOR IN A STRUCTURE OR OF AN INDIVIDUAL SPACE WITHIN A BUILDING. A SCALE FOR A FLOOR PLAN IS A WORKABLE SET OF MEASUREMENTS APPROPRIATE FOR THE SURFACE ON WHICH THE DRAWING WILL BE MADE.

SCALE: 1/4" = 1'0"

A PERSPECTIVE DRAWING OF AN INTERIOR IS EASIER TO CREATE IF A SCALED FLOOR PLAN OF THE SPACE IS DRAWN FIRST. THIS PLAN SHOULD INCLUDE THE ARCHITECTURAL FEATURES OF THE ROOM AND THE SPACE ALLOCATIONS FOR THE PIECES OF FURNITURE.

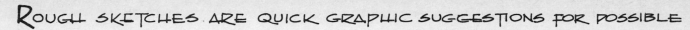

ROUGH SKETCHES ARE QUICK GRAPHIC SUGGESTIONS FOR POSSIBLE
LINEAR PERSPECTIVE DRAWINGS.
IN THESE SKETCHES THE DESIGNER
CAN DISCOVER THE MOST EFFECTIVE
LOCATION FOR THE EYE LEVEL, THE
PLACEMENT OF THE VANISHING
POINTS, AND POSSIBLY, THE BEST
PERSPECTIVE FORM FOR THE
FINAL ILLUSTRATION.

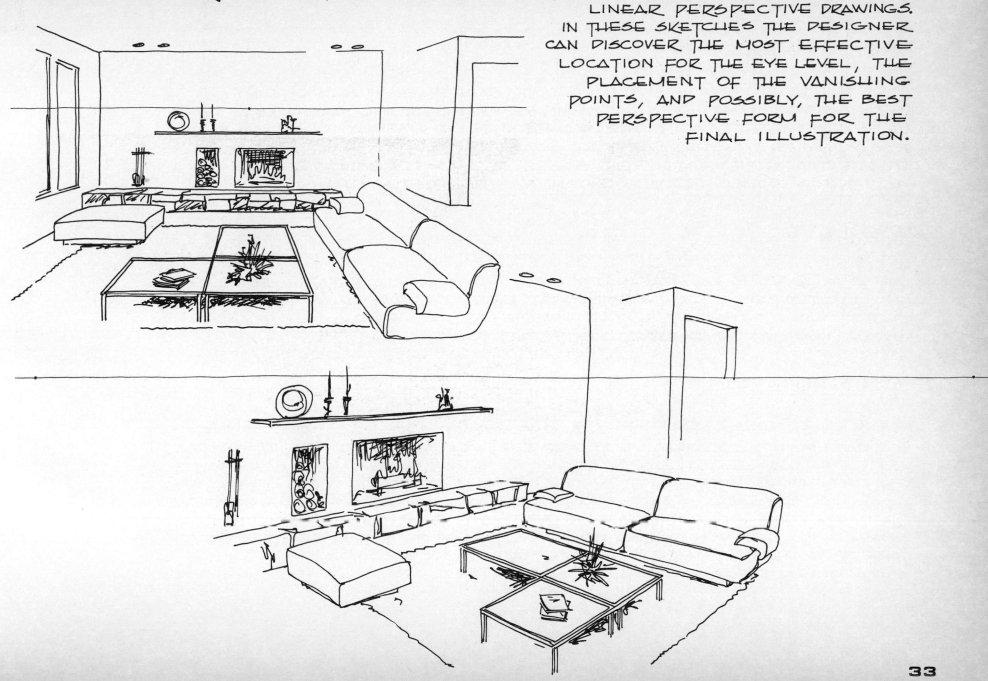

ONE-POINT PERSPECTIVE

TRUE HEIGHT WALL

THE TRUE HEIGHT WALL IS THE REAR OR BACK WALL IN A ONE-POINT PERSPECTIVE ILLUSTRATION OF AN INTERIOR. BECAUSE THIS COMPLETE WALL HAS BEEN DRAWN IN SCALE, MEASUREMENTS MAY BE TAKEN FROM ANY POINT ON ITS SURFACE. THE SCALE OF 1/2"=1'0" WILL PRODUCE AN ADEQUATE DRAWING; THE SCALE OF 3/4"=1'0" WILL PRODUCE A DRAWING IN WHICH DETAILS CAN BE MORE CLEARLY SHOWN.

EYE LEVEL

THE EYE LEVEL IS AN IMAGINARY LINE DRAWN HORIZONTALLY THROUGH AN ILLUSTRATION. THIS HORIZONTAL LINE CORRESPONDS TO A DIRECT LINE OF SIGHT IN THE VISION OF THE VIEWER. A WORKABLE HEIGHT FOR AN EYE LEVEL IS 5' OR 5 1/2'.

VANISHING POINT

THE VANISHING POINT (VP) IN A ONE-POINT PERSPECTIVE DRAWING IS THAT POINT LOCATED ON THE EYE LEVEL AT WHICH ALL LINES OF DEPTH IN THE ILLUSTRATION SEEM TO CONVERGE. THE PLACEMENT OF THE VP IS IMPORTANT TO THE TOTAL EFFECT OF THE ILLUSTRATION. ITS LOCATION SHOULD NOT BE DIRECTLY ABOVE AN EDGE OF A PIECE OF FURNITURE OR ON AN ARCHITECTURAL FEATURE WITHIN THE SPACE. IF THE VANISHING POINT IS PLACED IN THE CENTER OF THE TRUE HEIGHT WALL THE RESULTING COMPOSITION IS SOMETIMES DULL AND UNIMAGINATIVE.

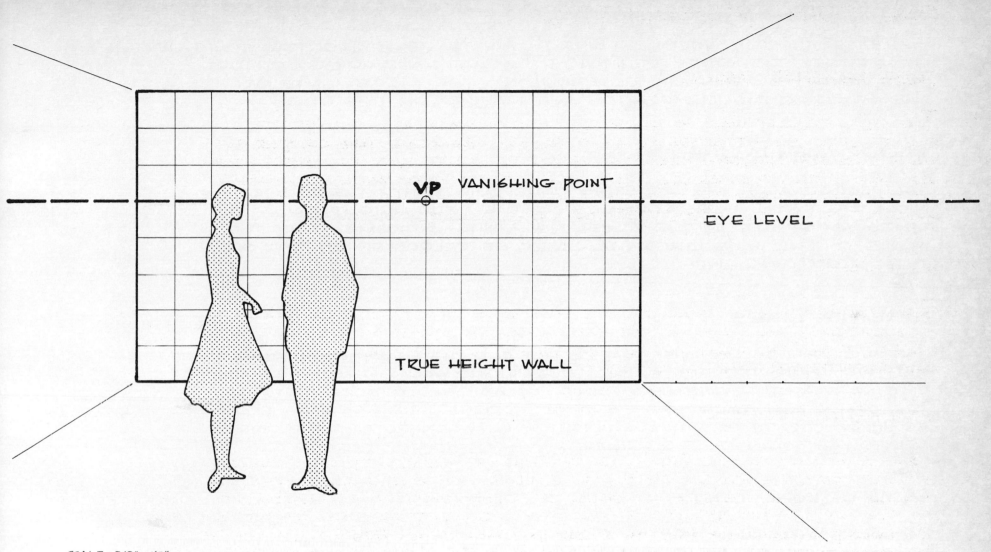

VP VANISHING POINT

EYE LEVEL

TRUE HEIGHT WALL

SCALE : 3/8" = 1'0"

BASE LINE

The base line is a 'working' line that extends horizontally from either the lower right-hand or left-hand corner of the true height wall in the illustration. The increments of the scale of the illustration are marked on this line.

FLOOR/WALL LINES

The floor/wall lines are lines that project into the illustration from the two lower corners of the true height wall. The lines originate at the vanishing point. Increments of the scale on the base line will later be relocated on one of these floor/wall lines.

CEILING LINES

The ceiling lines are lines that project into the illustration from the two upper corners of the true height wall. These lines also originate at the vanishing point. Occasionally, increments of the scale are placed on a second 'working' line extending from an upper corner of the true height wall when details and objects are to be drawn on the ceiling.

MEASURING POINT

The measuring point (MP) in a one-point perspective is an imaginary point placed on the eye level beyond the limits of the true height wall. The MP is the key for the relocation of the scale.

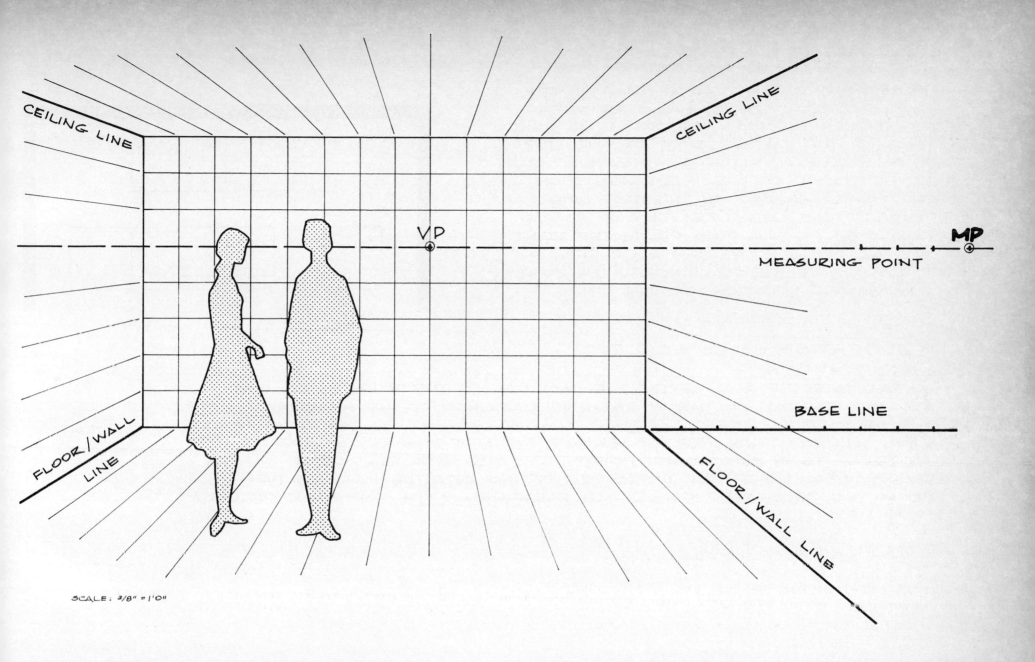

CEILING LINE

CEILING LINE

VP

MP

MEASURING POINT

FLOOR / WALL LINE

BASE LINE

FLOOR / WALL LINE

SCALE: 3/8" = 1'0"

PLACEMENT OF THE MEASURING POINT

To DETERMINE A WORKABLE LOCATION FOR
THE MEASURING POINT, MEASURE ON THE
FLOOR PLAN THE DISTANCE FROM THE REAR
WALL TO THE FAR EDGE OF THE FURNITURE
TO BE INCLUDED IN THE ILLUSTRATION. PLOT
THIS DISTANCE ON THE INCREMENTS ON
THE SCALE MARKED ON THE BASE LINE.
PROJECT THIS MEASUREMENT UP TO THE
EYE LEVEL. MOVE THIS PROJECTED POINT
TWO OR THREE INCREMENTS OR FEET IN
THE SCALE OF THE DRAWING TO THE RIGHT:
A WORKABLE LOCATION FOR THE MP.

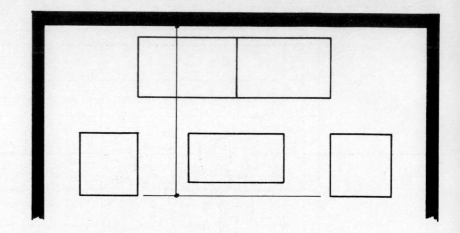

RELOCATION OF THE SCALE

To RELOCATE THE SCALE FROM THE BASE LINE TO THE FLOOR/WALL LINE,
ALIGN THE FIRST OF THE INCREMENT MARKINGS OF THE SCALE WITH
THE MEASURING POINT. PROJECT THE INCREMENT TO THE FLOOR/WALL
LINE. REPEAT THIS PROCEDURE FOR EACH OF THE REMAINING
INCREMENTS IN SUCCESSION, UNTIL ALL ARE NOW RELOCATED ON THE
FLOOR/WALL LINE. ALL LINES PROJECTING INTO THE ILLUSTRATION
FROM THE RELOCATED SCALE ARE PARALLEL WITH THE BASE OF THE
TRUE HEIGHT WALL.

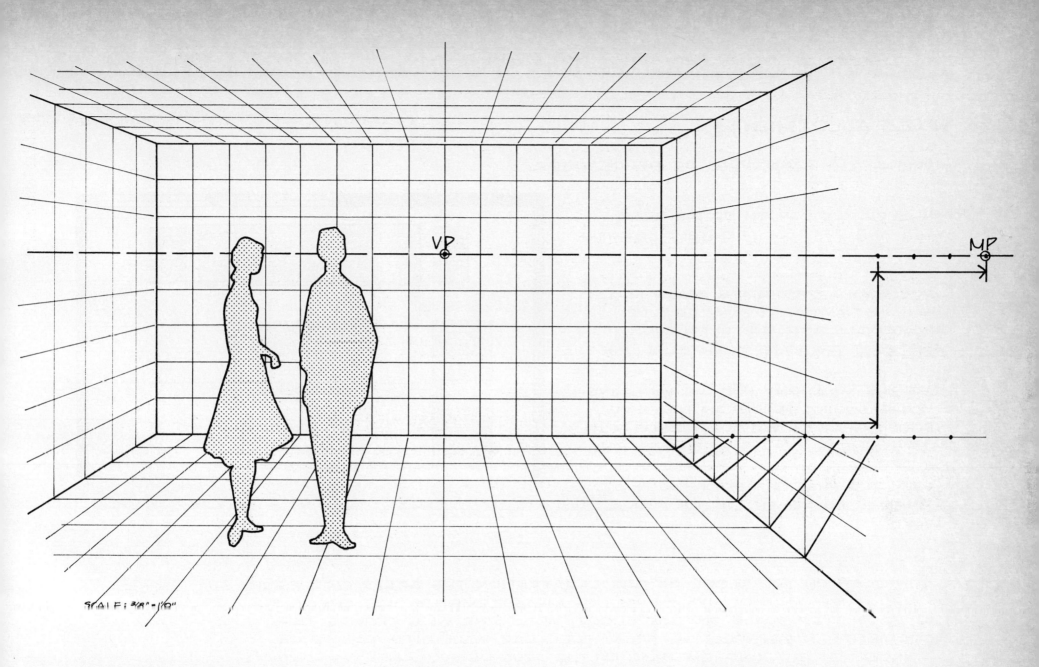

VP

MP

SCALE: 3/8"=1'0"

ONE-POINT PERSPECTIVE ILLUSTRATION

SPACE ALLOTMENTS

CONSTRUCT A FLOOR PLAN OF THE INTERIOR.

MEASURE THE LENGTH OF THE REAR WALL. AND DEPTH OF FURNITURE GROUPING. FOR THE DRAWING.

CHOOSE AN APPROPRIATE SCALE FOR THE ILLUSTRATION. DRAW THE TRUE HEIGHT WALL AND THE EYE LEVEL. CONSTRUCT THE SCALE ON THE BASE LINE.

PLOT THE LOCATIONS FOR THE VANISHING AND MEASURING POINTS ON THE EYE LEVEL. RELOCATE SCALE ON FLOOR/WALL LINES.

CHECK THE DIMENSIONS OF THE FURNITURE AS DRAWN ON THE FLOOR PLAN.

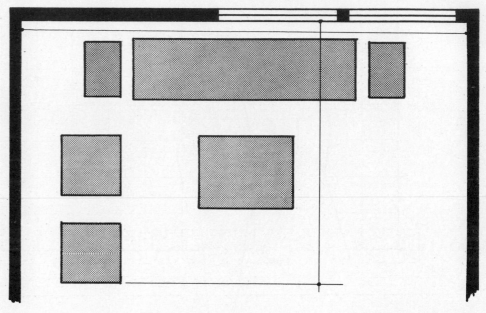

SCALE: 1/4" = 1'0"

CONSTRUCT ON THE FLOOR OF THE ILLUSTRATION THE AREAS EACH PIECE OF FURNITURE WILL OCCUPY USING THE MEASUREMENTS JUST CHECKED. THE RELOCATED SCALE ON THE FLOOR/WALL LINE WILL PROVIDE THE INCREMENTS IN PERSPECTIVE FROM THE REAR WALL INTO THE SPACE. THE INCREMENTS ALONG THE BASE OF THE TRUE HEIGHT WALL WILL PROVIDE THE DISTANCES FROM EACH OF THE SIDE WALLS.

THIS BEGINNING STEP SHOULD GUARANTEE THAT NO TWO PIECES OF FURNITURE WILL BE DRAWN IN THE SAME LOCATION, AND THAT ALL THE SPACES BETWEEN THE FURNITURE ARE CORRECT.

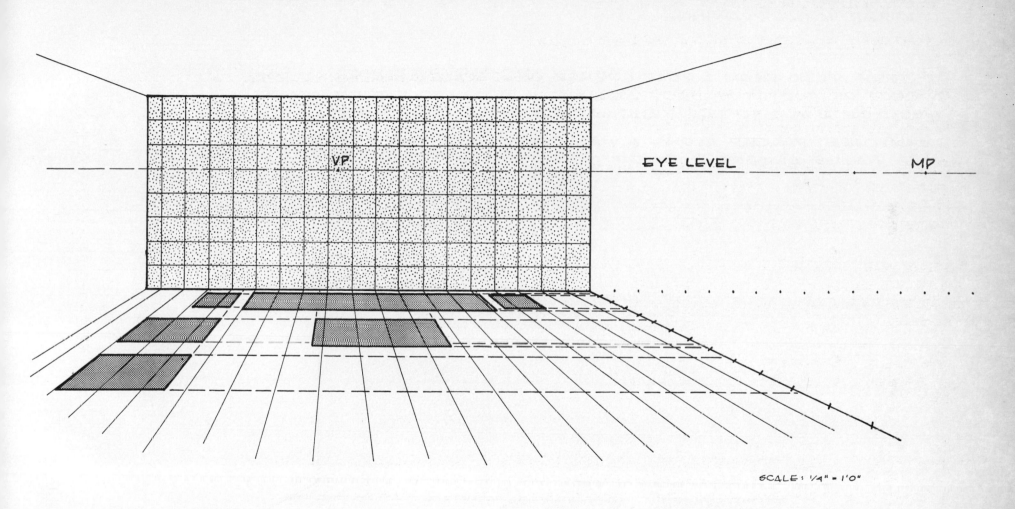

V.P.

EYE LEVEL M.P.

SCALE: 1/4" = 1'0"

HEIGHTS

CHECK THE HEIGHTS OF THE PIECES OF FURNITURE THAT ARE TO BE INCLUDED IN THE DRAWING.

EXTEND A LINE FROM A REAR CORNER ON A SPACE ALLOTMENT FOR A PIECE OF FURNITURE NOT AGAINST A WALL TO EITHER A SIDE WALL OR BACK TO THE TRUE HEIGHT WALL OR TO BOTH.

FURNITURE PLACED ALONG A WALL WILL HAVE THE CORNERS AND WALLS ALREADY JOINED.

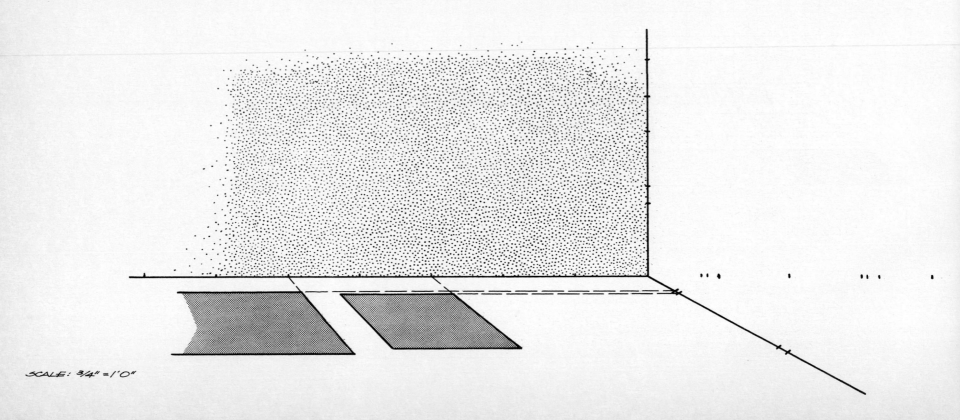

SCALE: 3/4" = 1'0"

CONSTRUCT A VERTICAL LINE AT THE POINT WHERE THE EXTENDED
LINES AND THE WALLS MEET.

MARK THE HEIGHT OF THE PIECE OF FURNITURE ON THE VERTICAL LINE
DRAWN ON THE TRUE HEIGHT WALL OR LOCATE THE DESIRED HEIGHT
ON THE SCALE ON THE CORNER OF THE TRUE HEIGHT AND THE SIDE
WALLS. ALIGN THIS MEASUREMENT AND THE VANISHING POINT
AND PROJECT THE HEIGHT TO THE VERTICAL LINE ERECTED AT THE
POINT ON THE SIDE WALL WHERE THE EXTENDED LINE AND
THE WALL MET.

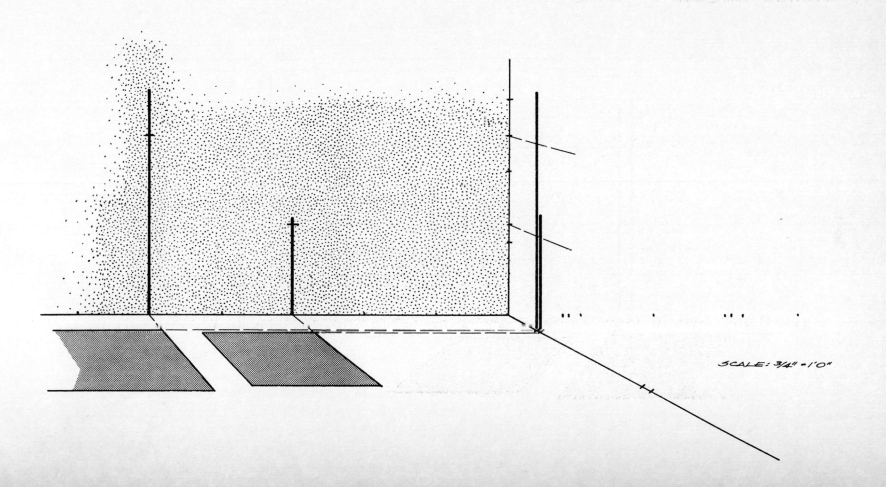

SCALE: 3/4" = 1'0"

TO BRING A HEIGHT MEASUREMENT INTO THE ILLUSTRATION FROM ITS LOCATION ON THE TRUE HEIGHT WALL, ALIGN THE VANISHING POINT AND THE HEIGHT MARK ON THE WALL AND EXTEND THIS MEASUREMENT INTO THE COMPOSITION TO ITS INTERSECTION WITH A VERTICAL LINE CONSTRUCTED AT THE CORNER ON THE SPACE ALLOTMENT.

FOR THE HEIGHT MEASUREMENT ON THE SIDE WALL, ALIGN THE MARK AND AN EDGE AND DRAW A LINE PARALLEL TO THE EYE LEVEL INTO THE DRAWING TO ITS INTERSECTION WITH THE VERTICAL LINE ERECTED AT THE CORNER ON THE SPACE ALLOTMENT.

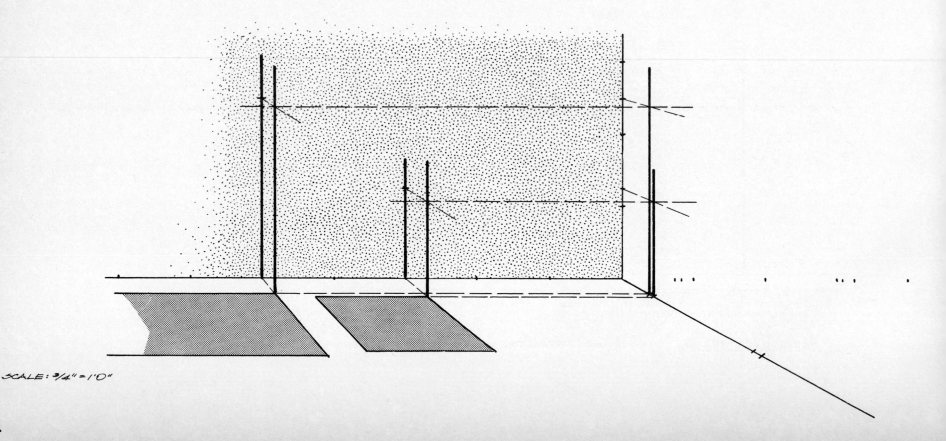

SCALE: 3/4" = 1'0"

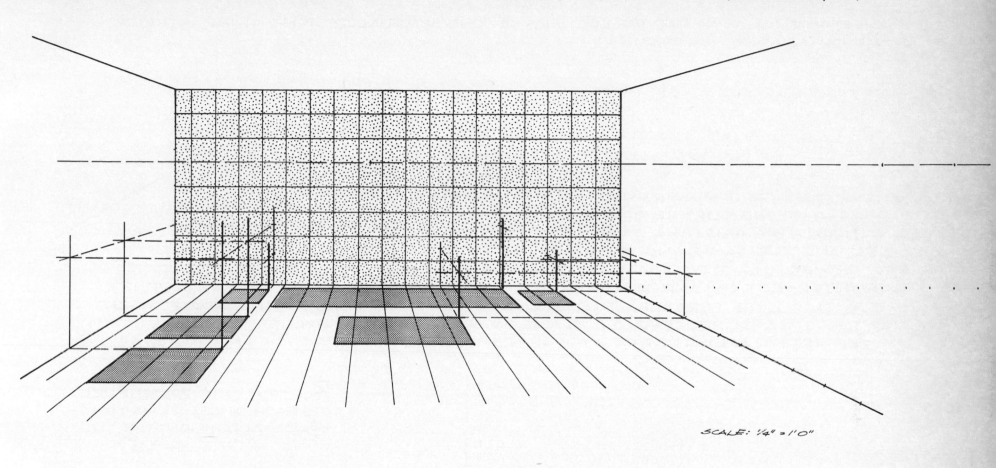

SCALE: 1/4" = 1'0"

45

'BLOCKING IN' FORMS

PROJECT VERTICAL LINES AT THE CORNERS ON ONE SPACE ALLOTMENT IN THE INTERIOR SPACE OR AGAINST THE WALL.

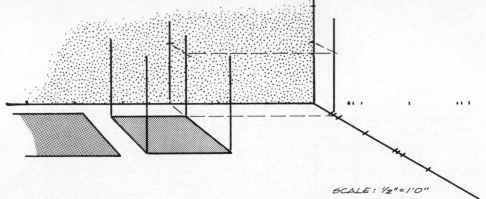

SCALE: ½"=1'0"

EXTEND THE HEIGHT MEASUREMENT PROJECTED TO THE CORNER OF THE ALLOTMENT BY ALIGNING THIS MARK AND THE VANISHING POINT AND PROJECTING THE HEIGHT TO THE NEXT CORNER. PLACE AN EDGE AT THIS INTERSECTION AND CONTINUE THE MEASUREMENT ON TO THE NEXT CORNER LINE WITH A LINE PARALLEL TO THE EYE LEVEL. AGAIN ALIGN THE HEIGHT MARK AND THE VP AND PROCEED ON TO THE NEXT CORNER. COMPLETE THE CONSTRUCTION BY PROJECTING A LINE BETWEEN THIS LAST HEIGHT INTERSECTION AND THE FIRST ONE.

REPEAT THIS PROCEDURE FOR EACH OF THE REMAINING SPACE ALLOTMENTS IN THE ILLUSTRATION.

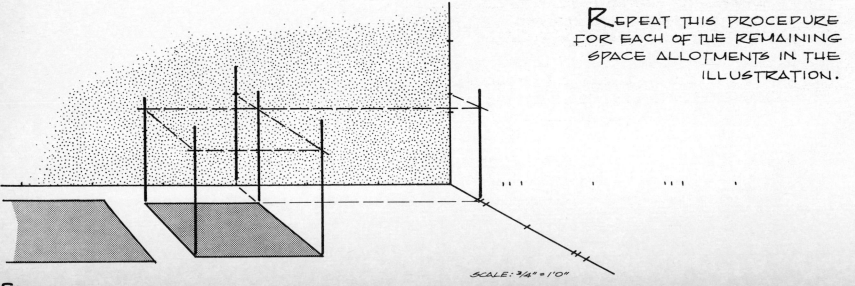

SCALE: ¾"=1'0"

THESE CONSTRUCTED FORMS SHOULD RESEMBLE THREE DIMENSIONAL BOXES DRAWN IN PERSPECTIVE WAITING FOR TRANSFORMATION INTO PARTICULAR PIECES OF FURNITURE IN THE ILLUSTRATION. THE ORNAMENTATION OR CONFIGURATIONS OF AN INDIVIDUAL PIECE OF FURNITURE SHOULD REMAIN WITHIN THE SPECIFIC MEASUREMENTS AND/OR CONFINEMENTS OF THE FORMS.

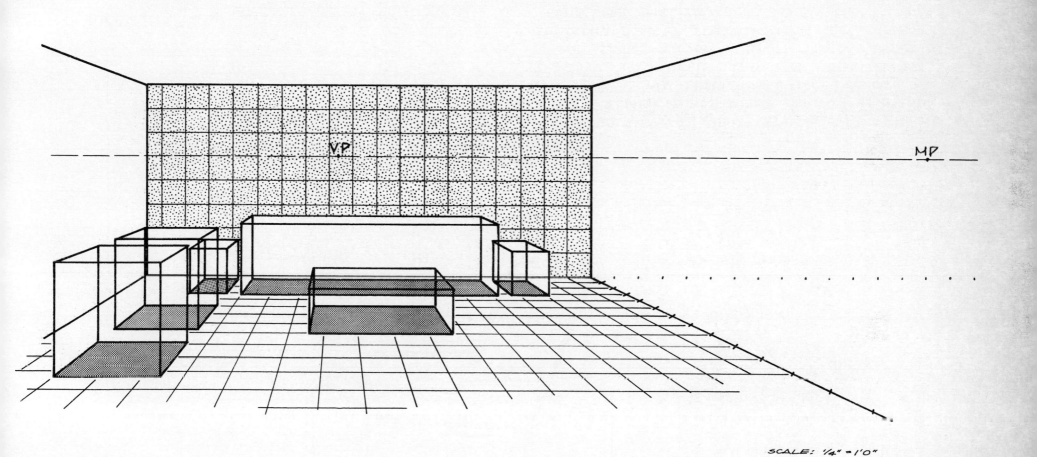

SCALE: 1/4" = 1'0"

TRANSFORMATION of FORMS

The transformation of a 'blocked-in' form into an object usually requires additional height and depth measurements. The heights of the details for the object are obtained from the true height wall; the depths of the details from the relocated scale on the floor/wall line. Both are transferred into the illustration through an interplay of measurements, vanishing point and parallel.

TEXTURAL LINES DESCRIBE THE SURFACE QUALITIES OF OBJECTS FOR THE VIEWER. THEY ADD INTEREST AND CONTRAST TO A LINE DRAWING.

WHEN TRANSFORMING UPHOLSTERED, OVERSTUFFED OR TEXTURED PIECES OF FURNITURE, THE BLOCKED-IN LOOK MUST BE ADAPTED UNTIL THE FORMS BECOME BELIEVABLE. THIS STEP INVOLVES PRACTICE, CAREFUL OBSERVATIONS AND THE DEVELOPMENT OF A PERSONAL VOCABULARY OF TEXTURAL LINES.

VARIATIONS

Occasionally the concepts in the solution to an interior design problem are most effectively presented through a variation in the viewpoint.

A higher eye level in the illustration is a nice variation for a one-point perspective when more of the top surfaces of all objects need to be shown. However, if the VP is placed too close to the right sidewall, the forms of the objects located on the opposite side of the room from the VP may have some distortion due to the closeness of the VP and MP.

A LOW EYE LEVEL WILL PRODUCE A MORE DRAMATIC ILLUSTRATION IF MOST OF THE OBJECTS ARE OF LOW TO MODERATE HEIGHT.

BIRDSEYE PERSPECTIVE

A BIRDSEYE PERSPECTIVE IS AN AERIAL VIEW OF AN INTERIOR, PRESENTING THE ILLUSION THAT THE CEILING OF THE ROOM HAS BEEN REMOVED AND THE CONTENTS ARE BEING VIEWED FROM ABOVE. ANY INTERIOR CAN BE PRESENTED AS A BIRDSEYE. KITCHENS AND BATHROOMS, AREAS INFREQUENTLY PRESENTED IN ONE- OR TWO-POINT PERSPECTIVE, ARE SUITABLE SUBJECTS FOR A BIRDSEYE BECAUSE OF THE PRESENCE OF NUMEROUS GEOMETRIC FORMS AND A LIMITED NUMBER OF IRREGULARLY SHAPED PIECES OF FURNITURE.

A BIRDSEYE PERSPECTIVE IS A ONE-POINT PERSPECTIVE. THE FLOOR HAS BECOME THE TRUE HEIGHT WALL AND THE WALLS THE FORMER FLOOR, CEILING AND SIDE WALLS OF THE ONE-POINT. BECAUSE THE FLOOR IS NOW DRAWN IN THE SCALE OF THE ILLUSTRATION, THE SPACE REQUIREMENTS FOR EACH OBJECT CAN BE ACCURATELY DRAWN ON THE FLOOR. IF THE ROOM MEASURES LARGER THAN 10' ON A SIDE, THE WORKABLE SCALE SHOULD BE 1/2" = 1'0". IF THE ROOM IS SMALLER THAN 10' ON A SIDE, THE WORKABLE SCALE SHOULD BE 3/4" = 1'0". BECAUSE OF PAGE LIMITATIONS, THE SCALE OF THE BIRDSEYE IN THE TEXT IS 3/8" = 1'0".

DRAW THE WALLS OF THE PLAN IN SCALE. PLACE THE VP SOMEWHERE NEAR THE MIDDLE OF THE FLOOR, BUT NOT CLOSE TO AN EDGE IF INSIDE A PIECE OF FURNITURE. EXTEND A HORIZONTAL LINE THROUGH THE VP AND PLACE THE MP ON IT. USE THE TECHNIQUES DESCRIBED ON PP. 34 - 38 IN THIS CHAPTER. THE SCALE ON THE BASE LINE CORRESPONDS TO THE HEIGHT OF THE ROOM AND IS DRAWN FROM THE LOWER INTERIOR CORNER. (A)

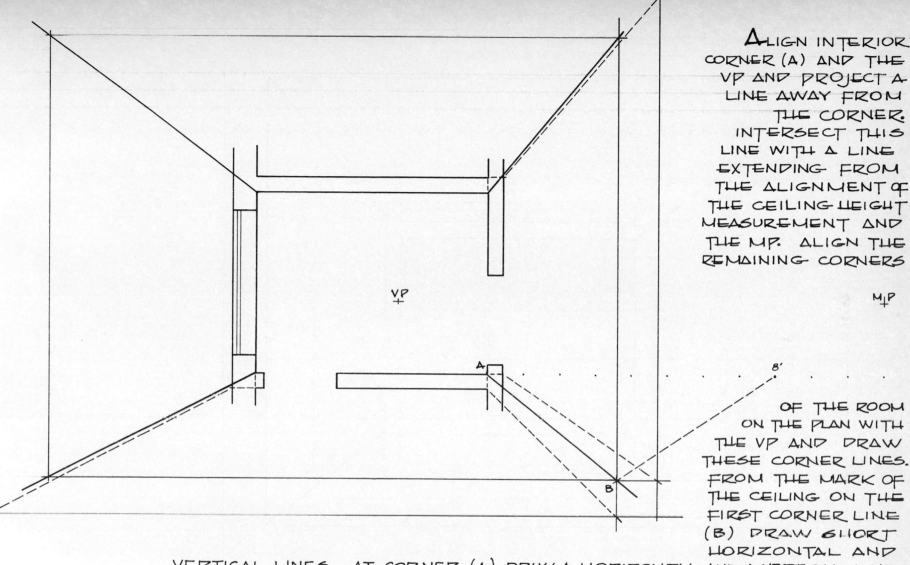

ALIGN INTERIOR CORNER (A) AND THE VP AND PROJECT A LINE AWAY FROM THE CORNER. INTERSECT THIS LINE WITH A LINE EXTENDING FROM THE ALIGNMENT OF THE CEILING HEIGHT MEASUREMENT AND THE MP. ALIGN THE REMAINING CORNERS OF THE ROOM ON THE PLAN WITH THE VP AND DRAW THESE CORNER LINES. FROM THE MARK OF THE CEILING ON THE FIRST CORNER LINE (B) DRAW SHORT HORIZONTAL AND VERTICAL LINES. AT CORNER (A) DRAW A HORIZONTAL AND A VERTICAL LINE ACROSS THE THICKNESS OF THE WALL. ALIGN THESE INTERSECTING POINTS ON THE EXTERIOR OF THE WALL AND THE VP. MARK THEIR INTERSECTIONS ON THE LINES EXTENDING FROM (B). THE THICKNESS OF THE WALL HAS NOW BEEN PROJECTED TO THE CEILING HEIGHT. FROM (B) CAREFULLY DRAW HORIZONTAL AND VERTICAL LINES TO THE OTHER CORNER LINES. DRAW ADDITIONAL LINES ACROSS THE WALL THICKNESS AS NEEDED TO COMPLETE THE WALL AT CEILING HEIGHT.

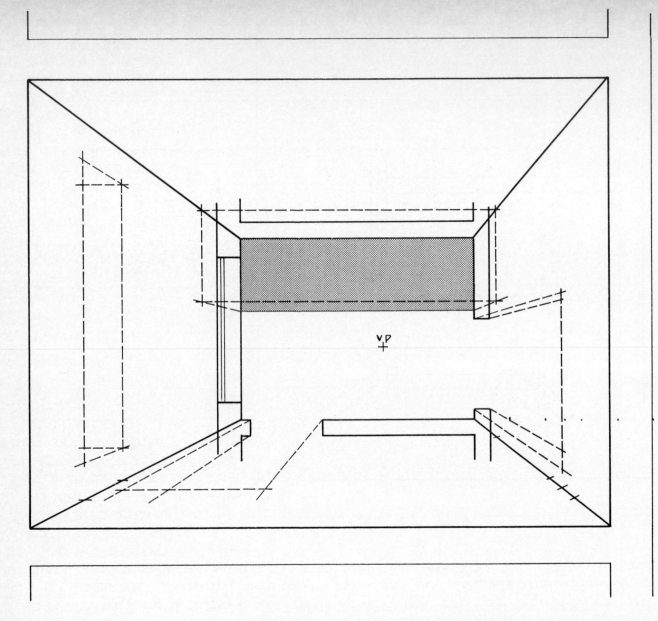

VP

Draw the space allotments for the furniture on the floor. Align the corners of the areas and architectural details with the VP and project the edges into the interior. All heights are obtained from the base line scale, transposed to the primary corner line and projected along the wall to location needed.

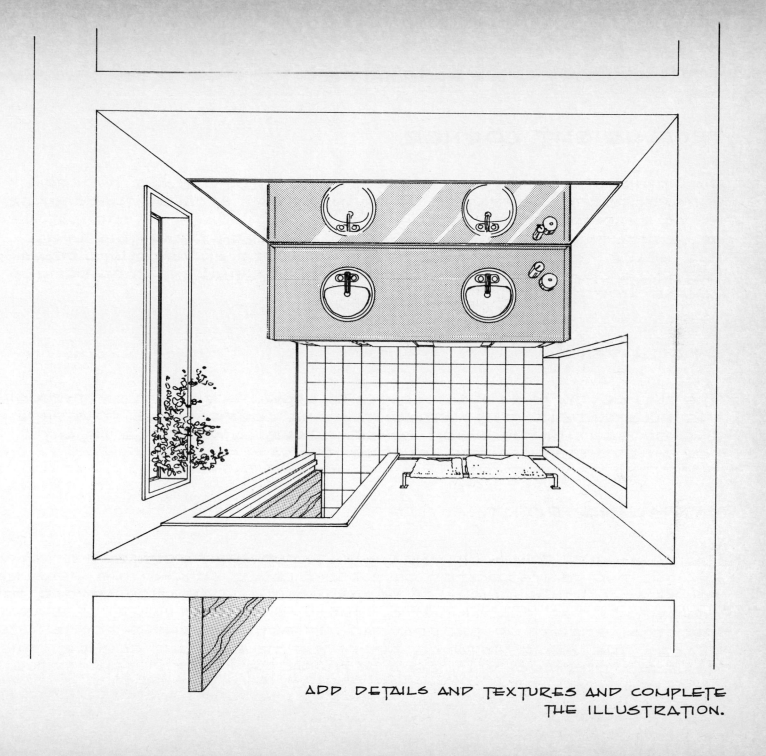

ADD DETAILS AND TEXTURES AND COMPLETE
THE ILLUSTRATION.

TWO-POINT PERSPECTIVE

TRUE HEIGHT CORNER

THE TRUE HEIGHT CORNER IS THE PRIMARY CORNER IN A TWO-POINT PERSPECTIVE ILLUSTRATION OF AN INTERIOR. BECAUSE THIS CORNER IS THE ONLY VERTICAL DRAWN IN THE TRUE SCALE OF THE DRAWING ALL HEIGHT MEASUREMENTS MUST BE TAKEN FROM THIS LINE. THE SCALE OF 1/2" = 1'0" WILL AGAIN PRODUCE AN ADEQUATE DRAWING; THE SCALE OF 3/4" = 1'0" WILL PRODUCE A DRAWING IN WHICH DETAILS CAN BE MORE CLEARLY SHOWN.

EYE LEVEL

THE EYE LEVEL IS AN IMAGINARY LINE DRAWN HORIZONTALLY THROUGH THE ILLUSTRATION. THIS HORIZONTAL LINE CORRESPONDS TO A DIRECT LINE OF SIGHT IN THE VISION OF THE VIEWER. A WORKABLE HEIGHT FOR AN EYE LEVEL OFTEN IS 5' OR 5 1/2'.

VANISHING POINTS

THE VANISHING POINTS (VP₁ AND VP₂) IN A TWO-POINT PERSPECTIVE DRAWING ARE THE TWO POINTS LOCATED ON THE EYE LEVEL BEYOND THE MEASURING POINTS AT WHICH ALL LINES OF DEPTH IN THE ILLUSTRATION APPEAR TO CONVERGE. THE PLACEMENT OF THE VPS SHOULD WORK TO ENHANCE THE TOTAL EFFECT OF THE DRAWING. IF BOTH VANISHING POINTS ARE PLACED THE SAME DISTANCE FROM THE TRUE HEIGHT CORNER, THE FINISHED DRAWING WILL BE A SATISFACTORY, BUT UNIMAGINATIVE ILLUSTRATION.

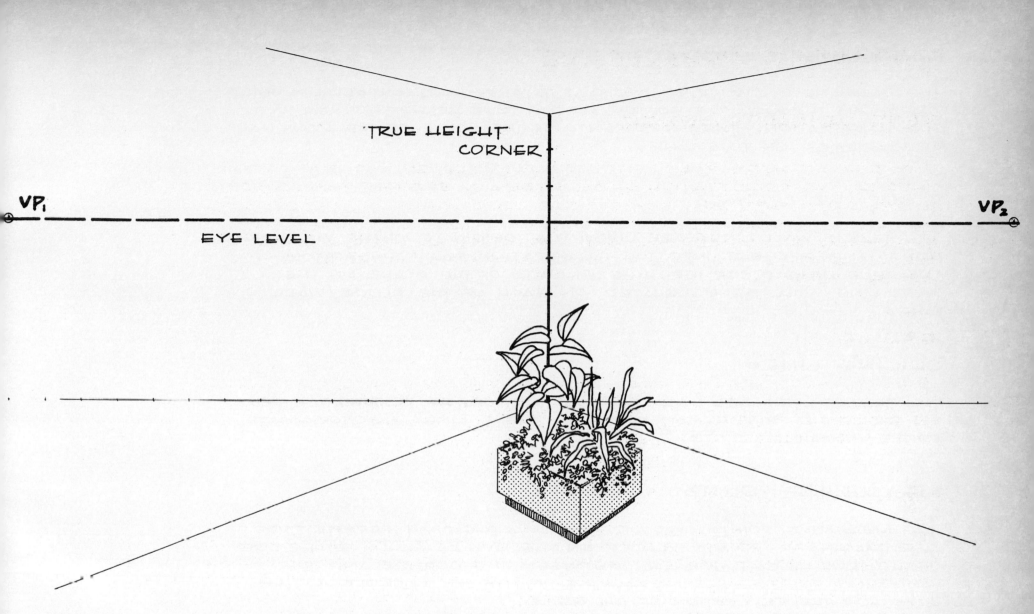

TRUE HEIGHT
CORNER

VP₁ VP₂

EYE LEVEL

SCALE: 3/8" = 1'0"

BASE LINE

The base line is a 'working' line that extends horizontally in both directions through the bottom of the true height corner in the illustration. The increments of the scale of the drawing are marked on this line.

FLOOR/WALL LINES

The floor/wall lines are lines that originate at the vanishing points and project into the illustration from the bottom of the true height corner. Increments of the scale on the base line will be relocated on each of the floor/wall lines.

CEILING LINES

The ceiling lines are lines that project into the illustration from the top of the true height corner. These lines also originate at the vanishing points.

MEASURING POINTS

The measuring points (MP_1 and MP_2) in a two-point perspective are imaginary points placed on the eye level on either side of the true height corner, between the corner and the vanishing points. The measuring points again serve as the keys for the relocation of the scale.

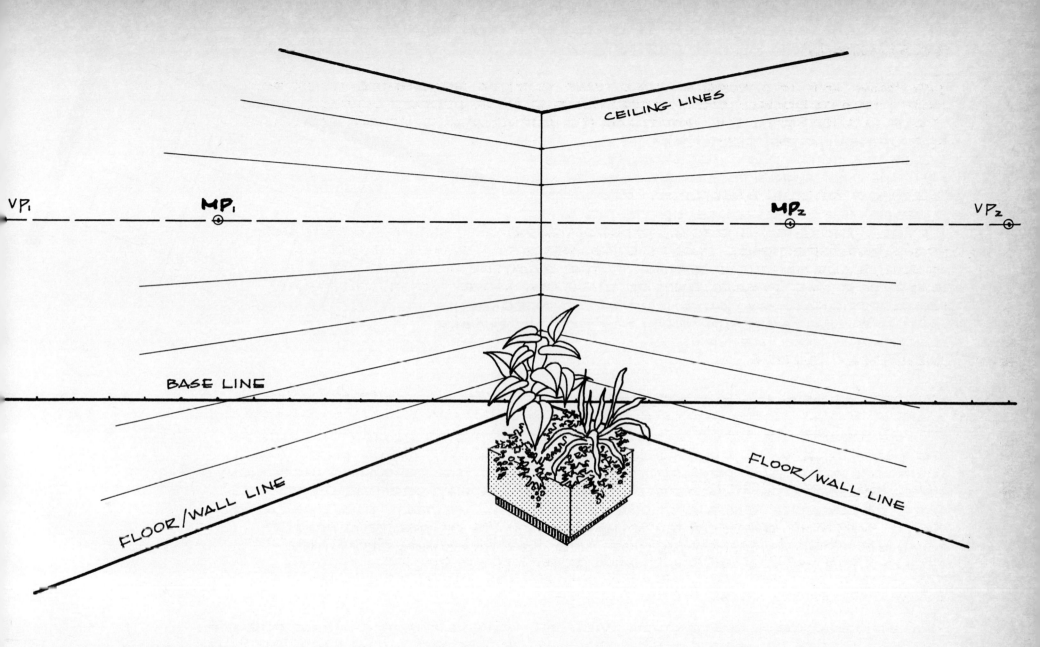

VP₁ **MP₁** **MP₂** VP₂

CEILING LINES

BASE LINE

FLOOR/WALL LINE

FLOOR/WALL LINE

SCALE: 3/8" = 1'0"

PLACEMENT OF THE POINTS

TO DETERMINE WORKABLE LOCATIONS FOR THE MEASURING
AND THE VANISHING POINTS, MEASURE ON THE FLOOR
PLAN THE LENGTH AND WIDTH OF THE FURNITURE
GROUPING TO BE FEATURED IN THE
ILLUSTRATION. PLOT THESE DISTANCES
ON THE INCREMENTS ON THE SCALE
MARKED ON THE BASE LINE. PROJECT
THESE MEASUREMENTS UP TO THE EYE
LEVEL. MOVE EACH PROJECTED POINT TWO
OR THREE ADDITIONAL INCREMENTS OR FEET
IN THE SCALE OF THE DRAWING TO THE RIGHT OR
LEFT FOR THE PLACEMENT OF THE MPS. MOVE
AN ADDITIONAL SIX, SEVEN OR EIGHT INCREMENTS
IN THE SCALE BEYOND THE MPS FOR WORKABLE
LOCATIONS FOR THE VPS.

RELOCATION OF THE SCALE

TO RELOCATE THE SCALE, ALIGN THE FIRST OF THE INCREMENT MARKINGS
OF THE SCALE WITH MP_1. PROJECT THE INCREMENT TO THE FLOOR/WALL
LINE. REPEAT THIS PROCEDURE FOR EACH OF THE REMAINING INCREMENTS
IN SUCCESSION ON THIS SIDE OF THE TRUE HEIGHT CORNER UNTIL ALL
ARE RELOCATED ON THE FLOOR/WALL LINE. REPEAT THIS OPERATION
WITH MP_2 AND THE SCALE ON THE OTHER SIDE OF THE TRUE HEIGHT
CORNER. ALL LINES PROJECTING INTO THE DRAWING FROM THE
RELOCATED SCALE WILL ORIGINATE AT VP_1 OR VP_2.

A BELIEVABLE ILLUSTRATION WILL BE ACHIEVED IF THE ANGLE FORMED
BY THE LIMITS OF THE COMPOSITION AS PROJECTED FROM EACH VP INTO
THE SPACE IS GREATER THAN NINETY DEGREES.

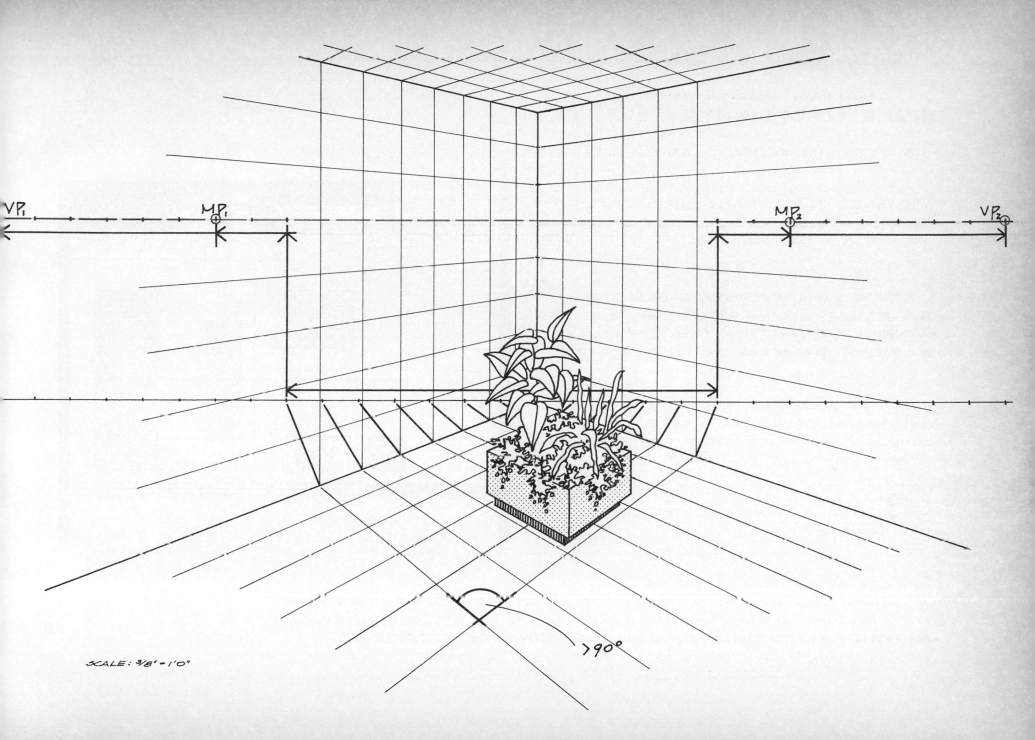

VP₁ MP₁ MP₂ VP₂

SCALE: 3/8" = 1'0"

>90°

TWO-POINT PERSPECTIVE ILLUSTRATION

SPACE ALLOTMENTS

CONSTRUCT A FLOOR PLAN OF THE INTERIOR.

MEASURE THE LENGTH AND WIDTH OF THE FURNITURE GROUPING THAT IS TO BE INCLUDED IN THE DRAWING.

CHOOSE AN APPROPRIATE SCALE FOR THE ILLUSTRATION. DRAW THE TRUE HEIGHT CORNER, AND THE EYE LEVEL. CONSTRUCT THE SCALE ON THE BASE LINE.

PLOT THE LOCATIONS FOR THE VANISHING AND MEASURING POINTS ON THE EYE LEVEL. CONSTRUCT THE FLOOR/WALL LINES. RELOCATE THE SCALE.

CONSTRUCT THE ANGLE AT THE LIMITS OF THE ILLUSTRATION.

SCALE: ¼" = 1'0"

CONSTRUCT ON THE FLOOR OF THE DRAWING THE AREAS IN PERSPECTIVE EACH PIECE OF FURNITURE WILL OCCUPY USING THE INCREMENTS ON THE RELOCATED SCALES AND THE VANISHING POINTS AS THE POINTS OF REFERENCE.

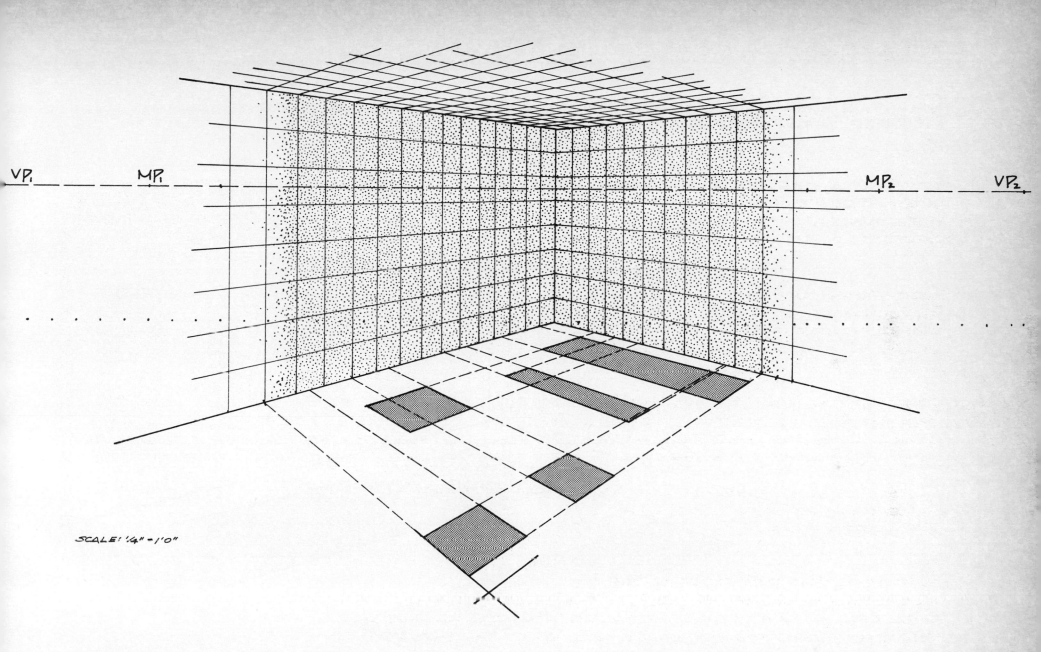

VP₁ — — MP₁ — — · — — MP₂ — VP₂

SCALE: ¼" = 1'0"

63

HEIGHTS

CHECK THE HEIGHTS OF THE PIECES OF FURNITURE THAT ARE TO BE INCLUDED IN THE DRAWING.

EXTEND A LINE FROM A REAR CORNER ON A SPACE ALLOTMENT FOR A PIECE OF FURNITURE NOT AGAINST A WALL TO EITHER SIDE WALL.

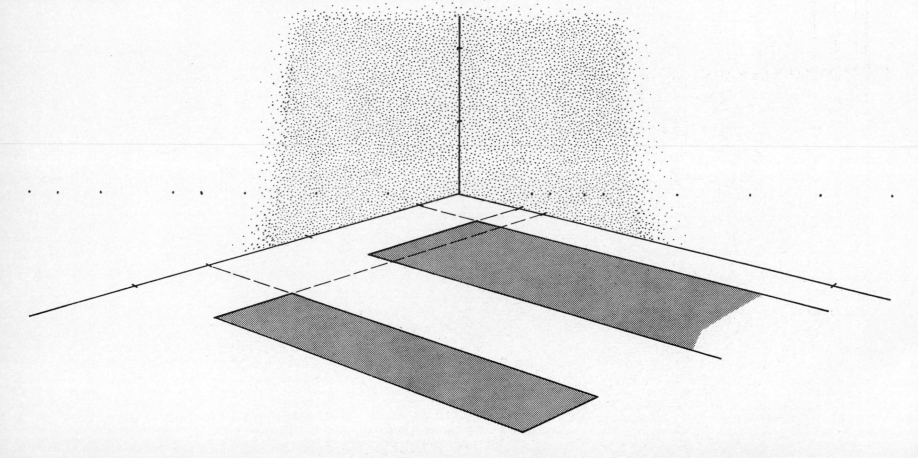

CONSTRUCT A VERTICAL LINE AT THE POINT WHERE THE EXTENDED
LINES AND THE WALLS MEET.

MARK THE HEIGHT OF THE PIECE OF FURNITURE ON THE TRUE HEIGHT
CORNER. ALIGN EITHER VP₁ OR VP₂ AND THE MEASUREMENT AND
PROJECT THE HEIGHT TO THE VERTICAL LINE ERECTED AT THE POINT
WHERE THE EXTENDED LINE AND WALL MET.

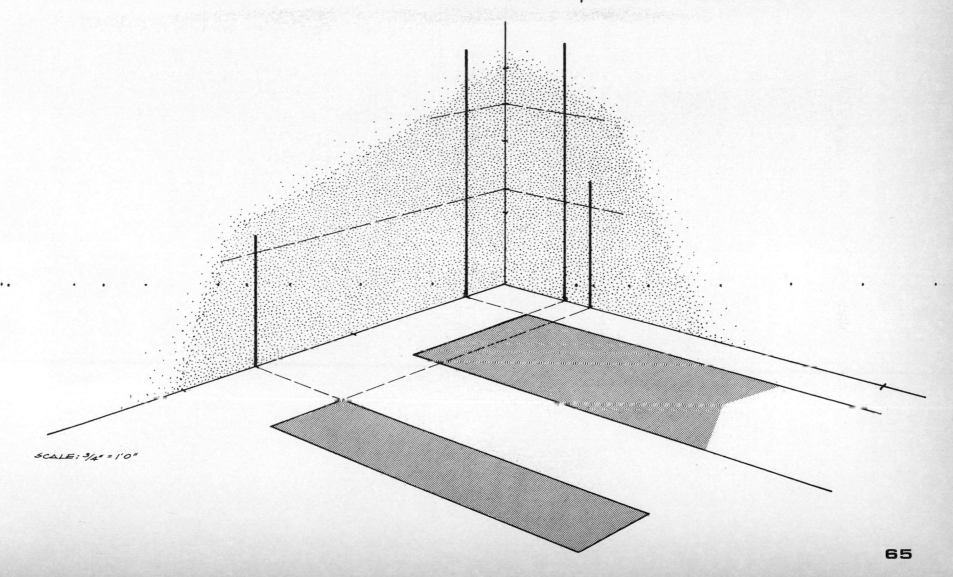

SCALE: 3/4" = 1'0"

CHANGE THE ALIGNMENT TO THE OTHER VANISHING POINT.

PROJECT THE HEIGHT INTO THE ILLUSTRATION TO ITS INTERSECTION WITH A VERTICAL LINE CONSTRUCTED AT THE CORNER ON THE SPACE ALLOTMENT.

REPEAT THE PROCEDURE FOR EACH OF THE REMAINING SPACE ALLOTMENTS IN THE ILLUSTRATION.

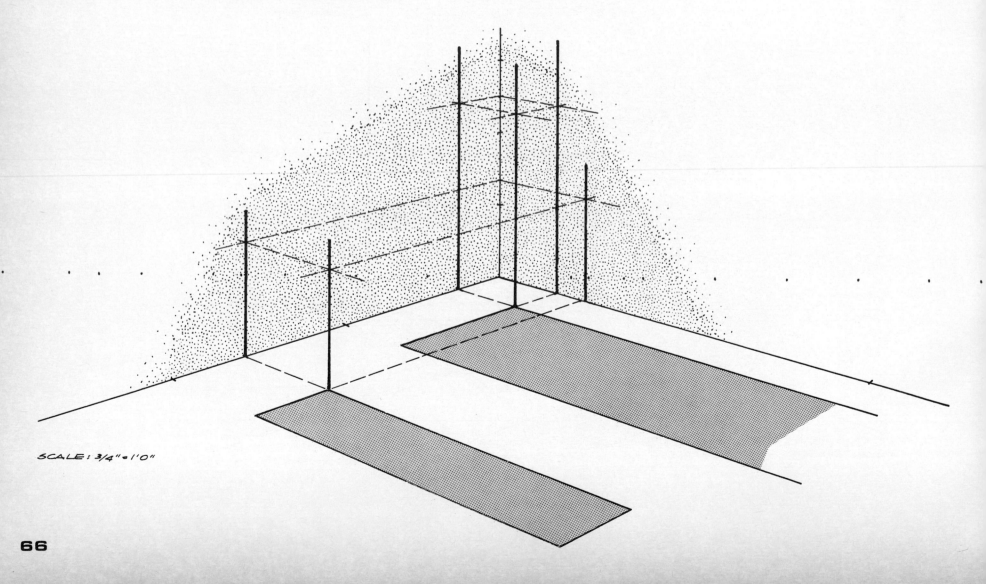

SCALE: 3/4" = 1'0"

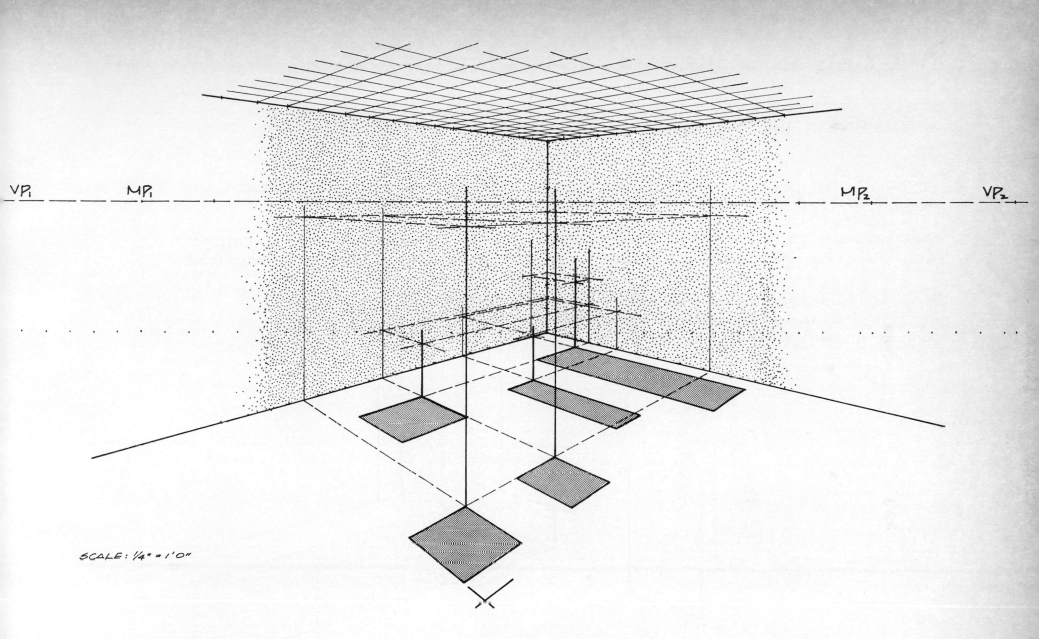

VP₁ MP₁ MP₂ VP₁ VP₂

SCALE: 1/4" = 1'0"

'BLOCKING IN' FORMS

ERECT VERTICAL LINES AT THE REMAINING CORNERS ON ONE SPACE
ALLOTMENT IN THE INTERIOR SPACE OR AGAINST THE WALL.

EXTEND THE HEIGHT MEASUREMENT PROJECTED TO THE CORNER OF THE
ALLOTMENT TO THE NEXT CORNER BY ALIGNING THIS MARK AND A VP.
CHANGE THE ALIGNMENT TO THE OTHER VANISHING POINT AND PROJECT
THE HEIGHT TO THE NEXT CORNER. CONTINUE TO ALTERNATE THE ALIGNMENT
WITH THE VPS UNTIL THE MARK HAS BEEN PROJECTED TO ALL CORNER VERTICALS.

REPEAT THIS PROCEDURE FOR EACH
OF THE REMAINING SPACE ALLOTMENTS
IN THE ILLUSTRATION.

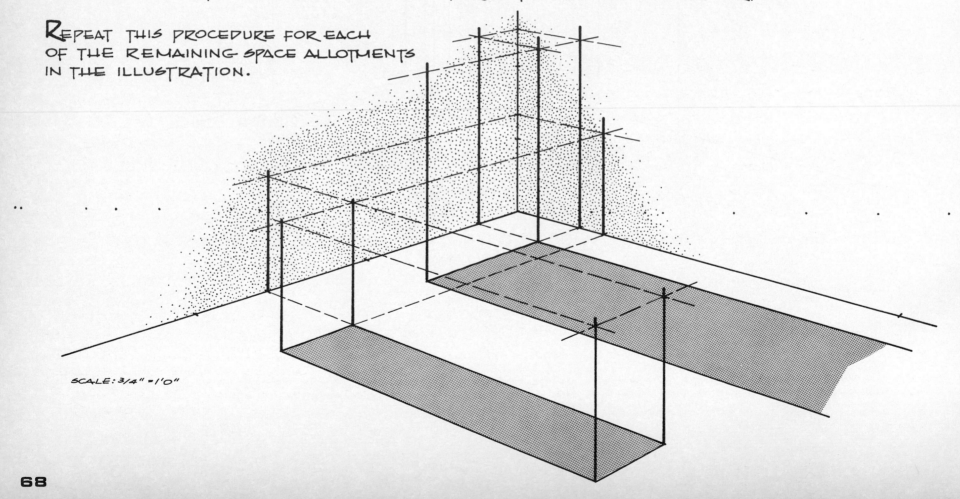

SCALE: 3/4" = 1'0"

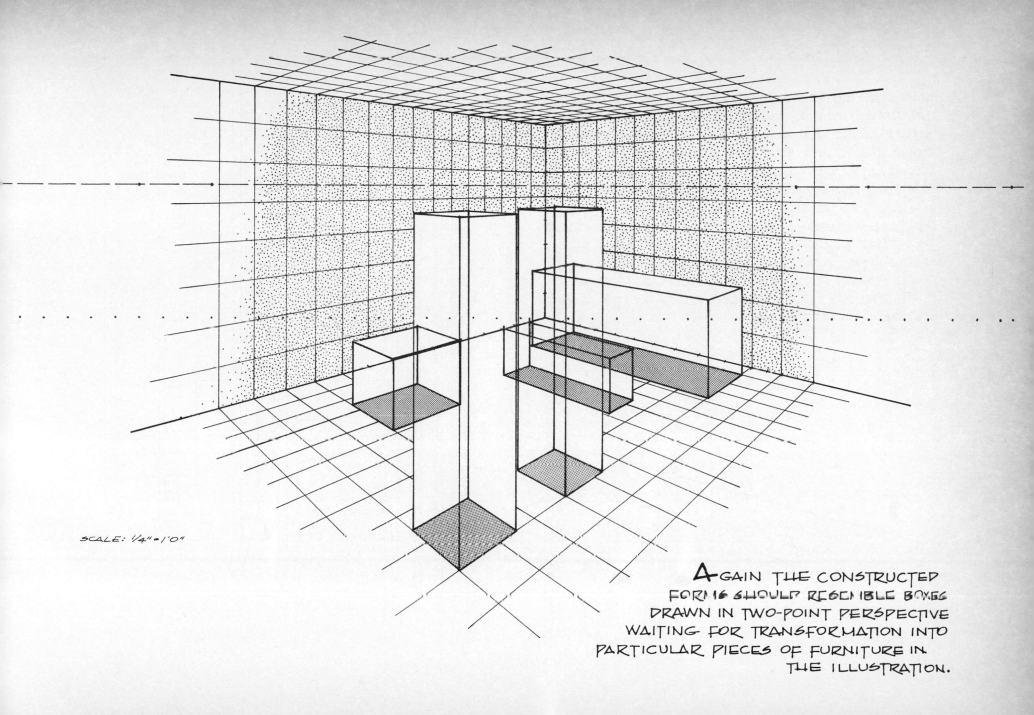

SCALE: 1/4" = 1'0"

Again the constructed forms should resemble boxes drawn in two-point perspective waiting for transformation into particular pieces of furniture in the illustration.

TRANSFORMATION OF FORMS

THE TRANSFORMATION OF A 'BLOCKED-IN' FORM IN A TWO-POINT PERSPECTIVE WILL ALSO REQUIRE ADDITIONAL DEPTH AND HEIGHT MEASUREMENTS. THE HEIGHTS OF THE DETAILS FOR THE OBJECT ARE OBTAINED FROM THE TRUE HEIGHT CORNER; THE DEPTHS OF THE DETAILS FROM THE RELOCATED SCALE ON THE FLOOR/WALL LINES. BOTH HEIGHTS AND DEPTHS ARE BROUGHT INTO THE DRAWING THROUGH THE INTERPLAY OF MEASUREMENTS AND VANISHING POINTS.

UPHOLSTERED FURNITURE AND TEXTURED ACCESSORIES MUST ALSO
APPEAR BELIEVABLE IN TWO-POINT PERSPECTIVE. CONTINUE TO
TRANSFORM THEIR BLOCKED-IN FORMS WITH STROKES ADAPTED FROM
YOUR VOCABULARY OF TEXTURAL LINES UNTIL NATURALISTIC
INTERPRETATIONS HAVE BEEN ACHIEVED. OBSERVE OBJECTS IN
A VARIETY OF SETTINGS AND LIGHTING CONDITIONS. NOTICE HOW
THE VALUES OF THE LINES AND TEXTURES VARY.

VARIATIONS

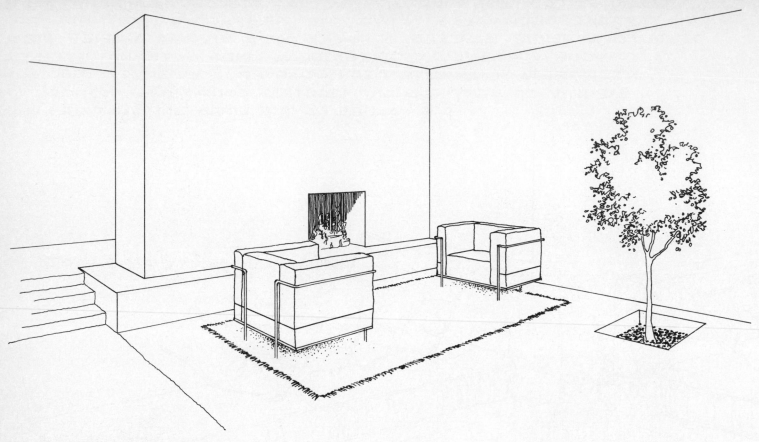

THE PLACEMENT OF THE MEASURING AND VANISHING POINTS AT IDENTICAL DISTANCES FROM THE TRUE HEIGHT CORNER ON AN EYE LEVEL THAT DIVIDES THE INTERIOR IN HALF CAN SOMETIMES PRODUCE A SUCCESSFUL TWO-POINT PERSPECTIVE DRAWING.

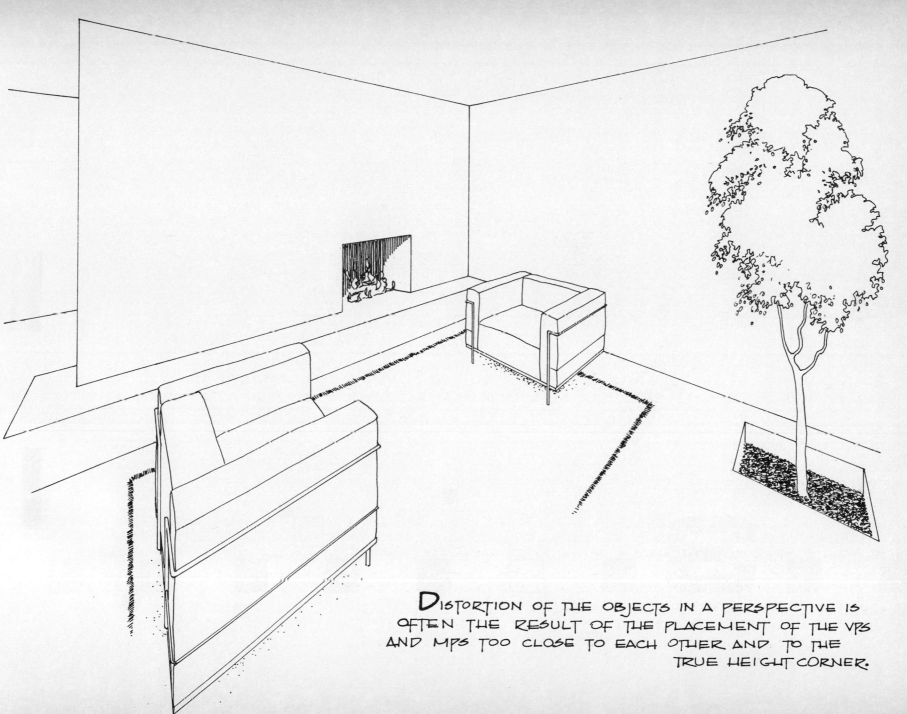

DISTORTION OF THE OBJECTS IN A PERSPECTIVE IS OFTEN THE RESULT OF THE PLACEMENT OF THE VPS AND MPS TOO CLOSE TO EACH OTHER AND TO THE TRUE HEIGHT CORNER.

detailing

THE ABILITY TO GRAPHICALLY PRESENT A SIMPLE DRAWING OR EVEN A ROUGH SKETCH OF AN IDEA IN EITHER ONE- OR TWO-POINT PERSPECTIVE IS A REMARKABLE ACHIEVEMENT TO THE INDIVIDUAL WHO CANNOT VISUALIZE AN INTERIOR FROM A FLOOR PLAN. WHEN THE SAME ILLUSTRATION CONTAINS A FLIGHT OF STAIRS, A BAY WINDOW, A WINDOW SEAT, A FIREPLACE, AN ARCHED DOORWAY, A NICHE, A RECESSED OR PROJECTING WALL OR ANY ARCHITECTURAL CONFIGURATION WITHIN ITS LIMITS, THE DRAWING HAS BECOME A 'MASTERPIECE'.

MOST INTERIOR SPACES DO NOT HAVE FOUR FLAT WALLS WITHOUT ANY BREAKS IN THEIR SURFACES. RATHER, MANY HAVE SOME ARCHITECTURAL DETAILING THAT ADDS INTEREST, VISUAL IMPACT TO THE SPACE. WHEN THE DETAILING IS PRESENT IN AN ILLUSTRATION, THE UNIQUENESS OF THESE ARCHITECTURAL EMBELLISHMENTS BECOMES EVIDENT FOR THE VIEWER.

THESE ARCHITECTURAL DETAILS ARE NOT DIFFICULT TO CREATE IN A PERSPECTIVE, IF THE DESIGNER REMEMBERS ONE SIMPLE, YET FUNDAMENTAL STEP: REDUCE THE DETAIL INTO A BASIC GEOMETRIC FORM. WHEN THIS STEP IS UNDERSTOOD AND PRACTICED, FEW OBJECTS CANNOT BE INCLUDED IN A DRAWING.

CONSIDER THE CONSTRUCTION OF ARCHITECTURAL DETAILINGS AS A SKILL, A STEP, A CHALLENGE THAT MUST BE MASTERED BEFORE PROCEEDING ON TO THE NEXT SKILL, STEP OR CHALLENGE.

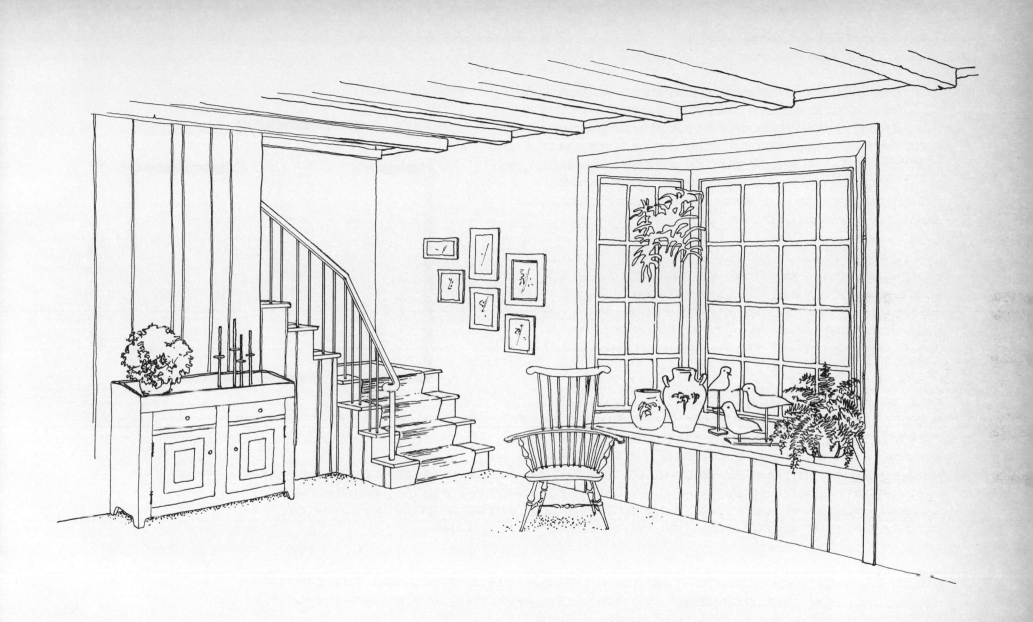

RECESSED AREAS

The drawing of straight-sided, floor-to-ceiling recessed areas in one-point perspective begins with a recheck of the dimensions of the areas in the floor plan. Recessed areas usually are rectangular shapes and when completed will become rectangular solids in perspective.

Plot the dimensions of the recesses from a corner of the room. Plot the lengths of their openings on the relocated scale on a floor/wall line or on the true height wall.

If a recessed area is in the true height wall, extend the floor/wall line back toward the VP a brief distance. From the lower right corner of the true height wall, find the measurement on the scale along the base of the wall that corresponds with the depth of the area. Align this measurement and the MP and mark where this alignment crosses the extension of the floor/wall line.

Draw a line parallel to the true height wall through the depth mark. Align the corners of the area and the vanishing point and extend lines back to the depth line.

SCALE: 3/16" = 1'0"

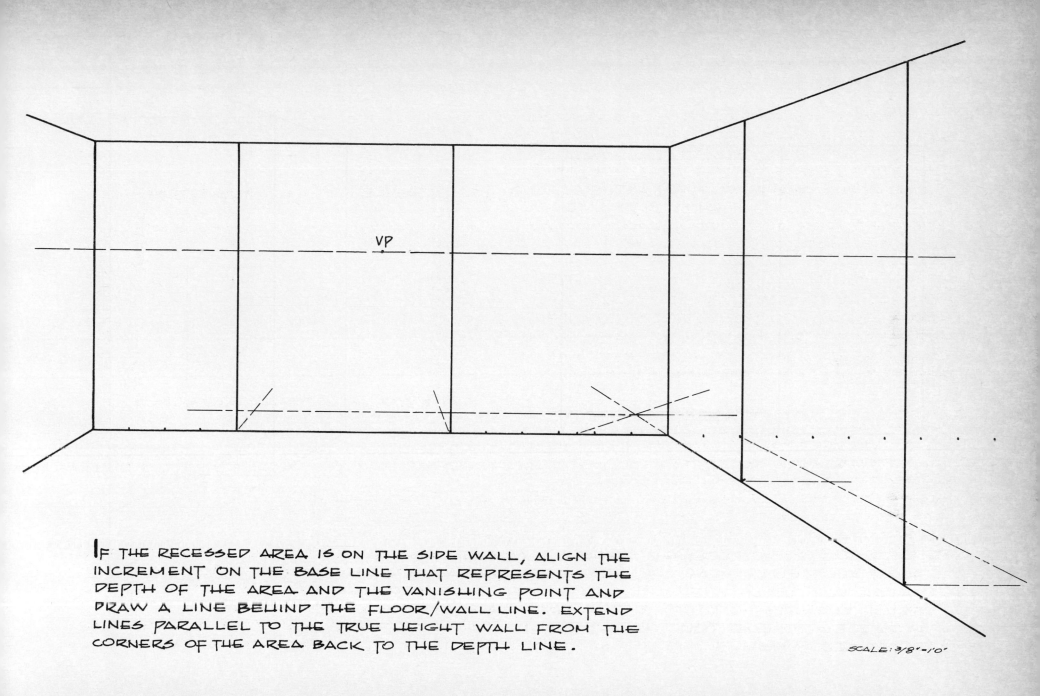

VP

If the recessed area is on the side wall, align the increment on the base line that represents the depth of the area and the vanishing point and draw a line behind the floor/wall line. Extend lines parallel to the true height wall from the corners of the area back to the depth line.

SCALE: 3/8" = 1'0"

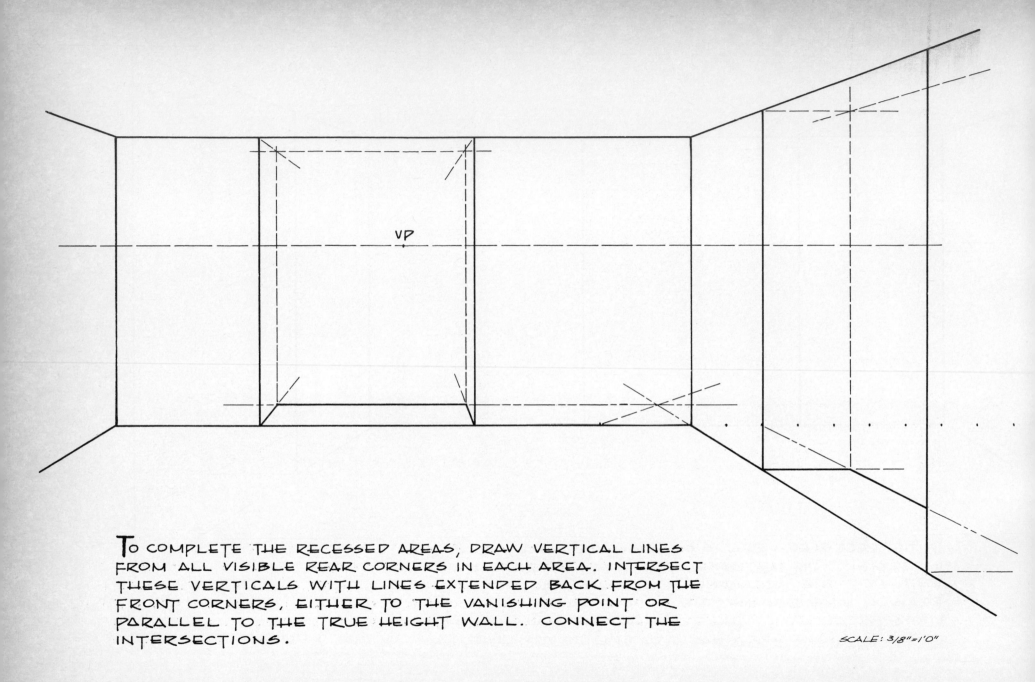

VP

TO COMPLETE THE RECESSED AREAS, DRAW VERTICAL LINES
FROM ALL VISIBLE REAR CORNERS IN EACH AREA. INTERSECT
THESE VERTICALS WITH LINES EXTENDED BACK FROM THE
FRONT CORNERS, EITHER TO THE VANISHING POINT OR
PARALLEL TO THE TRUE HEIGHT WALL. CONNECT THE
INTERSECTIONS.

SCALE: 3/8"=1'0"

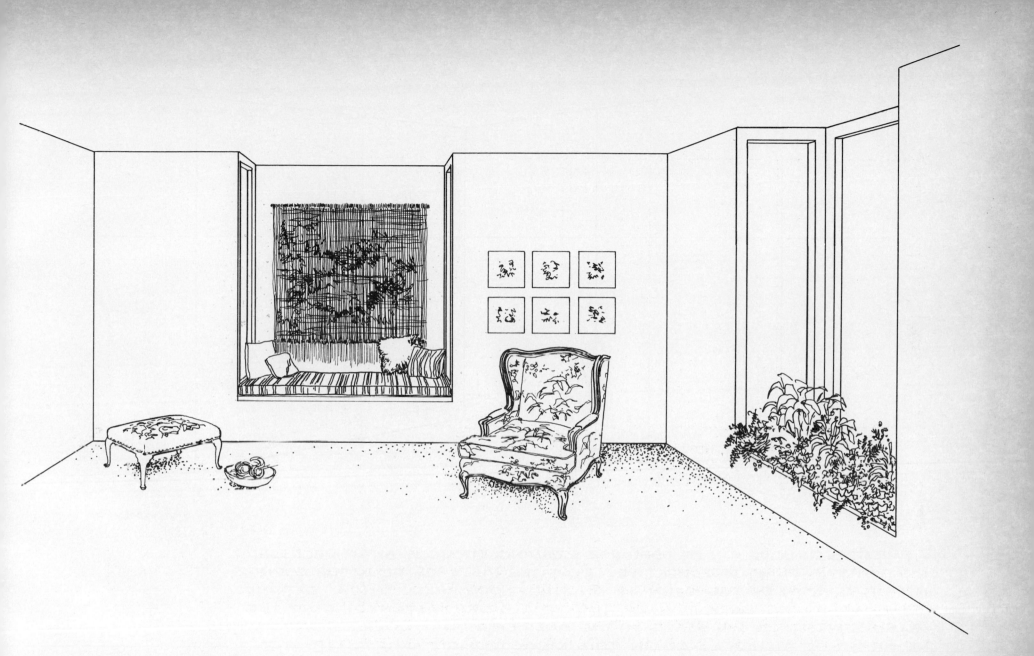

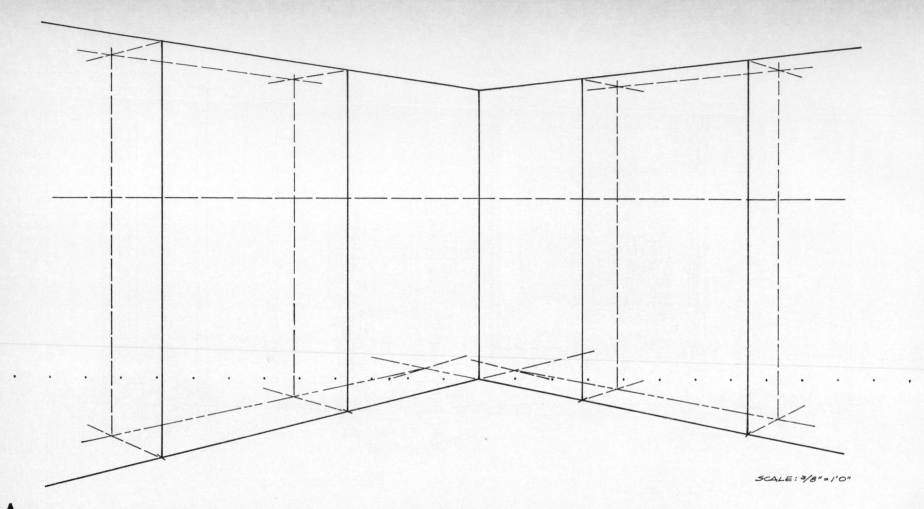

SCALE: 3/8" = 1'0"

A SIMILAR TECHNIQUE CAN BE USED FOR DRAWING STRAIGHT-SIDED RECESSED
AREAS IN TWO-POINT PERSPECTIVE. PLOT THE DISTANCE FROM THE CORNER
AND THE LENGTH OF THE OPENING ON THE FLOOR/WALL LINES. EXTEND A
FLOOR/WALL LINE BACK TOWARD THE VP A BRIEF DISTANCE. FIND THE
MEASUREMENT ON THE SCALE ON THE BASE LINE THAT CORRESPONDS WITH
THE DEPTH OF THE AREA. ALIGN THIS MEASUREMENT AND A <u>MP</u> AND
MARK WHERE THIS ALIGNMENT CROSSES THE EXTENSION OF THE FLOOR/
WALL LINE. ALIGN THIS INTERSECTION AND A <u>VP</u> AND DRAW THE DEPTH
LINES. DRAW LINES FROM THE CORNERS OF THE AREA TOWARD THE VP,
BUT ONLY AS FAR AS THE DEPTH LINE.

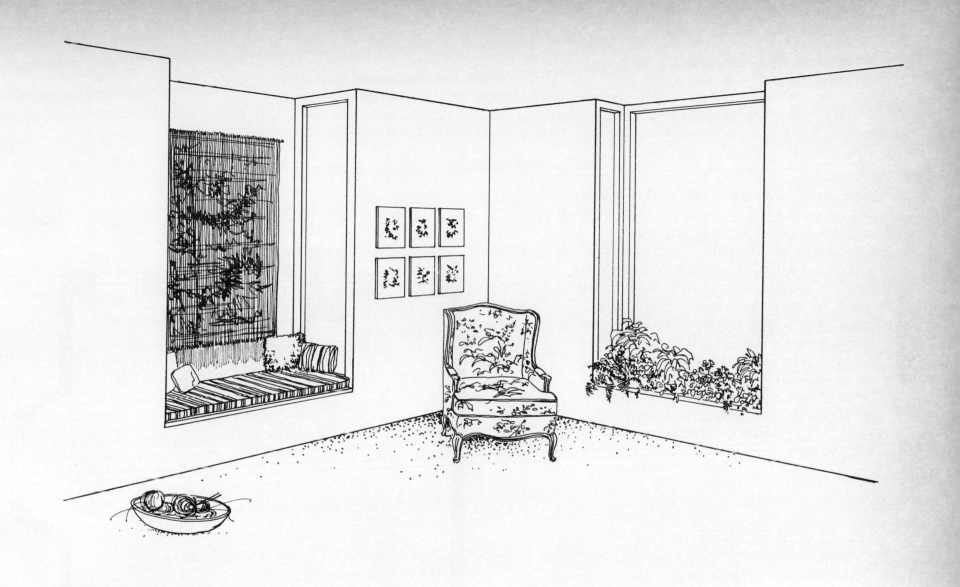

DRAW VERTICAL LINES FROM ALL VISIBLE REAR CORNERS IN EACH AREA. INTERSECT THESE VERTICALS WITH LINES EXTENDED BACK FROM THE FRONT CORNERS TO THE VANISHING POINTS. CONNECT THE INTERSECTIONS. ENRICH THE DRAWING.

ARCHITECTURAL DETAILS WITH ANGLED OR SLANTED SIDES ARE ALSO POSSIBLE. ON THE FLOOR PLAN, DRAW A LINE ACROSS THE FRONT OF THE RECESS. FROM THE REAR CORNERS OF THE AREA, PROJECT LINES TO THE FRONT ENCLOSURE LINE. MEASURE THE DISTANCE BETWEEN THE INTERSECTION OF THE EXTENDED LINES AND THE FRONT CORNERS.

IN THE ILLUSTRATION, PLOT THESE MEASUREMENTS ON A LINE DRAWN ACROSS THE FRONT OF THE RECESSED DETAIL. ALIGN THE MARKS WITH THE VANISHING POINT AND EXTEND THEM BACK TO THE DEPTH LINE. CONNECT THE FRONT CORNERS AND THE INTERSECTIONS ON THE DEPTH LINE. THESE LINES DO NOT GO TO A VANISHING POINT. EXTEND VERTICAL LINES FROM THE CORNERS TO THE PLANNED HEIGHTS AND COMPLETE THE DRAWING.

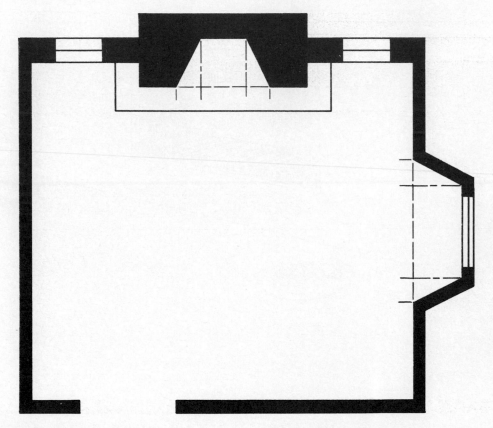

SCALE: 1/4" = 1'0"

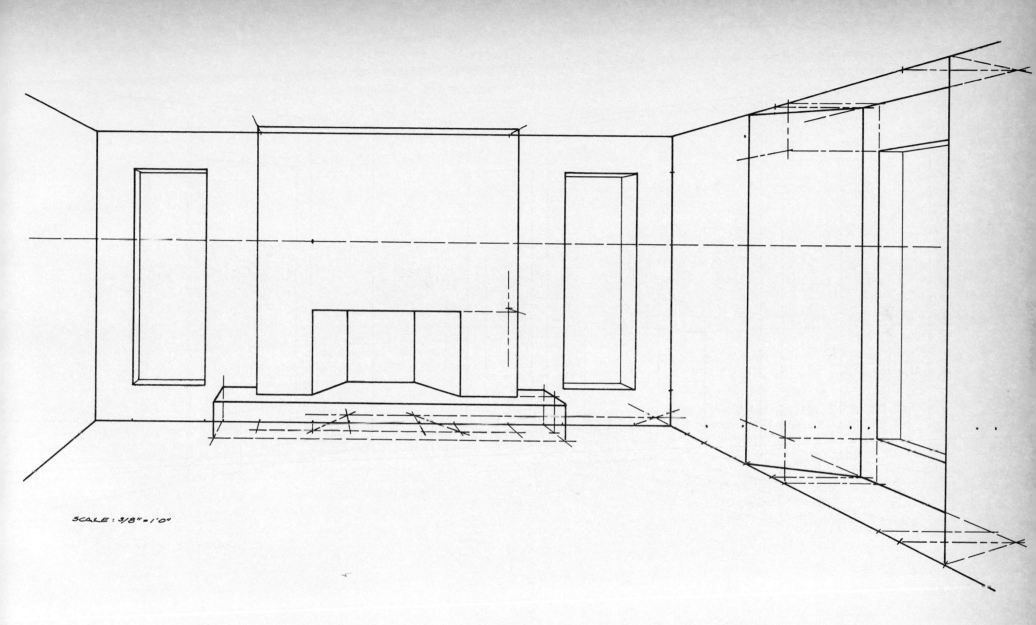

SCALE : 3/8" = 1'0"

85

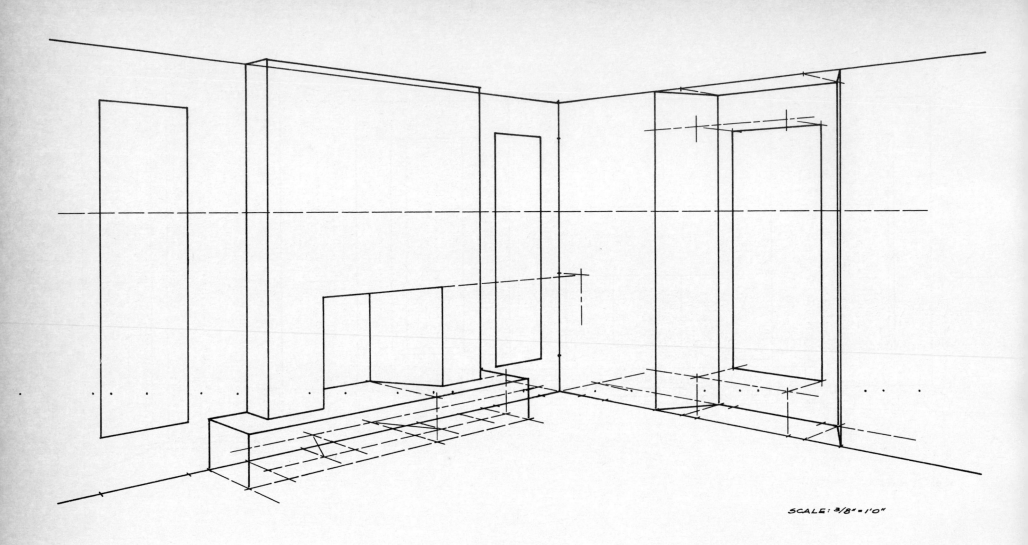

SCALE: 3/8" = 1'0"

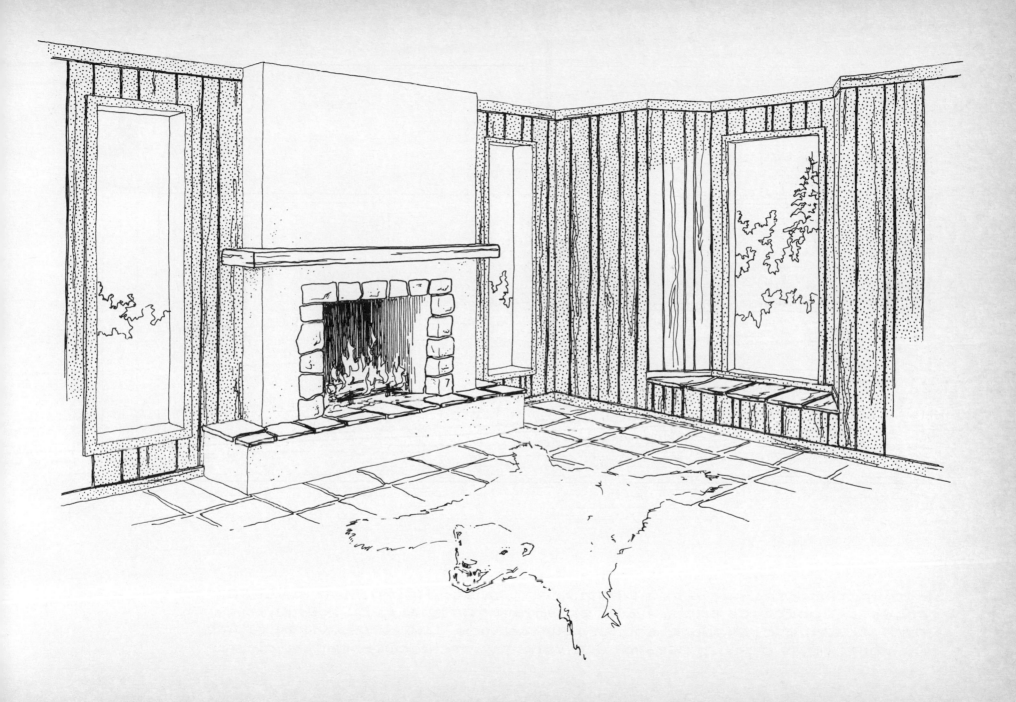

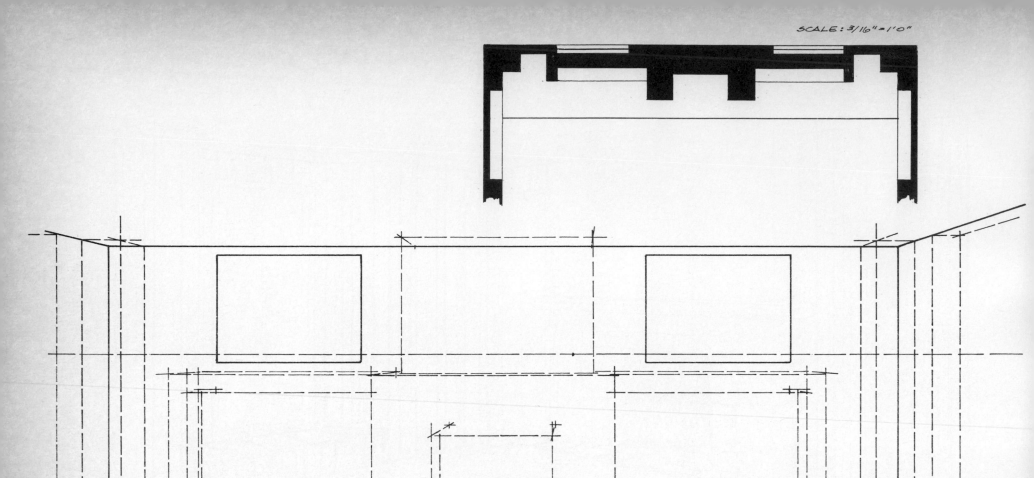

A PROJECTING, STRAIGHT-SIDED FIREPLACE, A RAISED HEARTH AND SEVERAL RECESSED BOOKCASES SHOULD ALL BE WITHIN THE REALM OF POSSIBILITY NOW. ALL ARE RECTANGULAR SOLIDS, AND, AS SUCH, CAN BE DRAWN IN EITHER ONE-POINT OR TWO-POINT PERSPECTIVE WITH THE TECHNIQUES JUST DESCRIBED.

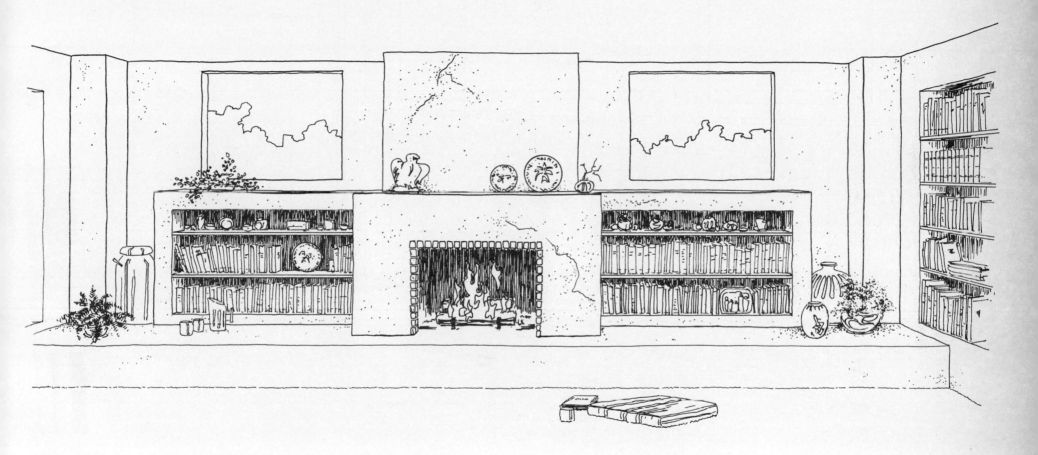

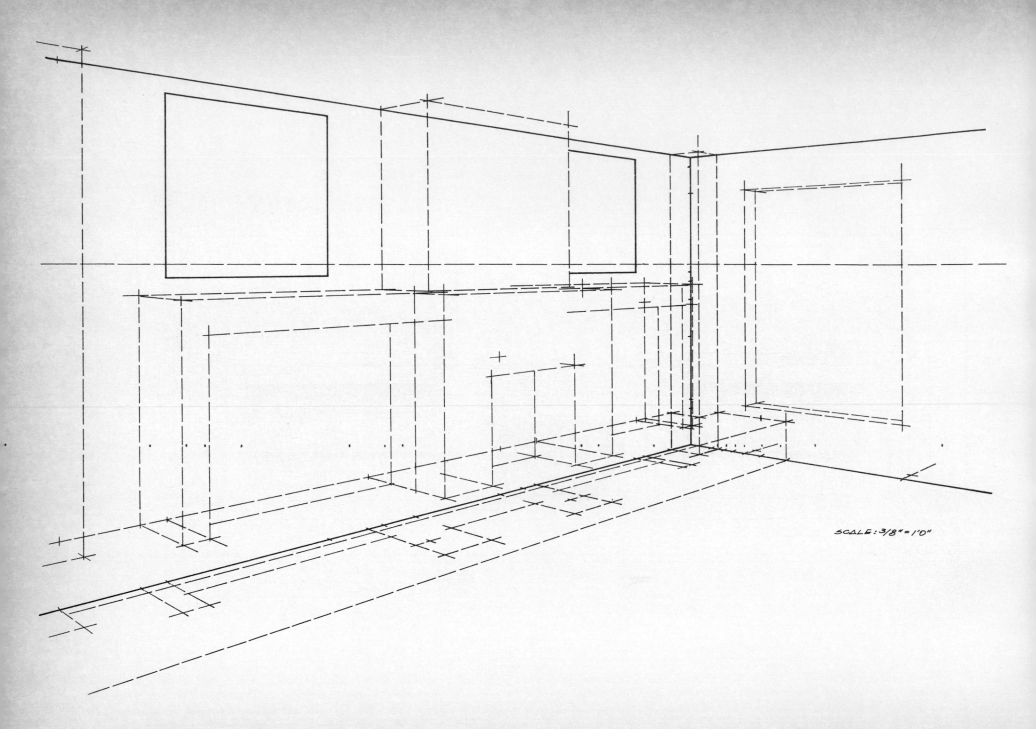

SCALE: 3/8"=1'0"

90

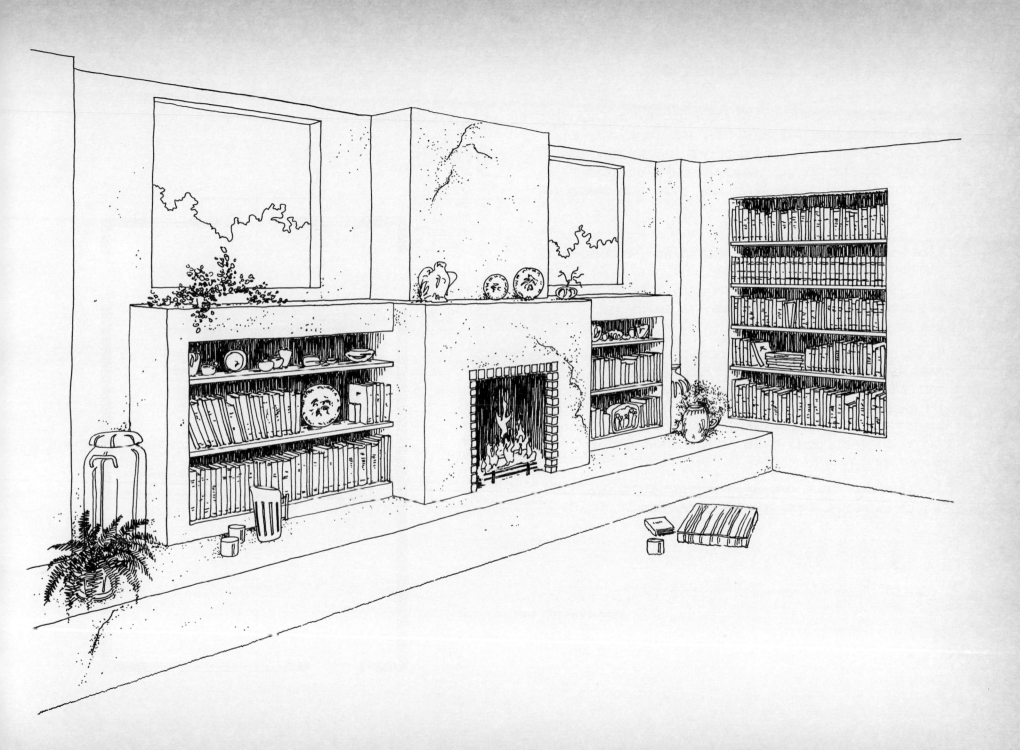

CATHEDRAL CEILINGS

CATHEDRAL CEILINGS ARE OFTEN A FEATURE OF A CONTEMPORARY HOME. THIS INTERIOR DETAIL CAN BE PRESENTED IN ONE-POINT PERSPECTIVE, BUT CAN BE MORE EFFECTIVELY SHOWN IN TWO-POINT. SEVERAL QUICK SKETCHES SHOULD SUGGEST THE BEST FORM TO USE.

TO DRAW A CATHEDRAL CEILING IN ONE-POINT PERSPECTIVE, OBTAIN THE DISTANCE THE PEAK OF THE CEILING IS FROM THE SIDE WALLS AS WELL AS ITS HEIGHT.

LOCATE THE DISTANCE ON THE TRUE HEIGHT WALL. EXTEND A VERTICAL LINE FROM THIS POINT. PLOT THE PLANNED HEIGHT IN SCALE ON THIS VERTICAL. EXTEND THE HEIGHT OF THE CEILING INTO THE DRAWING WITH A LINE FROM THE VANISHING POINT.

CONNECT THE PEAK TO THE SIDE WALLS AND COMPLETE THE DRAWING.

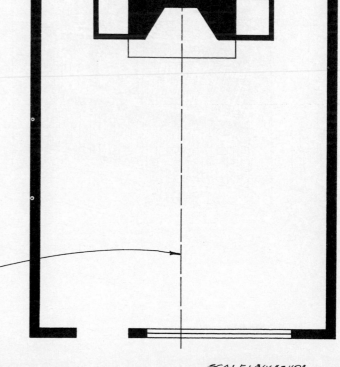

PEAK OF THE CEILING

SCALE: 3/16" = 1'0"

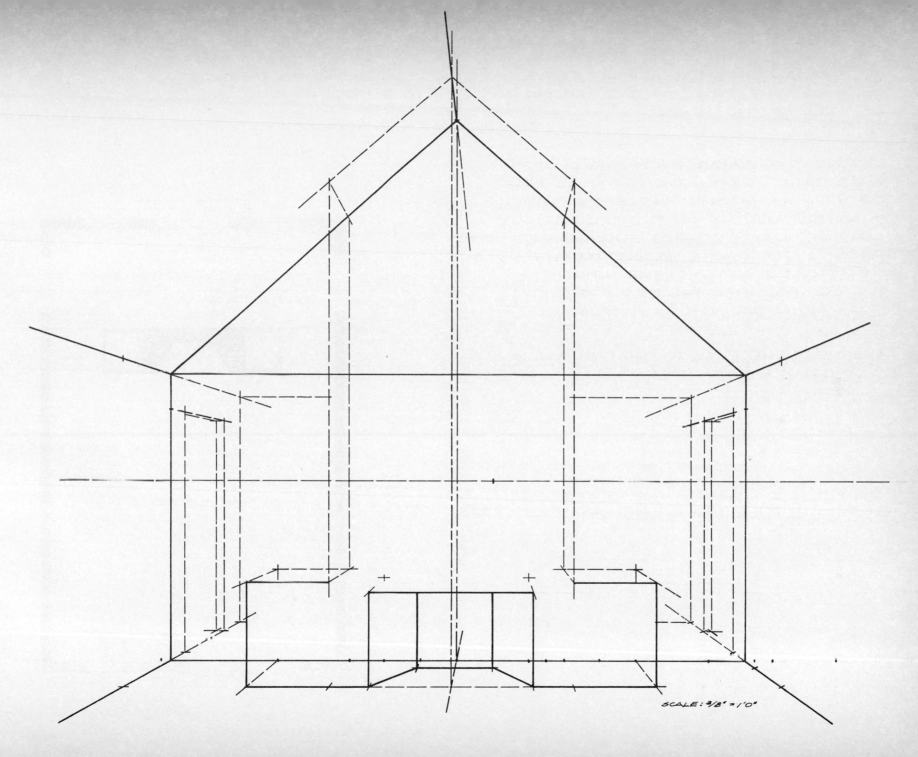

SCALE: 3/8" = 1'0"

93

TO DRAW A CATHEDRAL CEILING IN TWO-POINT PERSPECTIVE, OBTAIN THE DISTANCE THE PEAK OF THE CEILING IS FROM THE SIDE OR END WALLS AS WELL AS ITS HEIGHT.

LOCATE THE DISTANCE ON THE FLOOR/WALL LINE. EXTEND A VERTICAL LINE FROM THIS POINT. MEASURE THE PLANNED HEIGHT ON THE TRUE HEIGHT CORNER AND PROJECT THE HEIGHT FROM A VANISHING POINT TO THE VERTICAL. EXTEND THE HEIGHT OF THE CEILING INTO THE DRAWING WITH LINES FROM THE VANISHING POINTS.

CONNECT THE PEAK TO THE END WALLS AND COMPLETE THE DRAWING.

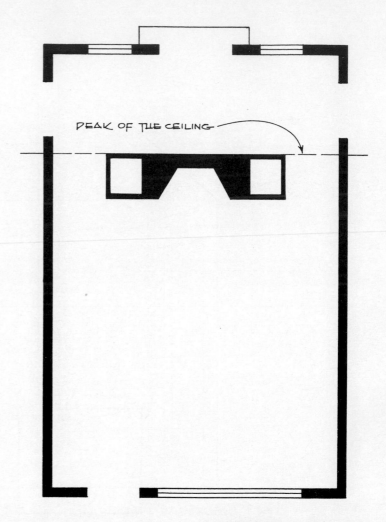

PEAK OF THE CEILING

SCALE: 3/16" = 1'0"

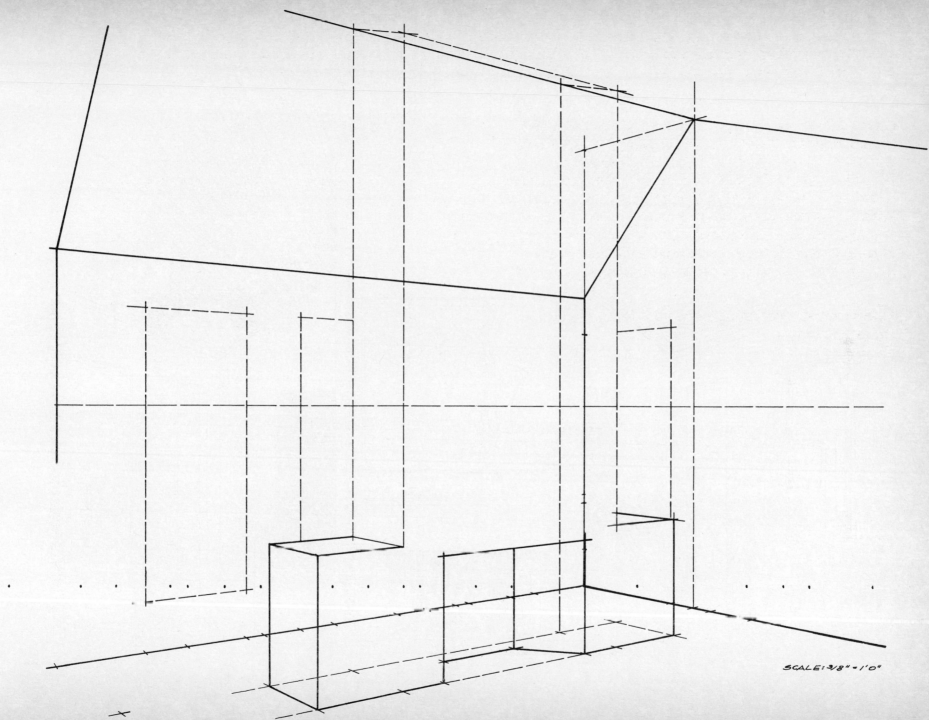

SCALE: 3/8" = 1'0"

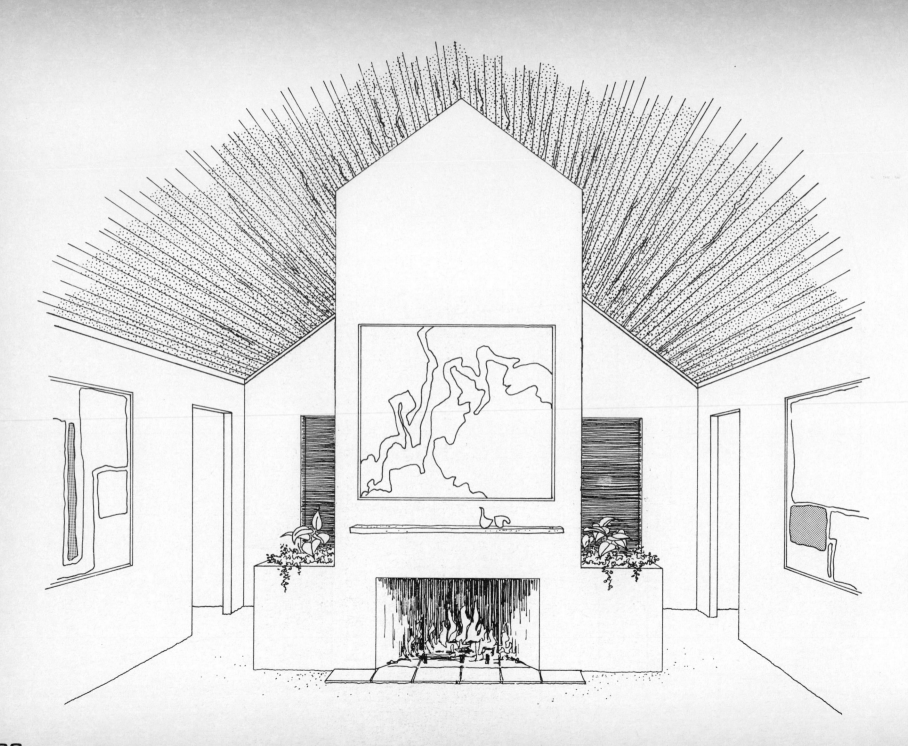

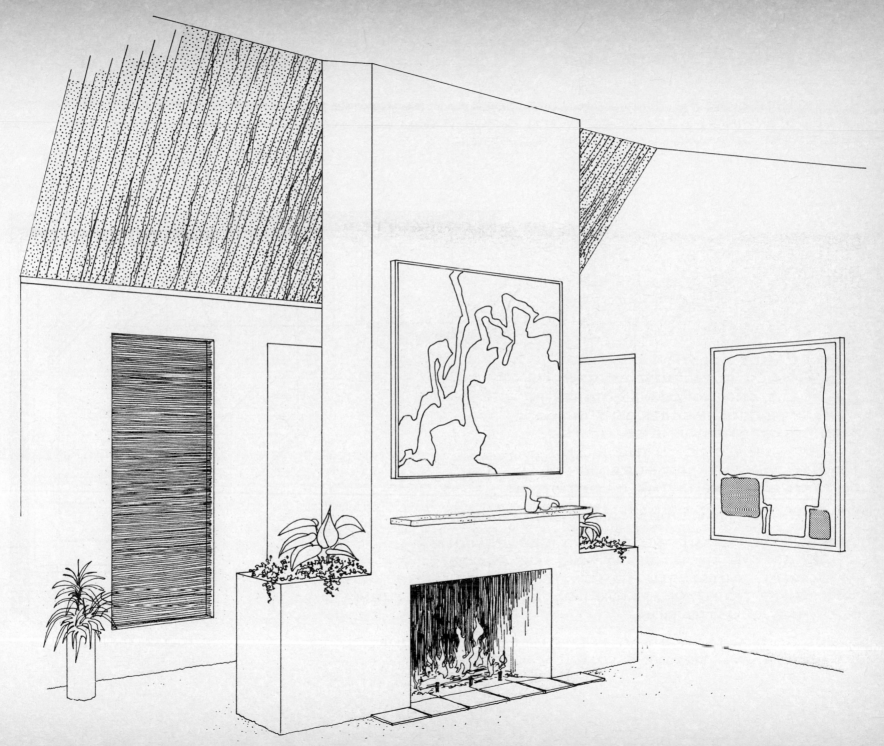

FURNITURE ON ANGLES

IN ANY INTERIOR SETTING, THE FURNITURE CAN BE AGAINST THE WALLS OR FREE-STANDING, ARRANGED WITH SIDES PARALLEL TO THE WALLS OR PLACED AT ODD ANGLES WITHIN THE SPACE.

A WORKABLE SOLUTION FOR THE INCLUSION OF FURNITURE ABUTING THE WALLS AND ACROSS A CORNER IN AN ILLUSTRATION BEGINS ON THE FLOOR PLAN. PLOT THE CORNERS OF THE ANGLED FURNITURE ON THE PLAN. TRANSPOSE THE MEASUREMENTS ONTO THE FLOOR IN THE ILLUSTRATION.

EXTEND VERTICAL LINES FROM THE CORNERS.

LOCATE THE HEIGHT AND DEPTH MEASUREMENTS EITHER ON THE TRUE HEIGHT WALL OR FLOOR/WALL LINE. ALIGN THESE POINTS WITH THE VANISHING POINT OR PARALLEL AND PROJECT THEM INTO THE ILLUSTRATION.

CONNECT THE DIAGONALS AND THE INTERSECTIONS. COMPLETE THE DRAWING.

SCALE: 3/8" = 1'0"

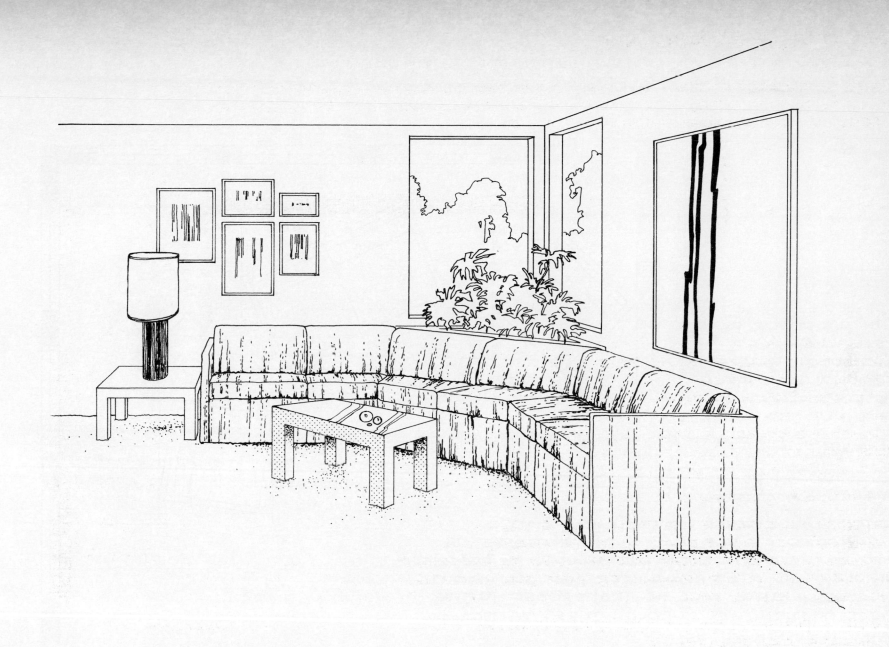

AN ALTERNATIVE, WORKABLE SOLUTION FOR FURNITURE PLACED
ON ODD ANGLES IN A PERSPECTIVE.

ON THE FLOOR PLAN
DRAW A SIMPLE
GEOMETRIC SHAPE
AROUND EACH PIECE
OF FURNITURE. THE
SIDES OF THE SHAPES
SHOULD BE PARALLEL TO
THE WALLS.

PLOT THE SHAPES ON THE FLOOR IN
THE ILLUSTRATION.

EXTEND ONE CORNER OF EACH SHAPE TO A
WALL. ERECT A VERTICAL AT THIS INTERSECTION
AND AT THE CORNER ON THE SHAPE. AS DESCRIBED
ON P. 64 AND P. 65 IN CHAPTER TWO, ALL HEIGHT
MEASUREMENTS WILL BE TRANSPOSED TO THE
PIECE OF FURNITURE THROUGH THESE VERTICALS.

SCALE: 3/8" = 1'0"

100

PLOT THE POINTS OF TANGENCY FOR THE ANGLED FURNITURE WITHIN EACH SHAPE IN THE DRAWING. THESE ARE THE POINTS WHERE THE FURNITURE TOUCHES THE SIDES OF THE SHAPES DRAWN AROUND THEM.

EACH PAIR OF EDGES JUST DRAWN SHOULD CONVERGE AT A NEW VP OR PAIR OF VPS SOMEWHERE ON THE EYELEVEL.

SCALE: 3/8" = 1'0"

EXTEND VERTICAL LINES FROM THE POINTS OF TANGENCY INSIDE A SHAPE.

LOCATE THE HEIGHT AND DEPTH MEASUREMENTS. ALIGN THESE POINTS WITH THE ORIGINAL VPS AND PROJECT THEM INTO THE ILLUSTRATION.

TRANSFER THESE MEASUREMENTS TO THE VERTICALS USING THE OLD AND NEW VPS IN COMBINATION. CONNECT THE INTERSECTIONS.

REPEAT THIS PROCEDURE FOR EACH PIECE OF FURNITURE IN TURN UNTIL ALL ARE DRAWN.

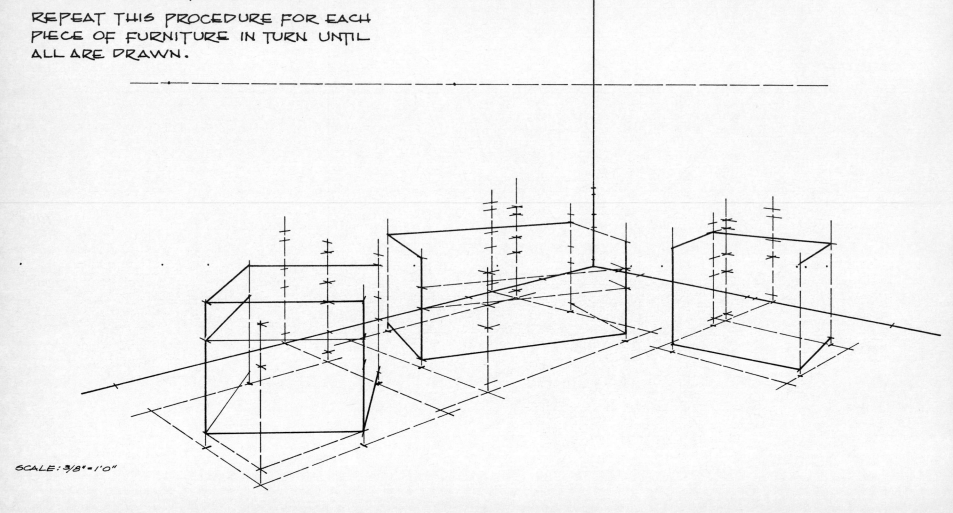

SCALE: 3/8" = 1'0"

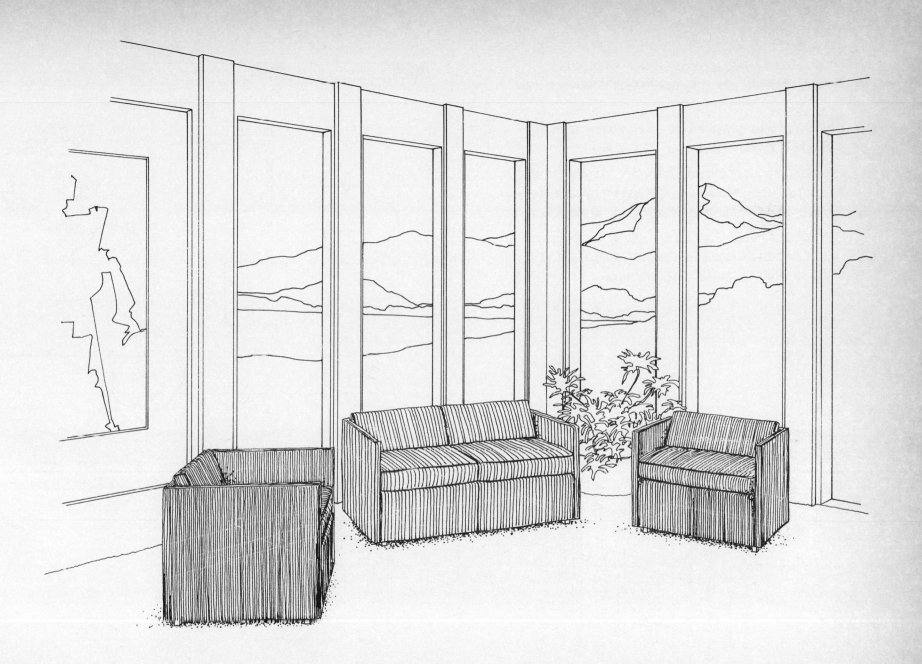

AN ADAPTION OF THE SOLUTION CAN BE
UTILIZED FOR DRAWING MOLDED
FURNITURE IN PERSPECTIVE.

BEGIN THE DRAWING AS DESCRIBED
ON THE PRECEDING PAGES.

EXTEND VERTICAL LINES FROM THE
POINTS OF TANGENCY AND FROM
ALL CORNERS OF EACH SHAPE.

LOCATE THE HEIGHT AND DEPTH
MEASUREMENTS AND PROJECT
THEM INTO THE DRAWING.

SCALE: 3/8" = 1'0"

FREELY DRAW ONE PIECE OF FURNITURE IN EACH OUTLINED, MARKED FORM. THE POINTS OF TANGENCY ALONG THE VERTICALS SHOULD ACT AS POINTS OF REFERENCE AS THE DRAWING PROGRESSES. REPEAT THIS PROCEDURE FOR EACH UNIT UNTIL ALL ARE DRAWN. COMPLETE THE DRAWING.

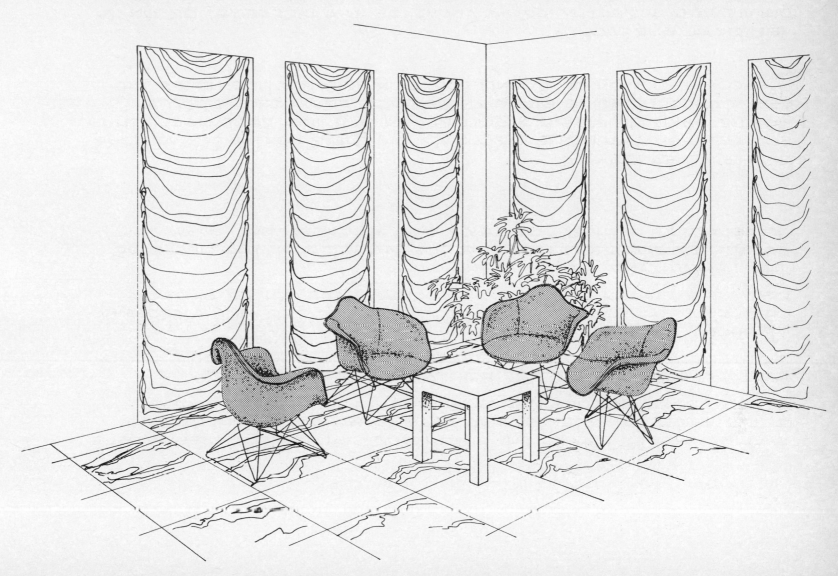

CIRCLES / ROUND FORMS

CIRCLES DRAWN IN PERSPECTIVE WILL ALWAYS APPEAR AS OVALS. IF A CIRCLE IS TO REMAIN AS A CIRCLE IN A PERSPECTIVE, IT MUST BE VIEWED DIRECTLY FROM ABOVE, AS IN A BIRDSEYE, OR ON A VERTICAL SURFACE.

THE CONSTRUCTION OF ROUND FORMS IN PERSPECTIVE NEEDS THE ASSISTANCE OF SOME BASIC KNOWLEDGE FROM GEOMETRY: A CIRCLE WILL FIT INSIDE A SQUARE; AN OVAL IN A RECTANGLE. THUS BOTH THE OVAL AND THE CIRCLE TOUCH THEIR CONTAINERS AT FOUR POINTS OF TANGENCY.

TO CONSTRUCT EITHER A CIRCLE OR OVAL IN PERSPECTIVE, DRAW THE SQUARE OR RECTANGULAR SHAPE THE DIAMETER OF THE CIRCLE OR THE LENGTH AND WIDTH OF THE OVAL.

DRAW THE DIAGONALS FROM THE CORNERS. THE CENTER OF THE CIRCLE OR THE OVAL IN PERSPECTIVE IS LOCATED AT THE CROSSING OF THESE DIAGONALS.

ALIGN THE CROSSING WITH THE VANISHING POINT OR POINTS AND/OR A PARALLEL TO OBTAIN THE POINTS OF TANGENCY.

FREELY DRAW THE DESIRED CURVED FORM TO FIT YOUR PLOTTED GUIDELINES. THIS STEP SOUNDS EASY TO DO, BUT MUCH PRACTICE WILL BE NEEDED BEFORE THE CIRCLES OR OVALS APPEAR `BELIEVABLE'.

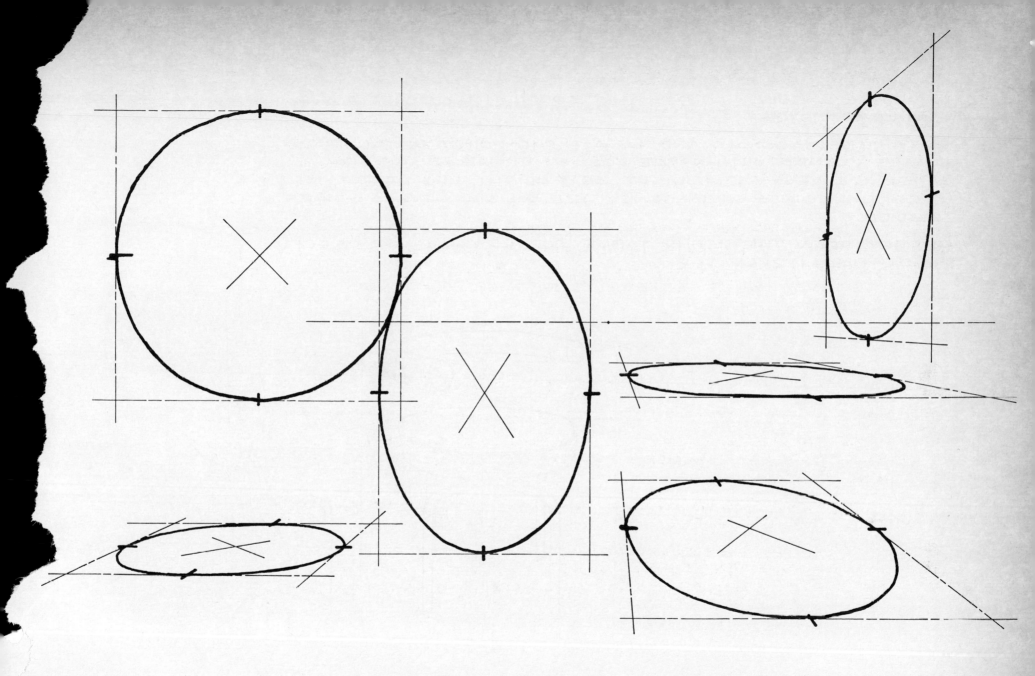

CURVED OBJECTS AND PIECES OF FURNITURE ARE MOST EASILY DRAWN IF THE RECTANGULAR FORMS THAT CONTAIN THE OBJECTS ARE COMPLETED FIRST.

DRAW THE DIAGONALS AND LOCATE THE POINTS OF TANGENCY ON ALL PLANES WITHIN THE FORMS. IF THE OBJECT HAS SEVERAL LEVELS: ARM HEIGHT, SEAT HEIGHT, LEG HEIGHT, BE SURE THE POINTS OF TANGENCY ARE ON ALL LEVELS WHERE NEEDED.

FREELY DRAW THE ROUND TABLE, CURVED CHAIR, OR OBJECT INSIDE THE MARKED FORM.

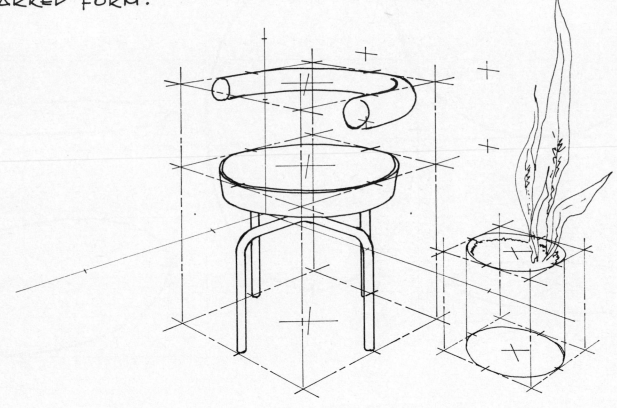

SCALE: 3/4" = 1'0"

TRADITIONAL OR SEMI-CIRCULAR ARCHES ARE HALF-CIRCLES.

TO CONSTRUCT A SEMI-CIRCULAR ARCH, DRAW THE RECTANGULAR SHAPE THAT WILL CONTAIN THE CURVED FORM AT ITS LOCATION IN THE DRAWING.

DRAW THE DIAGONALS TO OBTAIN THE CENTER OF THE ARCH. PROJECT A VERTICAL LINE THROUGH THE CENTER OF THE DIAGONALS TO LOCATE THE POINT OF TANGENCY AT THE TOP OF THE CURVE. THE TWO LOWER CORNERS OF THE RECTANGLE ARE THE OTHER POINTS OF TANGENCY.

FREELY DRAW THE ARCH INSIDE THE SPACE.

TO GIVE A DIMENSION TO THE ARCH, DUPLICATE THE ABOVE PROCEDURE ON A PLANE CONSTRUCTED BEHIND THE FIRST ONE, AT A DISTANCE THAT CORRESPONDS TO THE THICKNESS OF THE WALL.

FREELY COMPLETE AS MUCH OF THE ARCH AS NEEDED TO PROVIDE THE ILLUSION OF DEPTH.

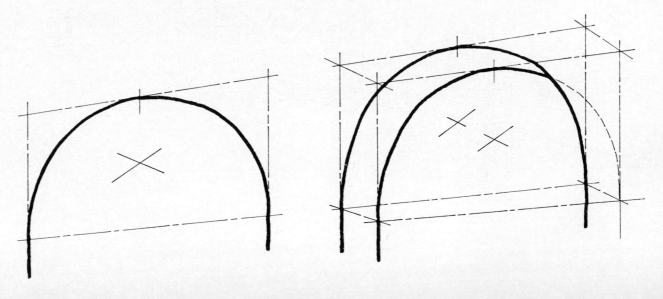

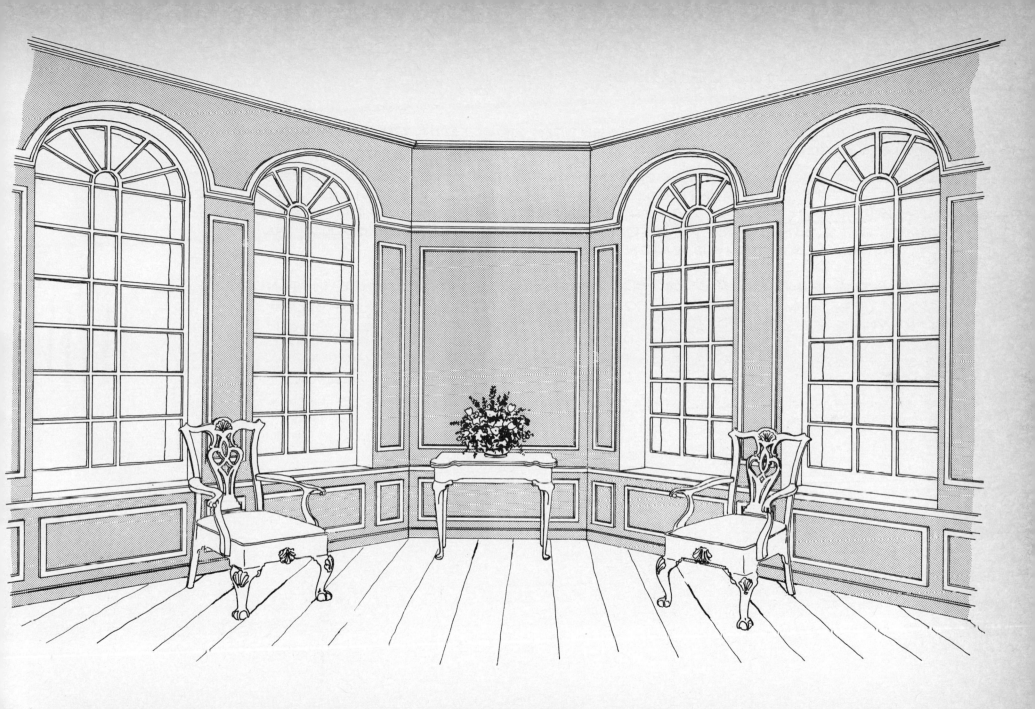

OBJECTS ON THE CEILING

CORRECTLY PLACED AND PRESENTED OBJECTS IN, ON OR PROJECTING FROM A CEILING CAN ADD MUCH TO AN ILLUSTRATION OF AN INTERIOR.

ANY DIFFICULTY IN THE DRAWING OF THE OBJECTS 'UP THERE' CAN BE KEPT TO A MINIMUM IF THE CEILING IS VISUALIZED AS AN 'UPSIDE-DOWN FLOOR'. IF THIS CONCEPT IS REMEMBERED, MANY OF THE TECHNIQUES PRESENTED IN CHAPTER TWO COULD BE OF SOME ASSISTANCE WHEN NEEDED.

AGAIN THE DIMENSIONS OF THE OBJECT, ITS LOCATION OR DISTANCE FROM THE WALLS AND ANY OTHER RELEVANT DETAILS MUST BE KNOWN.

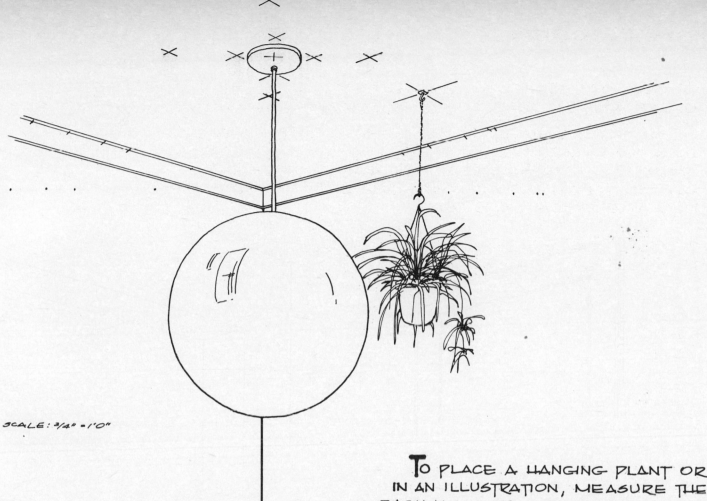

SCALE: 3/4" = 1'0"

TO PLACE A HANGING PLANT OR PENDANT LAMP
IN AN ILLUSTRATION, MEASURE THE DISTANCE FROM
EACH WALL TO THE CENTER OF THE OBJECT ON
THE PLAN. ALIGN THE MEASUREMENTS WITH THE
MPS AND VPS AND PROJECT THE DISTANCES ONTO THE CEILING IN THE
DRAWING. THE INTERSECTION OF THESE LINES SHOULD MARK THE POINTS
OF ATTACHMENT. EXTEND A VERTICAL LINE OR LINES DOWN FROM THE
POINTS THE DESIRED LENGTH. DRAW THE OBJECT IN SCALE AT THE END
OF THE VERTICAL. ADD ALL NECESSARY DETAILS AT THE CEILING AND
TO THE OBJECT.

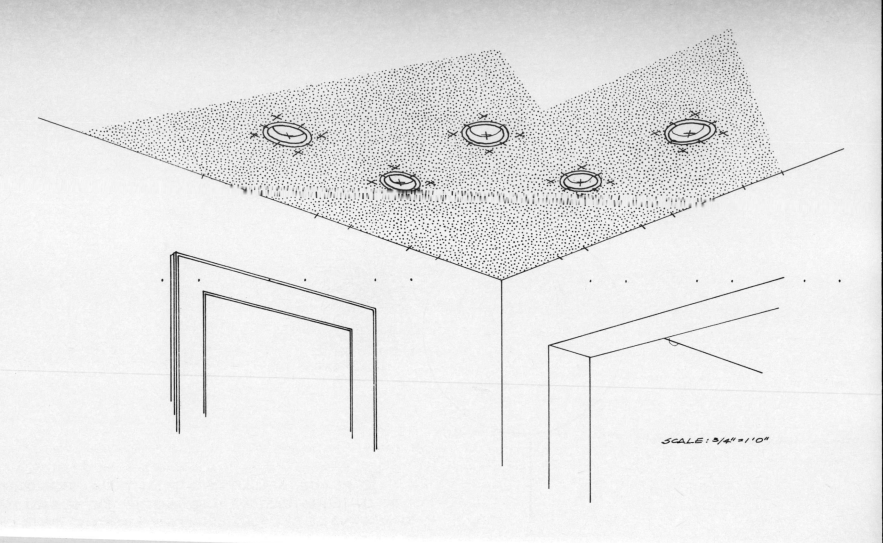

SCALE: 3/4" = 1'0"

TO CORRECTLY PLACE RECESSED SPOTS IN THE
CEILING, DRAW SQUARES AROUND THE LAMPS ON
THE FLOOR PLAN AND PROJECT THE MEASUREMENTS INTO THE
DRAWING. DRAW THE DIAGONALS IN THE RECTANGLES AND
LOCATE THE POINTS OF TANGENCY. DRAW THE OVALS OF THE
SPOTS. COMPLETE WITH ADDED DETAILS IF NEEDED.

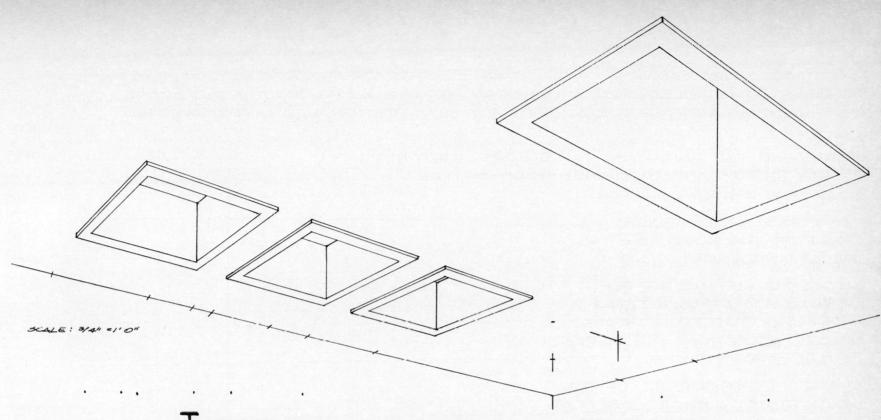

SCALE: 3/4" = 1'0"

To PLACE A SKYLIGHT IN A CEILING IN AN ILLUSTRATION, PROJECT THE
DIMENSIONS OF THE RECESSED FORM ONTO THE CEILING. IF THE SKYLIGHT IS
SHALLOW, PROJECT THE HEIGHT OF THE OPENING FROM AN EXTENSION TO
THE TRUE HEIGHT WALL OR CORNER TO THE AREA ON THE CEILING. THE
TECHNIQUE NEEDED IS A SIMPLE VARIATION ON THE PROCEDURE DESCRIBED
ON PP. 62-3 AND PP. 64-5 IN CHAPTER TWO.

IF THE SKYLIGHT IS DEEP OR HIGH, THE HEIGHT IS SUGGESTED BY
AN EXTENSION OF A VERTICAL FROM ONE REAR CORNER UNTIL IT
MEETS THE LIMITS OF THE AREA.

COMPLETE THE SPACE AND ADD FINISHING DETAILS.

STAIRS

A SET OF STAIRS CAN ADD MUCH TO AN ILLUSTRATION AND ARE NOT DIFFICULT TO DRAW. THE FOLLOWING IS A PROCEDURE FOR A ONE-POINT PERSPECTIVE. IT CAN ALSO BE ADAPTED FOR A TWO-POINT ILLUSTRATION WITH MINOR CHANGES.

DETERMINE THE HEIGHT OF THE RISERS, THE DEPTH OF THE TREADS AND THE DIMENSIONS OF THE SPACE THE STAIRS WILL FILL.

DRAW THIS RECTANGULAR SPACE ON THE FLOOR IN THE ILLUSTRATION.

ALIGN THE MP AND THE DEPTH INCREMENTS OF EACH TREAD AND MARK THE EDGE OF THE SPACE. TRANSPOSE THE MARKS TO THE OPPOSITE SIDE.

AT THE FRONT CORNER OF THE SPACE ERECT A SHORT VERTICAL. THIS LINE WILL BECOME THE RISER FOR THE FIRST STEP.

INTERSECT THIS VERTICAL WITH A LINE PROJECTING FROM THE VP AT THE HEIGHT OF THE FIRST RISER. THIS PROJECTING LINE WILL BECOME THE TREAD FOR THE FIRST STEP.

ERECT A VERTICAL FROM THE MARK OF THE SECOND TREAD. INTERSECT THIS VERTICAL WITH A LINE PROJECTING FROM THE MARK FOR THE SECOND RISER.

CONTINUE THIS PROCEDURE UNTIL ALL THE RISERS AND TREADS ALONG THE SIDE OF THE SET OF STAIRS ARE DRAWN.

SCALE: 3/8"=1'0"

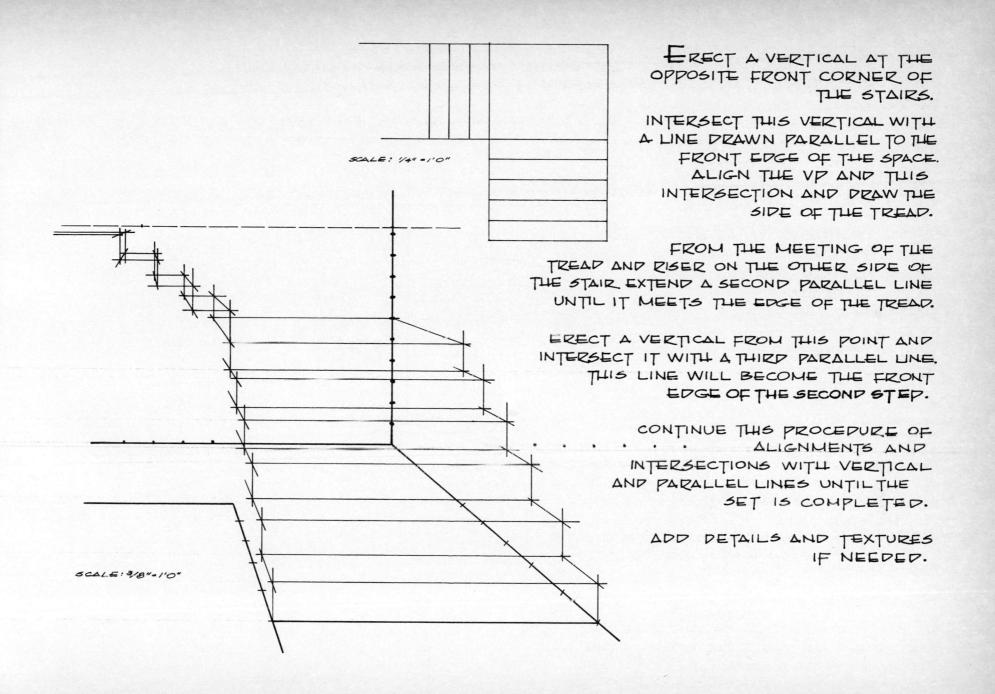

SCALE: 1/4" = 1'0"

SCALE: 3/8" = 1'0"

ERECT A VERTICAL AT THE OPPOSITE FRONT CORNER OF THE STAIRS.

INTERSECT THIS VERTICAL WITH A LINE DRAWN PARALLEL TO THE FRONT EDGE OF THE SPACE. ALIGN THE VP AND THIS INTERSECTION AND DRAW THE SIDE OF THE TREAD.

FROM THE MEETING OF THE TREAD AND RISER ON THE OTHER SIDE OF THE STAIR EXTEND A SECOND PARALLEL LINE UNTIL IT MEETS THE EDGE OF THE TREAD.

ERECT A VERTICAL FROM THIS POINT AND INTERSECT IT WITH A THIRD PARALLEL LINE. THIS LINE WILL BECOME THE FRONT EDGE OF THE SECOND STEP.

CONTINUE THIS PROCEDURE OF ALIGNMENTS AND INTERSECTIONS WITH VERTICAL AND PARALLEL LINES UNTIL THE SET IS COMPLETED.

ADD DETAILS AND TEXTURES IF NEEDED.

117

A SET OF STAIRS THAT IS NOT AGAINST A WALL IS NOT DIFFICULT TO ILLUSTRATE. THE FOLLOWING PROCEDURE IS PRESENTED IN TWO-POINT PERSPECTIVE. IT CAN ALSO BE ADAPTED FOR A ONE-POINT WITH MINOR CHANGES.

AGAIN, DETERMINE THE HEIGHT OF THE RISERS, THE DEPTH OF THE TREADS AND THE DIMENSIONS OF THE SPACE.

DRAW THE SPACE ON THE FLOOR IN THE ILLUSTRATION.

ALIGN THE MP AND THE DEPTH INCREMENTS AND TRANSPOSE THE MARKS TO THE FLOOR/WALL LINES AND TO BOTH SIDES OF THE SPACE ON THE FLOOR IN THE DRAWING.

DRAW A DIAGRAM OF THE PATTERN OF RISERS AND TREADS ON THE SIDE WALL OR WALLS.

ERECT SHORT VERTICALS AT BOTH CORNERS OF THE FRONT STEP.

ALIGN THE MEETING OF THE RISER AND TREAD OF THE FIRST STEP IN THE DIAGRAM WITH A PARALLEL OR VP AND TRANSPOSE THE INTERSECTION INTO THE DRAWING.

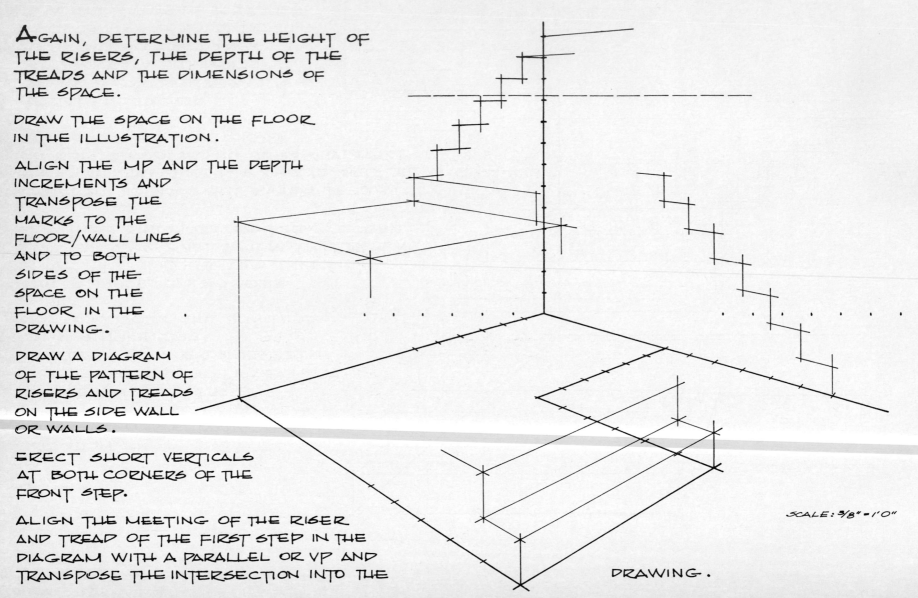

SCALE: 3/8" = 1'0"

CONTINUE THIS PROCEDURE OF ALIGNMENTS UNTIL
THE SET OF STAIRS IS COMPLETED.

ADD TEXTURES AND DETAILS IF NEEDED.

SCALE: 1/4" = 1'0"

SCALE: 3/8 = 1'0"

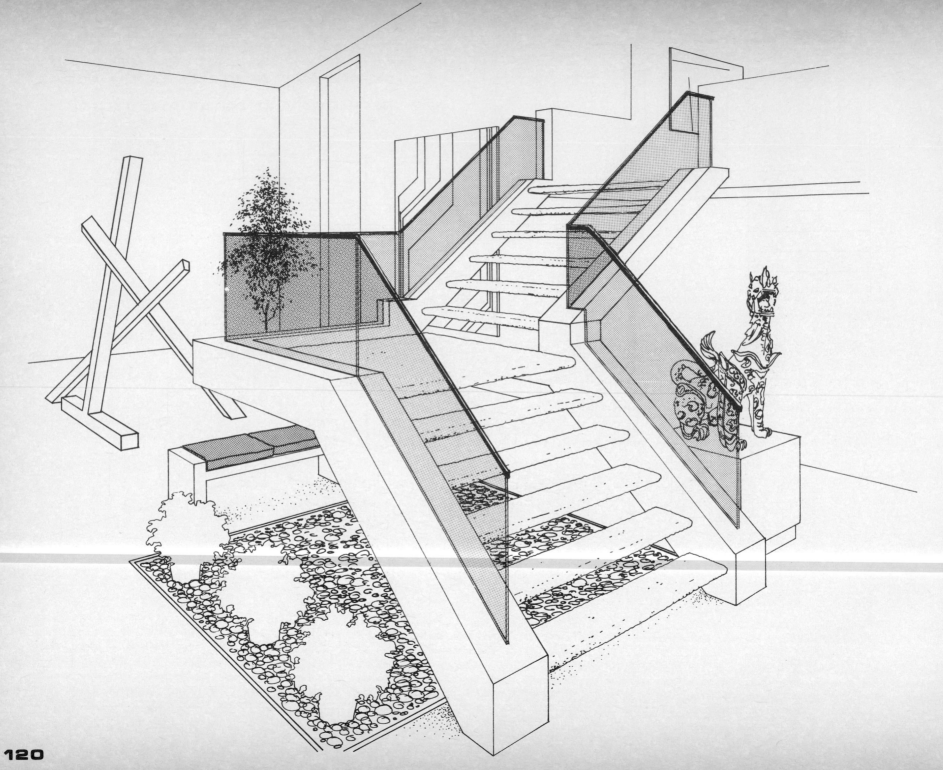

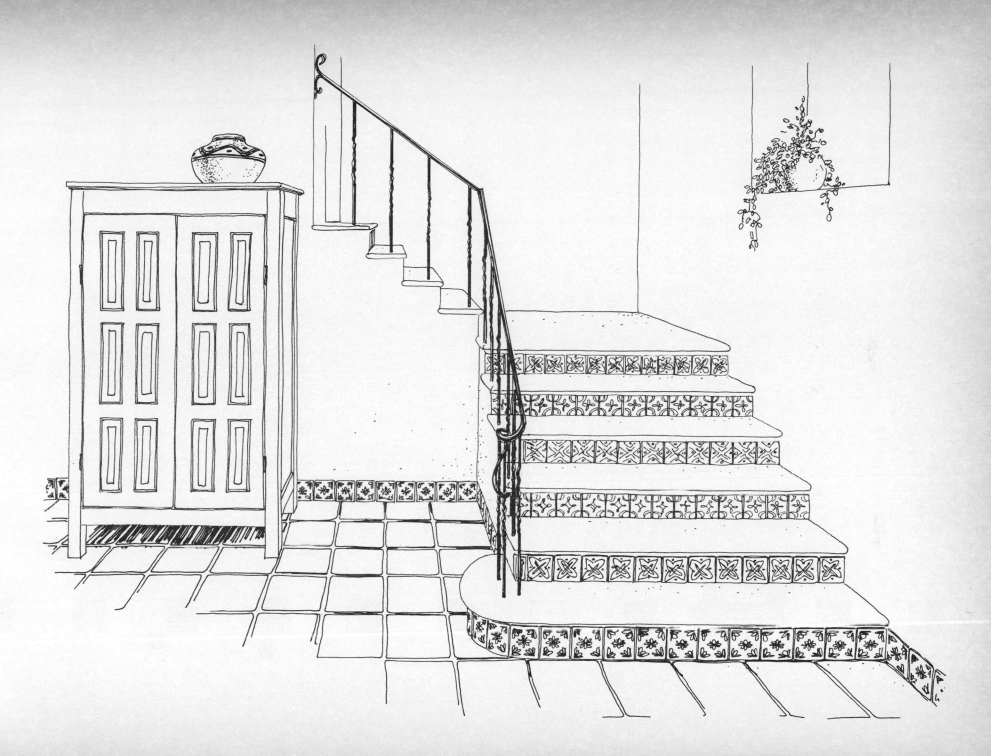

4

presentations

A SUCCESSFUL ILLUSTRATION OF AN INTERIOR USUALLY GOES BEYOND THE LINE DRAWING. LINES ARE INTEGRAL COMPONENTS OF A DRAWING. THEY ARE THE FUNDAMENTAL DELINEATORS OF THE FORMS, DETAILS AND TEXTURES, BUT UNLESS A VARIETY OF LINES IS USED BY THE ILLUSTRATOR, THE RESULTING DRAWING CAN BE DULL, STIFF AND UNREAL IN APPEARANCE.

ONCE THE DRAWING HAS BEEN CREATED, THE LINES CAN BE COMPLEMENTED OR POSSIBLY ELIMINATED THROUGH THE ADDITION OF VALUES IN LIGHT, SHADE AND SHADOW, RENDERED IN MONOCHROME OR FULL COLOR.

INTERIORS ARE BEST PRESENTED IN GRADED VALUES. BY CONTRASTING FLAT SURFACES WITH VALUES: LIGHT AGAINST DARK, DARK AGAINST LIGHT, GRADATIONS IN VALUES ON THE SAME OR ADJACENT SURFACES, THE FORMS IN THE PRESENTATION ARE GIVEN A MORE NATURALISTIC QUALITY.

INTERIORS RENDERED IN SIMPLE, FLAT VALUES HAVE SOME DIMENSIONAL QUALITIES, BUT WITHOUT ADDITIONAL GRADED VALUES, THEY LACK BELIEVABILITY.

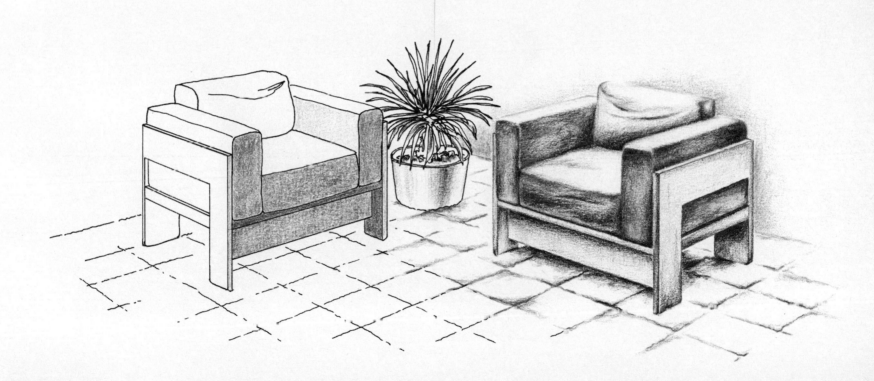

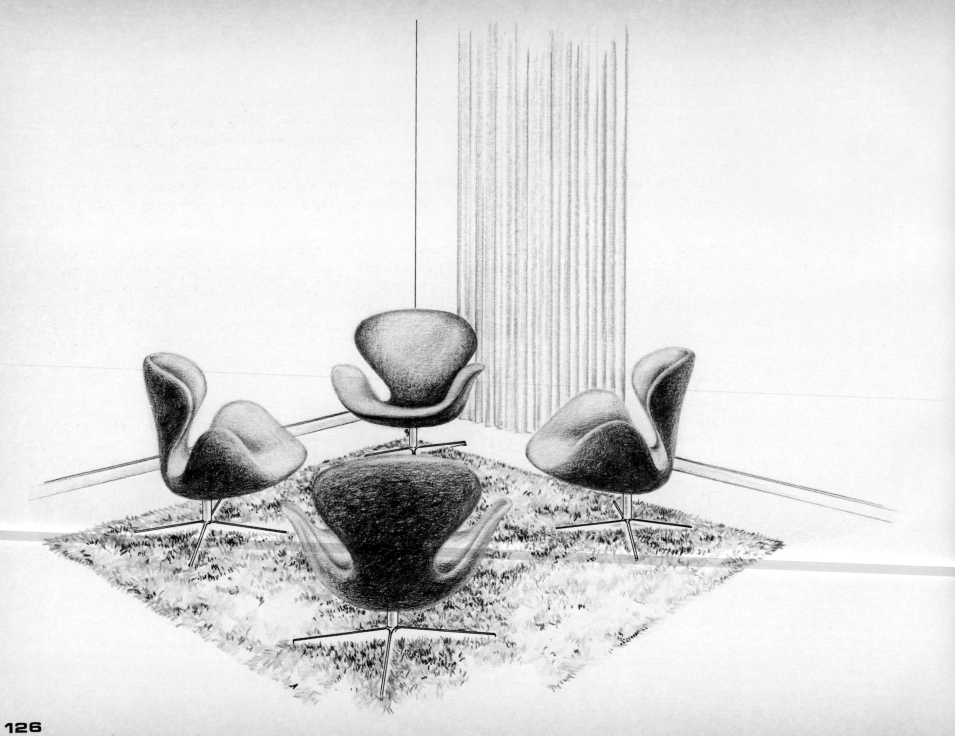

BEGIN TO CAREFULLY OBSERVE OBJECTS IN LIGHT. OFTEN THE TOP SURFACES WILL HAVE THE LIGHTEST VALUES; THE SIDES OF OBJECTS, THE FULL RANGE OF MIDDLE VALUES; AND THE AREAS UNDER OBJECTS OR CLOSE TO THE FLOOR, THE DARKEST VALUES.

VALUES ALSO HELP TO DESCRIBE TEXTURES. TEXTURES CAN BE FOUND ON EVERY SURFACE AND RANGE FROM VERY SMOOTH, EVEN TEXTURES TO VERY COARSE, SHAGGY ONES.

CAREFULLY OBSERVE TEXTURES. STUDY THEIR SURFACES IN LOW, MEDIUM OR HIGH LIGHT, IN DIRECT, RAKING OR REFLECTED LIGHT. TRY TO INTERPRET YOUR OBSERVATIONS IN LINE, AND MORE IMPORTANTLY, IN VALUES. IF THESE TEXTURES HAVE BEEN CORRECTLY INTERPRETED IN LINE OR IN VALUE, THE OBSERVER WILL RECEIVE THE DESIRED TACTILE SENSATIONS FROM THE ILLUSTRATION.

EXTENSIVE AND CONTINUED PRACTICE WILL BE BENEFICIAL.

THE AUTHORS OF MANY EXCELLENT, AVAILABLE TEXTS DISCUSS DRAWING TEXTURES AND VALUES IN EXTENSIVE DETAIL. I SUGGEST THAT THEY BE READ AND STUDIED, AND, IF POSSIBLE, ADDED TO YOUR PERSONAL LIBRARY.

COMPOSITIONAL PLANES / CENTER OF INTEREST

IN WELL-PLANNED RENDERINGS OF INTERIORS, THE ILLUSTRATOR ACKNOWLEDGES THE PRESENCE OF THREE PLANES WITHIN THE COMPOSITION : THE FOREGROUND, THE MIDDLE-GROUND AND THE BACKGROUND. EACH PLANE MUST HAVE SOME OPTICAL WEIGHT IN THE ILLUSTRATION. IF ANY OF THE PLANES ARE NEGLECTED OR OMITTED, THE COMPOSITION WILL BE UNBALANCED AND UNNATURAL TO THE VIEWER.

RENDERERS OFTEN TAKE LIBERTIES WITH THESE PLANES, BUT DO NOT IGNORE THEM.

THE ORGANIZATION OF THE COMPOSITION HAS FOCUSED THE VIEWER'S ATTENTION TO A PARTICULAR PORTION OF A ROOM. THE DOMINANT FEATURE OF THE COMPOSITION OR THE CENTER OF INTEREST, IS USUALLY PRESENTED THROUGH CONTRASTS IN COLOR AND/OR VALUE. THIS FOCAL POINT IS USUALLY PLACED IN THE MIDDLE-GROUND OR BACKGROUND.

IF THE CENTER OF INTEREST HAS BEEN RENDERED IN STRONG VALUES OR INTENSE COLORS, THE ATTENTION OF THE VIEWER WILL BE FOCUSED ON THIS PORTION OF THE COMPOSITION AND NOT ON THE COMPLETE ILLUSTRATION. A SUCCESSFUL ILLUSTRATION WILL HAVE ALL PARTS OF THE COMPOSITION CAREFULLY UNIFIED INTO A PLEASING WHOLE.

OCCASIONALLY OBJECTS CAN BE DRAWN IN OUTLINE OR SILHOUETTE WITH NO VISIBLE VALUES OR TEXTURES INDICATED ON ANY PLANE IN AN ILLUSTRATION. IF THE DETAILED RENDERING OF AN OBJECT ADDS CONFUSION TO A VERY TEXTURED PORTION OF THE DRAWING, A SILHOUETTE OF THAT OBJECT MAY BE A SOLUTION TO THE PROBLEM.

APPROPRIATE CONTRASTING OR RELATED COLORS AND VALUES CAN THEN BE USED TO COMPLETE THE RENDERING.

MEDIA

THE APPROPRIATE MEDIUM FOR A RENDERING IS THE DECISION OF THE ILLUSTRATOR. TRADITIONALLY, PEN AND INK, TRANSPARENT WATERCOLOR AND TEMPERA ARE THE MEDIA USED FOR ILLUSTRATIONS. A SINGLE MEDIUM MIGHT BE USED FOR A RENDERING, HOWEVER, MORE THAN ONE MEDIA CAN BE USED, EACH COMPLEMENTING THE OTHER.

RENDERING TAKES PRACTICE. WHEN LEARNING TO RENDER, STAY WITH ONE MEDIUM UNTIL SOME DEGREE OF PROFICIENCY WITH THAT MATERIAL HAS BEEN ACHIEVED. THEN TRY A SECOND, A THIRD. AFTER LEARNING HOW TO HANDLE SEVERAL MEDIA INDIVIDUALLY, TRY COMBINATIONS.

ONLY PRACTICE, AND MORE PRACTICE WILL PRODUCE PROFICIENCY.

ON THE FOLLOWING PAGES THE SAME ILLUSTRATION HAS BEEN RENDERED IN THE MEDIUM UNDER DISCUSSION. THE FIVE ILLUSTRATIONS SHOULD PROVIDE SIMPLE COMPARATIVE REFERENCES.

CONSULT THE BIBLIOGRAPHY FOR A SELECTED LIST OF TEXTS ON PAINTING OR DRAWING IN A VARIETY OF MEDIA.

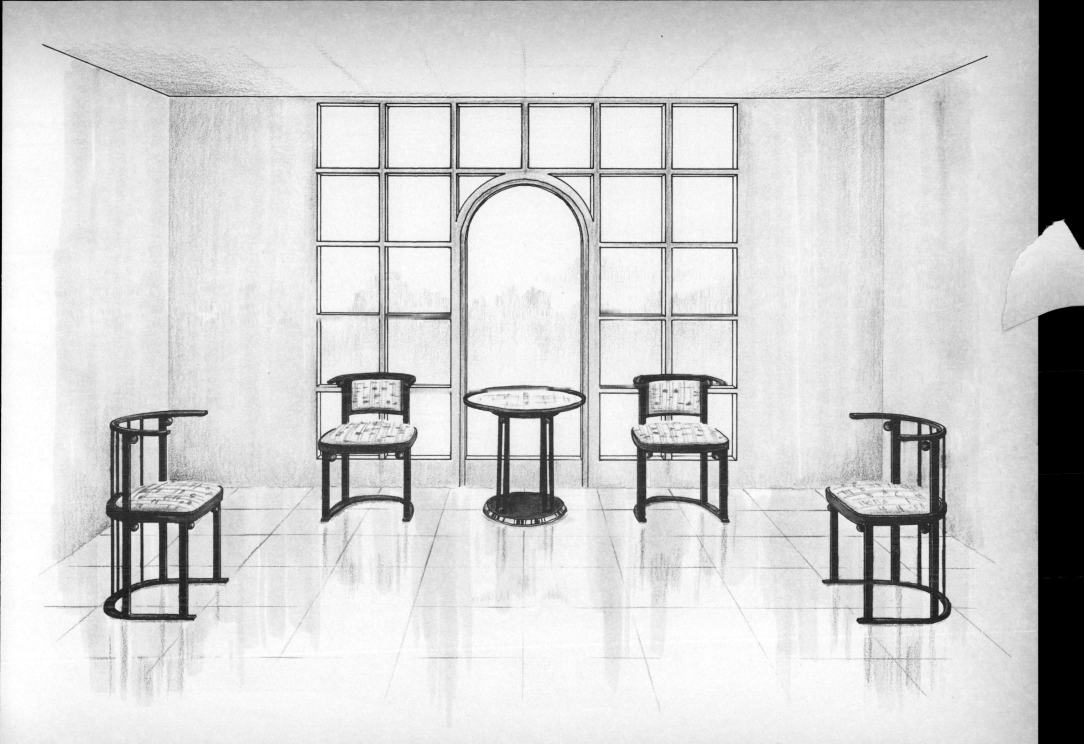

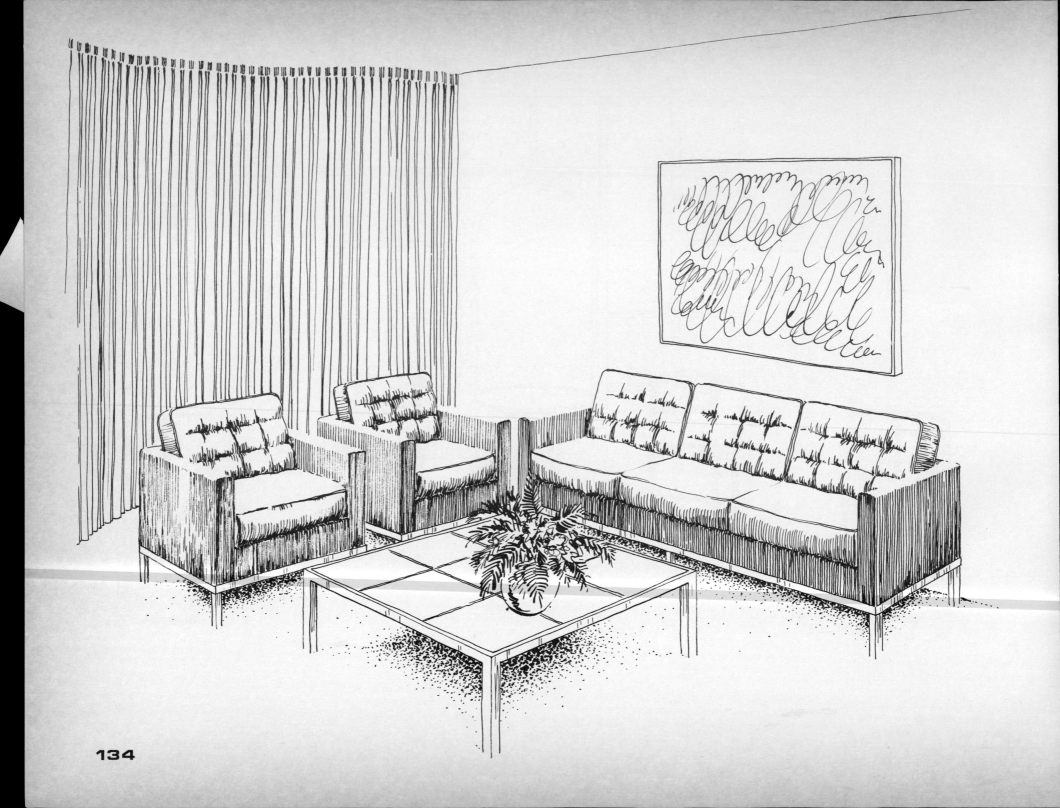

134

ALTHOUGH MOST OF THE ILLUSTRATIONS IN THIS TEXT WERE CREATED WITH TECHNICAL PENS, A VERY GOOD, INEXPENSIVE PEN FOR THE NOVICE OR THE PROFESSIONAL IS THE CROW QUILL. THE POINT RESPONDS INSTANTLY TO PRESSURES OF THE HAND, THE RESULTING LINES CAN RANGE FROM VERY DELICATE TO VERY BOLD IN THE SAME STROKE.

PRACTICE DRAWING WITH THE PEN. CREATE A VARIETY OF FORMS, TEXTURES AND TONES WITH AN ABUNDANCE OR MINIMUM OF LINES, WITH ACCENTED LINES, CROSSHATCHING, ETC. KNOW HOW THE PEN RESPONDS TO YOUR DEMANDS.

THE BEST SURFACES FOR PEN AND INK RENDERINGS ARE WHITE, HOT PRESS ILLUSTRATION BOARD OR TWO-PLY SMOOTH SURFACE BRISTOL BOARD.

INK WASH

INK WASH IS NOT A CONVENTIONAL MEDIUM FOR RENDERING, BUT IT IS A VERSATILE ONE. AS A LEARNING TOOL, INK WASH CAN HELP THE STUDENT COMPREHEND THE CONCEPTS OF DEVELOPING OBJECTS IN BLACK, WHITE AND VALUES OF GRAY. AS A FINISHED MEDIUM, A RENDERED INK WASH CAN BE A BASE FOR THE ADDITION OF COLOR FROM PERMANENT MARKERS.

INK WASH CAN BE APPLIED TO EITHER A WET OR DRY SURFACE.

COMPLEMENTARY DETAIL AND/OR TEXTURAL LINES CAN BE ADDED TO THE INK WASH WITH EITHER A TECHNICAL OR CROW QUILL PEN WHEN ALL WASHES ARE DRY.

VALUES IN INK WASH BEGIN WITH A SMALL AMOUNT OF WATER COVERING THE BOTTOM OF A PLASTIC CONTAINER. ADD ONE OR TWO SMALL DROPS OF BLACK DRAWING INK TO THE WATER. THIS WILL BE THE LIGHTEST GRAY VALUE. TECHNICAL PEN INK SHOULD NOT BE USED FOR INK WASHES, BECAUSE IT WILL PRODUCE A GRAINY RESIDUE IN THE DARKER VALUES WHEN THE WASH DRIES. CONTINUE TO ADD DROPS OF INK TO THE MIXTURE. EACH SUCCEEDING ADDITION OF INK WILL SUPPLY THE DARKER VALUES OF WASH AS NEEDED TO DEVELOP THE LIGHTS AND SHADOWS IN THE RENDERING.

THE BEST SURFACES FOR INK WASH ARE WHITE, COLD PRESS ILLUSTRATION BOARD OR COLORED MATT BOARD.

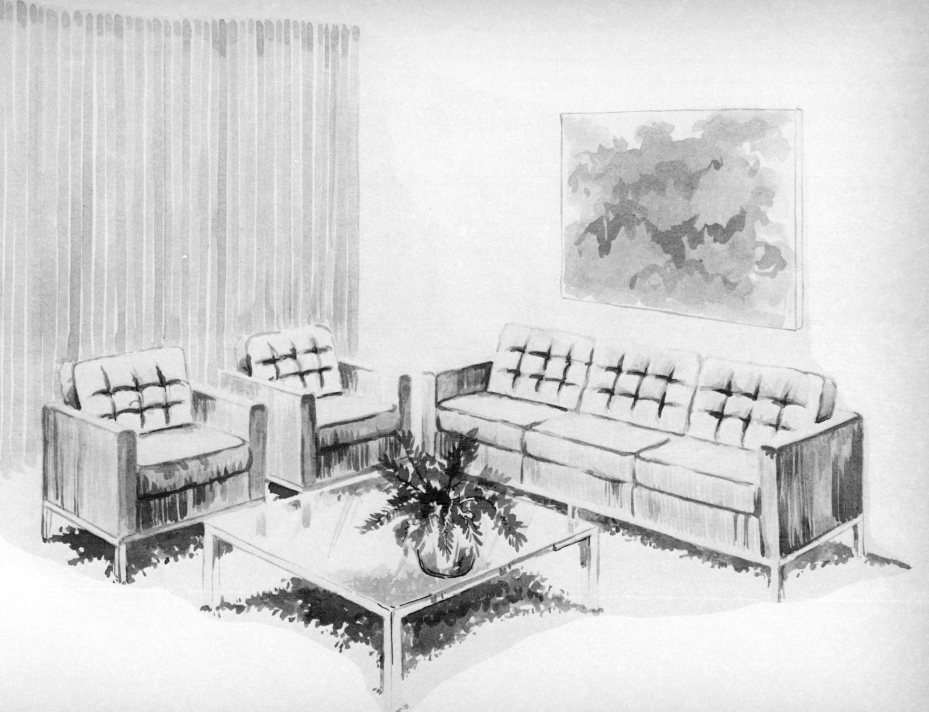

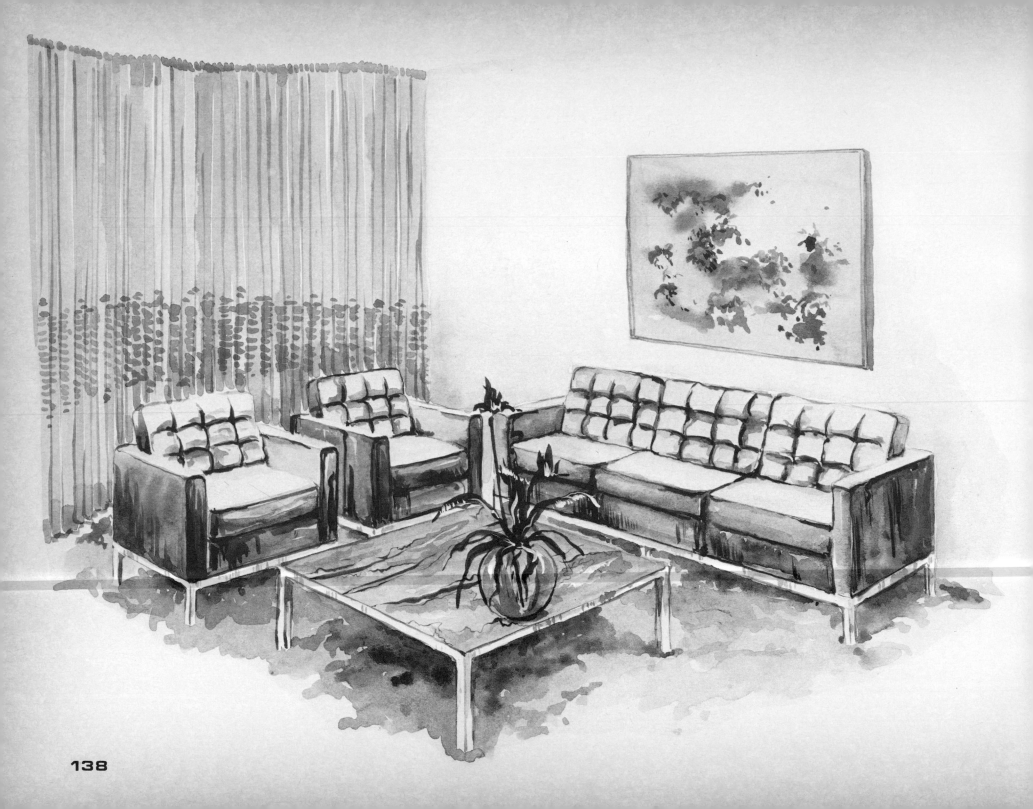

TRANSPARENT WATERCOLOR REQUIRES MORE TECHNICAL SKILLS AND PRACTICE THAN MOST OF THE OTHER MEDIA AND CAN BE A VERY FRIGHTENING MEDIUM FOR THE BEGINNING ILLUSTRATOR. MOST WATERCOLORS ARE CREATED THROUGH THE APPLICATION OF FLAT OR GRADED WASHES, ONE ON TOP OF THE OTHER, ON EITHER A WET OR DRY SURFACE.

PAINT THE LIGHTEST VALUES FIRST. DARKER COLORS CAN BE PAINTED OVER LIGHT VALUES, THE REVERSE IS INEFFECTIVE. MIX ENOUGH OF EACH COLOR, THEN MIX A BIT MORE. TEST THE COLOR BEFORE USING. TRANSPARENT WATERCOLORS WILL LIGHTEN IN VALUE AS THEY DRY.

TRANSPARENT WATERCOLORS SHOULD NOT BE USED OPAQUELY. LIGHTEN WATERCOLORS WITH WATER, NOT WHITE PIGMENT. THE ADDITION OF WHITE PIGMENT WILL CLOUD THE COLOR MIXTURES. OPAQUE WATERCOLORS, SUCH AS TEMPERA OR GOUACHE, MAY BE USED AS SEPERATE MEDIA FOR RENDERINGS, OR IN COMBINATION WITH TRANSPARENT WATERCOLOR.

USE AN APPROPRIATE BRUSH FOR THE AREA BEING PAINTED. PAINT LARGE AREAS WITH A LARGE BRUSH, DETAILS WITH A SMALL.

THE BEST SURFACES FOR WATERCOLORS ARE WHITE, COLD PRESS ILLUSTRATION BOARDS, COLORED MATT BOARDS, OR WATERCOLOR PAPERS AVAILABLE IN A VARIETY OF WEIGHTS AND TEXTURED SURFACES.

PERMANENT MARKER / COLORED PENCIL

A CONTEMPORARY MEDIUM FOR RENDERING IS PERMANENT MARKER. THESE FELT TIPPED PENS WITH FAST-DRYING INKS PROVIDE INSTANT COLOR TO DRAWINGS. MARKERS ARE PRODUCED IN AN EXTENSIVE RANGE OF COLORS. BEGIN THE COLLECTION OF LIGHT AND MIDDLE VALUES OF COLORS WITH SELECTIONS TAKEN FROM THE PRODUCT LINES AVAILABLE. A TEST OF THE COLORS ON SAMPLES OF BOARD OR PAPER BEFORE PURCHASING COULD PREVENT DUPLICATIONS. DON'T OVERLOOK THE GRAYS.

CONSIDER THE PURCHASE OF BLACK, MEDIUM-DARK WARM GRAY AND BROWN ULTRA-FINE TIPPED PENS. THEY ARE IDEALLY SUITED FOR DETAILING.

PERMANENT MARKERS CAN ADD RICH COLOR AND TONAL ACCENTS TO PEN AND INK DRAWINGS ON ILLUSTRATION OR MATT BOARDS AND ARE PERFECTLY DESIGNED FOR COLORING BLUEPRINTED DRAWINGS AND FLOOR PLANS. MARKERS DO NOT BLEED EXCESSIVELY ON BLUEPRINTS, BUT WILL BLEED, HOWEVER, BEYOND THE LIMITS OF THE LINES OF A DRAWING ON BOARDS.

COLORED PENCILS, PARTICULARLY THOSE WITH WAXY LEADS, ARE VERY COMPATIBLE WITH MARKERS. THEIR COLORS ADD INFINITE TONES AND SHADINGS THROUGH THE OVERLAY OF COMPLEMENTARY COLORS OR CONTRASTING VALUES.

REMEMBER THE COLOR WHEEL: TRY LIGHT VALUES OF PURPLE ON YELLOWS, VALUES OF RED ON GREENS, BLUES ON BROWNS. TRY THE REVERSE. SHADOWS DO NOT HAVE TO BE DULL AREAS. TRY COMBINATIONS OF COLORS TO BRING LIFE TO THESE SPACES.

DON'T OVERWORK THE APPLICATION OF COLORED PENCIL. DEVELOP A LIGHT TO MEDIUM TOUCH. RENDERINGS MADE WITH ONLY COLORED PENCILS ARE TIME-CONSUMING TO COLOR, AND LACK A SPONTANEOUS, FRESH APPEARANCE.

THE BEST SURFACES FOR MARKER AND COLORED PENCIL ARE ILLUSTRATION BOARDS, COLORED MATT BOARDS AND BLUEPRINTS.

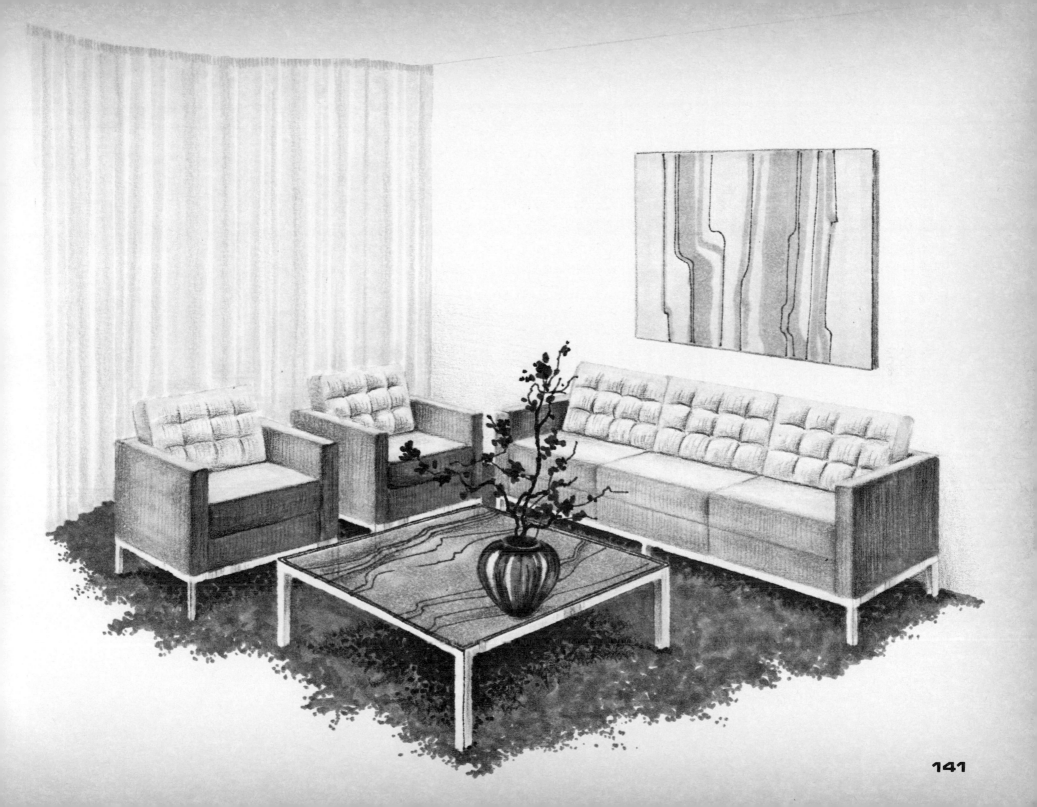

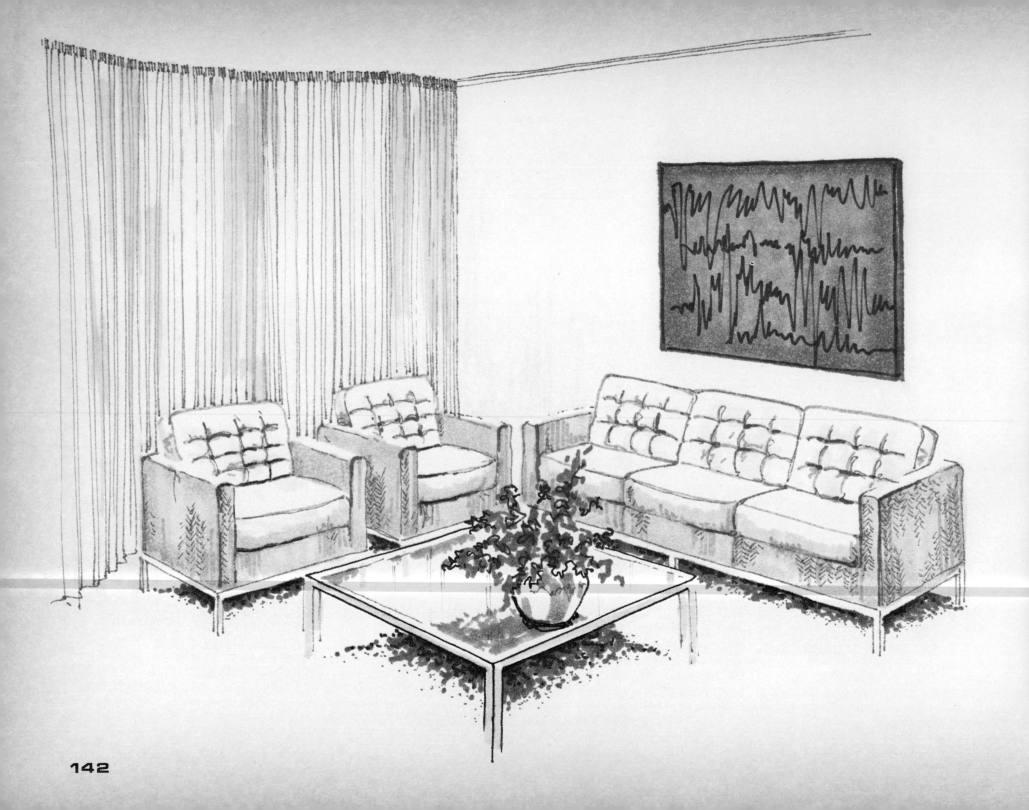

RAPID COLOR RENDERINGS ARE TIMED VARIATIONS ON THE TECHNIQUES REQUIRED TO COMPLETE A FINISHED ILLUSTRATION WITH MARKERS. BECAUSE THESE RENDERINGS ARE PRODUCED QUICKLY, A SECOND OR POSSIBLY A THIRD TIMED OVERLAY BASED ON A SECOND- OR THIRD-CHOICE COLLECTION OF SAMPLES CAN BE MADE.

COMPLETE A LINE DRAWING OF THE INTERIOR.

ASSEMBLE A COLLECTION OF SAMPLES : THE FLOORCOVERING, WALL TREATMENT, UPHOLSTERY AND OTHER MATERIALS CHOSEN FOR THE INTERIOR.

SELECT AN ASSORTMENT OF PERMANENT MARKERS THAT APPROXIMATES THE COLORS AND VALUES IN THE SAMPLES.

PLACE A PIECE OF WHITE, TRANSLUCENT MARKER PAPER OVER THE LINE DRAWING. RAPIDLY COLOR THE DRAWING WITH THE MARKERS. DO NOT TRACE THE DRAWING. INCLUDE SOME VALUES SO THAT THE FORMS ARE MODELLED IN LIGHT.

THE COLORS OF THE MARKERS WILL NOT BE AS INTENSE ON THE MARKER PAPER AS THEY ARE ON BLUEPRINTS OR BOARDS.

LIMIT YOUR WORKING TIME TO 45-60 MINUTES.

A FEW LINES MADE WITH THE WARM GRAY OR BLACK FINE-LINE MARKER MAY BE ADDED FOR ACCENTS AND/OR DETAILING NEAR THE END OF THE TIME LIMIT.

RENDER THE SECOND VERSION, IF DESIRED OR NEEDED.

COLORED BLUEPRINTS

Occasionally a solution may require an elaborately detailed blueprinted floor or room plan, one with the symbols of all furniture pieces and major accessories drawn in scale. These blueprinted plans may be colored with permanent markers and pencil. The coloring does not have to be extensive, i.e., from wall to wall with no uncolored areas visible. The coloring should <u>suggest</u> the values or tones of the carpeting, the woods, the upholstery fabrics, the plastic laminates, etc.

The addition of a 'shadow line' drawn with a broad gray marker on the <u>same two sides</u> of each piece of furniture where possible, and opposite the primary source of light, can suggest a dimensional quality to the furniture on the plan.

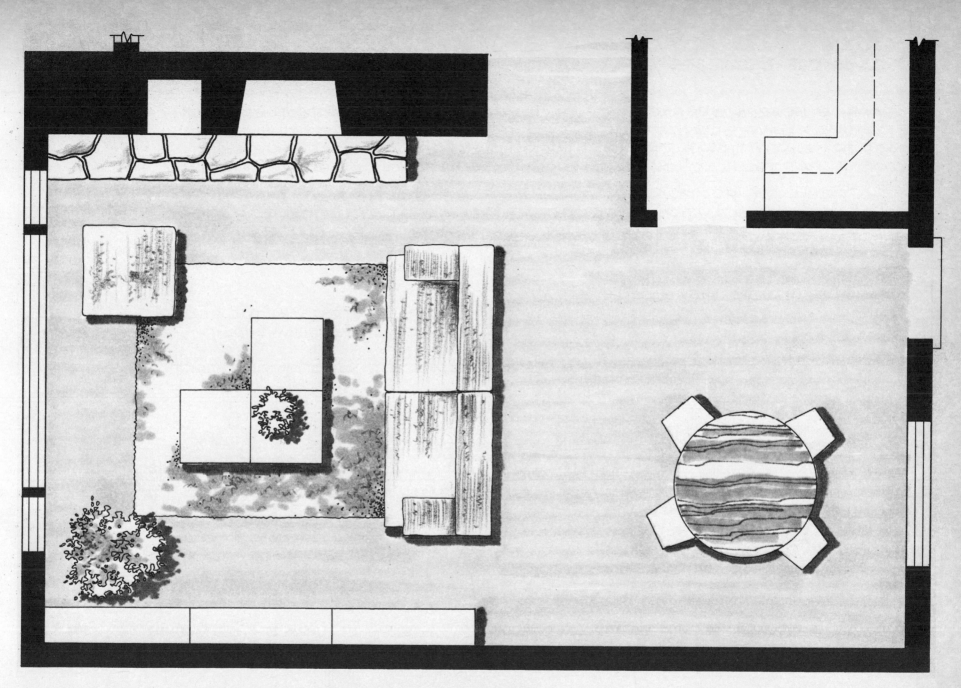

SCALE: 3/8" = 1'0"

SAMPLE BOARDS / PRESENTATION BOARDS

SAMPLE BOARDS, SURFACES TO WHICH ARRANGEMENTS OF PICTURES AND TEXTURES HAVE BEEN ATTACHED, REPRESENT A DESIGNER'S CHOICE OF APPROPRIATE ITEMS OF FURNITURE, FABRICS AND ACCESSORIES FOR A PARTICULAR RESIDENTIAL OR CONTRACT INTERIOR PROBLEM.

THE PRIMARY PURPOSE OF THESE BOARDS IS TO ASSIST IN THE SALE OF THE SOLUTION THROUGH A LOGICAL, AESTHETICALLY PLEASING ARRANGEMENT OF SAMPLES THAT COMPLEMENTS THE FLOOR PLAN AND LIGHTING SOLUTION.

SAMPLE BOARDS MAY ALSO DISPLAY:
 A KEY, RELATING THE SAMPLES TO INDIVIDUAL ITEMS IN THE PLAN;
 A RENDERED LINEAR PERSPECTIVE OR ISOMETRIC DRAWING IF
 NEEDED FOR CLARITY;
 A TITLE BLOCK WHICH USUALLY CONTAINS THE NAME OF THE CLIENT,
 AN IDENTIFICATION OF THE
 SPACE OR SAMPLES
 SHOWN AND THE INITIALS
 OR LOGO OF THE COMPANY
 OR DESIGNER.

 ALL LETTERING IS MADE
 WITH DRY TRANSFER
 LETTERS.

 THE CLIENT'S NAME
 SHOULD BE THE MOST
 PROMINENT.

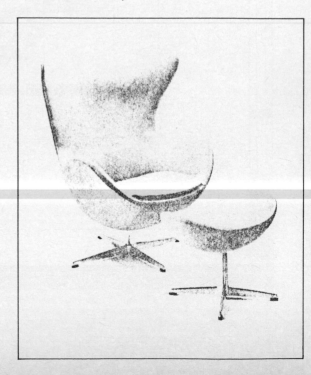

SAMPLE BOARDS ARE USUALLY MADE FROM WHITE, LIGHT COLORED OR NEUTRAL GRAY STOCK. THE COLORS OF THE BOARDS SHOULD CONTRAST IN VALUE AND SHOULD COMPLEMENT THE SAMPLES.

PHOTOGRAPHS SHOWN ON PRESENTATION/SAMPLE BOARDS SHOULD EITHER BE BLACK AND WHITE OR PHOTOCOPIES OF COLORED ORIGINALS TO AVOID MISCONCEPTIONS BY THE CLIENT. COLORED PHOTOGRAPHS OFTEN MISLEAD THE CLIENT INTO BELIEVING THAT THE COLOR OF THE ARTICLE SHOWN IN THE PHOTOGRAPH <u>IS</u> THE COLOR OF THE ARTICLE BEING RECOMMENDED. COLOR SHOULD BE RESERVED FOR PHOTOGRAPHS OF SELECTED ACCESSORIES OR SAMPLE MATERIALS.

CATALOG DRAWINGS, DIAGRAMS OR PHOTOGRAPHS MAY BE ENLARGED INTO PHOTOCOPIED ILLUSTRATIONS AND PRINTED ON WHITE OR TINTED STOCK.

SAMPLE BOARDS SHOULD HAVE A BORDER ON ALL SIDES. THIS BORDER CAN BE AN AN IMPLIED BORDER, AN EVEN AREA OF UNOCCUPIED SPACE, OR ONE MADE FROM CONTRASTING OR ACCENT COLORED MATT BOARD.

ALL BOARDS FOR A PRESENTATION SHOULD BE UNIFORM IN SIZE BECAUSE UNEVEN SIZES OF BOARDS DETRACT FROM THE TOTAL EFFECT OF THE PRESENTATION.

Before being adhered to the presentation boards, all fabric samples and/or photographs should be trimmed to final size and the edges of the fabrics treated with an anti-fray liquid or similar substance.

Photographs should be secured with rubber cement; textile samples with white glue or double-faced tape.

Most samples may be secured to pieces of matt board or foam core for additional strength and depth on the boards. Carpeting may or may not be glued to an accent board; rarely is carpeting backed with a piece of foam core.

Some related samples may be grouped together as a unit on an accent board if desired. Samples should be presented in the proportions used in the solution. For added interest selected samples may be double-mounted on two pieces of matt board, but this procedure involves additional time and effort.

THE FINAL UNIFIED ARRANGEMENT OF THE SAMPLES, PHOTOGRAPHS, DRAWINGS AND TITLE BLOCK ON THE PRESENTATION BOARDS IS THE RESULT OF CAREFUL PLANNING.

IMAGINARY LINES EXTEND FROM ALL CORNERS OF THE SAMPLES AND CAN PROVIDE AN ORGANIZATIONAL FRAMEWORK THROUGHOUT THE SET OF BOARDS.

PLAN ONE ARRANGEMENT. RECORD THE COMPOSITION IN A SIMPLE DIAGRAM. THEN PLAN A SECOND OR POSSIBLY A THIRD.

CHOOSE THE BEST ARRANGEMENT.

FOLLOW ITS DIAGRAM AND LAY OUT THE BOARDS FOR FINAL GLUING.

AN ARRANGEMENT THAT CONTAINS ONLY THE MAJOR ARTICLES AND A FEW SELECTED ACCESSORIES IS OFTEN BETTER THAN A MULTI-LAYERED BOARD CLUTTERED WITH EXCESSIVE SAMPLES.

THE FINAL ORGANIZATION OF THE BOARDS REFLECTS THE DESIGNER'S ABILITY TO DESIGN.

5

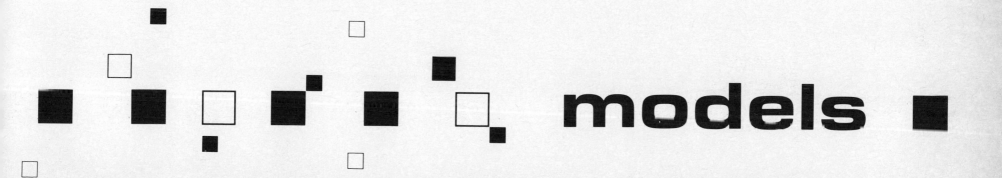

models

A SCALED, THREE-DIMENSIONAL MODEL IS OCCASIONALLY THE MOST EFFECTIVE VISUALIZATION TECHNIQUE FOR THE PRESENTATION OF THE SOLUTION TO A DESIGN PROBLEM. A MODEL OF AN INTERIOR CAN PROVIDE A READILY UNDERSTOOD REPRESENTATION BECAUSE IT CAN BE VIEWED FROM ALL SIDES AS WELL AS FROM ABOVE AND CAN CLEARLY PRESENT ALL PHYSICAL ASPECTS OF THE SPACE TO THE CLIENT.

THE FINISHED MODEL, CONSTRUCTED IN SCALE, MAY REPRESENT A SINGLE OR SEVERAL CONNECTING ROOMS, A COMPLETE FLOOR OR SEVERAL FLOORS OF A PRIVATE RESIDENCE OR COMMERCIAL BUILDING.

MODELS CAN VARY GREATLY IN DETAIL AND APPEARANCE. THEY MAY BE SIMPLE CARDBOARD FORMS WITH ONLY A SUGGESTION OF ARCHITECTURAL DETAILS NOTED AND FOLDED PAPER RECTANGULAR SOLIDS TO REPRESENT THE FURNITURE, OR THEY MAY BE COMPLEX AND DETAILED STRUCTURES CONSTRUCTED FROM AN EXTENSIVE VARIETY OF APPROPRIATE MATERIALS. RARELY DO THESE MODELS INCLUDE EXTERIOR DETAILS FROM THE SURROUNDING AREA UNLESS SUCH DETAILS ARE RELATIVE TO THE SOLUTION BEING PRESENTED.

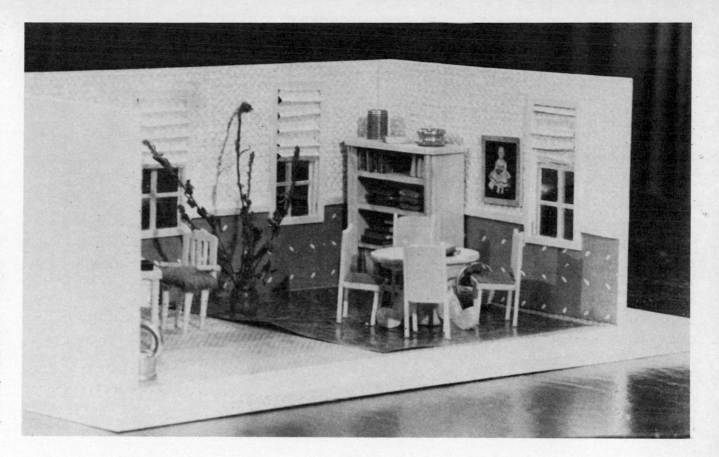

STUDENT MODEL BY HELEN W. BAUSS

ASSORTED MATERIALS MODEL

FURNITURE: CARVED BALSA WOOD
WALL COVERINGS: TEXTURED AND PRINTED WALLPAPER
FLOORING: WALLPAPER; PICTURE OF ORIENTAL RUG FROM MAGAZINE
CHAIR RAIL AND WINDOW TRIM: BALSA WOOD STRIPS
WINDOW TREATMENT: FOLDED PAPER
CHAIR CUSHIONS: STUFFED FABRICS
ACCESSORIES: BRASS FINDINGS; PICTURES FROM MAGAZINES
PLANT HOLDER: WOODEN BEAD

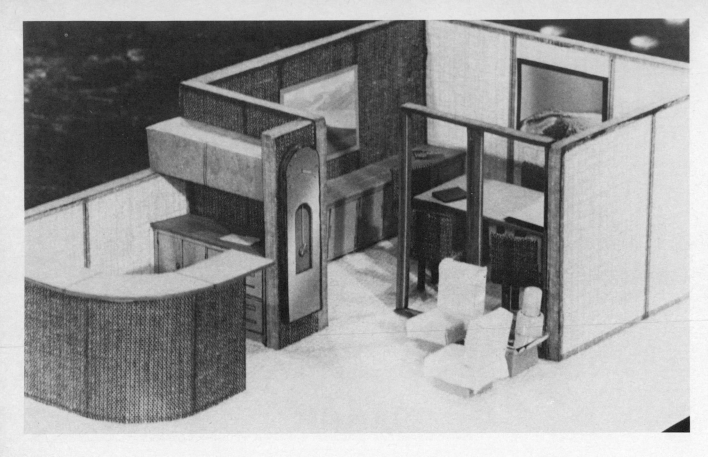

ASSORTED MATERIALS MODEL

FURNITURE: CHAIRS, FABRIC COVERED FOAM CORE AND CARDBOARD;
CABINETS AND TABLES, WRAPPING PAPER OVER MATT BOARD
COUNTER: BASE, FABRIC OVER SCORED CARDBOARD; TOP, MATT BOARD
 COLORED WITH PERMANENT MARKER
FLOORING: WALLPAPER
WALL COVERINGS: FABRIC AND WALLPAPER
CLOCK: PICTURE FROM MAGAZINE, ADHERED TO LAYERED CARDBOARD
PAINTING: PICTURE FROM MAGAZINE

STUDENT MODEL BY AMY L. LEINBACH

ALL-PAPER MODEL

UPHOLSTERED FURNITURE: SCORED AND FOLDED WALLPAPER;
TABLES: SCORED AND FOLDED CONSTRUCTION PAPER
FLOORING: WIDE-TIP PERMANENT MARKER
AREA RUG: CONSTRUCTION PAPER, TEXTURED WITH KNIFE
WALL COVERING: TRACING TISSUE
PAINTING: PICTURE FROM MAGAZINE
PLANTS: COLORED AREAS FROM MAGAZINE
VASES: ROLLS OF PAPER

INGENUITY, IMAGINATION AND INVENTIVENESS ARE ESSENTIAL IN
THE SELECTION OF APPROPRIATE MATERIALS FOR THE MODEL.
ARCHITECTURAL MODELS HAVE TRADITIONALLY BEEN CONSTRUCTED
FROM CARDBOARDS AND/OR SOFT WOODS, WITH LAMINATED
EXTERIOR DETAILS AND THEN DISPLAYED ON A TOPOGRAPHICALLY
CONTOURED BASE WITH DRIED WEED TREES.

VERY SUCCESSFUL MODELS OF INTERIORS CAN ALSO BE
CONSTRUCTED FROM CARDBOARDS AN OTHER PAPERS OR FROM
A VARIETY OF MATERIALS. PAPER IN THIS CONTEXT CAN INCLUDE
WALLPAPERS, CONSTRUCTION PAPERS, MAGAZINE PAGES, TISSUE,
WRAPPING AND DECORATIVE PAPERS, BRISTOL BOARD AND TAG
BOARD, PAPER-BACKED FOILS, ETC. AN ASSORTMENT OF
MATERIALS CAN INCLUDE BALSA WOOD, SOLDER, BEADS, TACKS
AND PINS, WIRE, FABRICS, ACETATES AND OTHER PLASTICS, AS
WELL AS 'FOUND' ITEMS.

ALMOST ANY MATERIAL MAY BE USED IN THE CONSTRUCTION OF
A MODEL IF IT IS APPROPRIATE FOR THE SCALE OF THE MODEL.
ALL MODELS ILLUSTRATED IN THIS CHAPTER WERE CREATED IN
THE SCALE 1/2" = 1'0".

WALLS AND BASES FOR MODELS OF INTERIORS CAN BE MADE FROM COLORED MATT BOARD, FOAM CORE BOARD OR OTHER CARDBOARDS. TO OBTAIN THE CORRECT WALL THICKNESS IN CARDBOARD, STRIPS MUST BE CUT THE THICKNESS OF THE WALL, MINUS THE THICKNESS OF THE SURFACE MATERIAL AND ATTACHED BETWEEN THE WALL SURFACES. REINFORCING THE WALLS WITH ADDITIONAL STRIPS OF CARDBOARD BEFORE CLOSING WILL PREVENT WARPING.

FOAM CORE, NOW MANUFACTURED IN SEVERAL THICKNESSES, WILL PRODUCE A STRONG BASE AND SATISFACTORY WALL SIZES FOR INTERIOR MODELS WITHOUT REINFORCEMENTS. FOAM CORE MAY EASILY BE CUT WITH A SHARP UTILITY KNIFE. HOWEVER, WHEN THE BLADE DULLS, THE FOAM WILL 'DRAG' AS IT IS BEING CUT AND A ROUGH INTERIOR EDGE WILL RESULT.

MOST PAPERS MAY BE ADHERED TO CARDBOARDS OR FOAM CORE WITH RUBBER CEMENT. WHITE GLUE SHOULD BE USED FOR MORE PERMANENT BONDING. GLUE THE WALL COVERING TO THE WALL SURFACE MATERIAL FIRST, THEN TRIM THE WALL TO THE CORRECT SIZE. TEMPERA OR OTHER WATER-SOLUBLE PAINTS WILL WARP CARDBOARDS OR FOAM CORE AS THEY DRY.

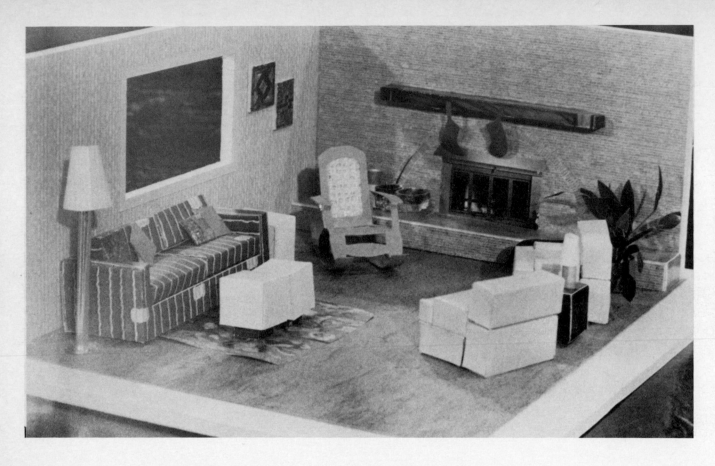

ALL-PAPER MODEL

WALL COVERINGS : WALLPAPER AND PICTURE FROM MAGAZINE
UPHOLSTERED FURNITURE : SCORED AND FOLDED WALLPAPER
ROCKING CHAIR : WALLPAPER
TABLES : BRISTOL BOARD
AREA RUG , PLANT , FIREPLACE WALL DETAILS : PICTURES FROM MAGAZINES
FLOORING : WALLPAPER
THROW PILLOWS AND PAINTINGS : PICTURES FROM MAGAZINES

ALL-PAPER MODEL

WALLS AND BED SPREAD: FOLDED WALLPAPER
WARDROBE: FOLDED AND LAYERED CONSTRUCTION PAPER
HEADBOARD AND ROCKING CHAIR: FOLDED CONSTRUCTION PAPER
PILLOW: STUFFED PICTURE FROM MAGAZINE
WALL HANGING, PAINTING AND PLANT: MAGAZINE CUTOUTS
FLOOR COVERING: WALLPAPER

ATTRACTIVE PIECES OF FURNITURE, CONSTRUCTED IN SCALE FROM A VARIETY OF MATERIALS, ARE ESSENTIAL DETAILS FOR THE MODEL. CARDBOARD FORMS, PADDED WITH COTTON OR FIBERFILL AND COVERED WITH FABRIC WILL RESEMBLE PIECES OF UPHOLSTERED FURNITURE. SO WILL ONE PIECE OF FOLDED AND SCORED WALLPAPER. A SCORED SURFACE IS ONE THAT HAS BEEN CUT PART WAY THROUGH WITH A KNIFE, AND FOLDED AWAY FROM THE CUT.

MENTALLY VISUALIZE THE SHAPE OF THE PIECE OF UPHOLSTERED FURNITURE TO BE CONSTRUCTED. REMEMBER ALL OF THE PLANES OR SURFACES. ROUGHLY SKETCH THE SURFACES ON A SCRAP PIECE OF PAPER. CUT OUT THE DIAGRAM. SCORE AND FOLD INTO THE DESIRED OBJECT. CORRECT ERRORS AND CONSTRUCT THE FINAL PIECE.

ALWAYS REMEMBER TO CHECK THE SCALE OF THE WEAVE OR TEXTURE OF THE FABRIC, THE SCALE OF THE PRINT OR TEXTURE OF THE WALLPAPER BEFORE USING.

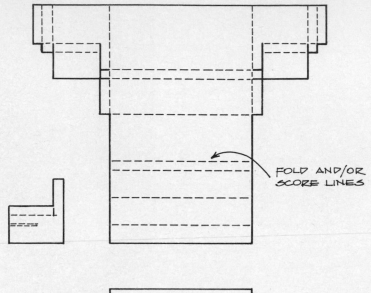

FOLD AND/OR SCORE LINES

NOT DRAWN IN SCALE

STRIPS OF SCORED AND FOLDED CARDBOARD OR PAPER CAN BE USED TO SUGGEST SIDE AND CANTILEVERED CHAIRS. BY PIERCING AND/OR SHAPING THE BACK OF THE CHAIR AND CUTTING LEGS IN THE STRIP MORE NATURALISTIC CHAIR FORMS, BOTH TRADITIONAL OR CONTEMPORARY, MAY BE SUGGESTED.

SCORED AND FOLDED BRISTOL BOARD OR CONSTRUCTION PAPER ARE VERY SATISFACTORY MATERIALS FOR THE CREATION OF TABLES, CABINETS OR SIMILAR CASE GOODS. LINES DRAWN ON THE SURFACES OF THE MATERIALS WITH A TECHNICAL PEN, COLORED PENCIL OR FINE-LINE MARKER WILL SUGGEST DOORS AND DRAWERS. A MORE DIMENSIONAL APPEARANCE OF DOORS OR DRAWER FRONTS CAN BE ACHIEVED BY APPLIQUÉING ANOTHER LAYER OF PAPER OR BOARD TO THE BASE SURFACE.

IF COLORING OR TONING THE CARDBOARD, BALSA WOOD OR PAPER, REMEMBER TO ALSO COLOR THE EDGES AND ALL SURFACES BEFORE GLUING.

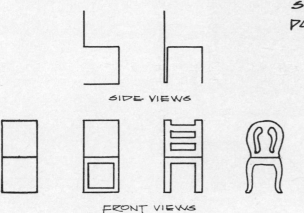

SIDE VIEWS

FRONT VIEWS

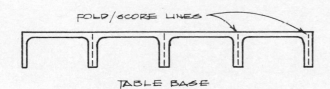

FOLD/SCORE LINES

TABLE BASE

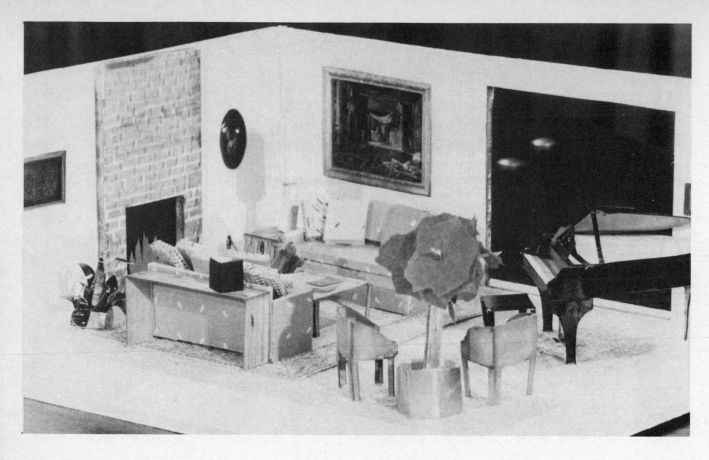

ALL-PAPER MODEL

UPHOLSTERED FURNITURE : WALLPAPER OVER CARDBOARD
TABLES AND ARMCHAIRS : BRISTOL BOARD COLORED WITH MARKER
FLOORING : TEXTURED WALLPAPER
AREA RUG AND LOOSE PILLOWS : WALLPAPER
PIANO AND STOOL : COLORED BRISTOL BOARD
FIREPLACE : MARKER AND CONSTRUCTION PAPER
PLANTS : CONSTRUCTION PAPER AND PAPER-BACKED FOIL
PAINTINGS : PICTURES FROM MAGAZINES
LAMP : ROLLED AND FOLDED PAPER

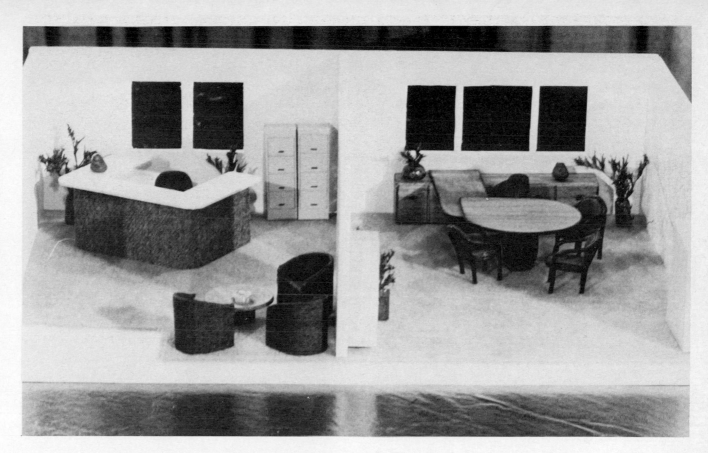

ASSORTED MATERIALS MODEL

WALL COVERING : WALLPAPERS
FLOORING : FABRIC
RECEPTIONIST'S STATION : FABRIC OVER SHAPED CARDBOARD,
TOP : ILLUSTRATION BOARD
TABLE AND DESK : STAINED BALSA WOOD
UPHOLSTERED CHAIRS : FABRIC OVER SHAPED CARDBOARD
OPEN ARM CHAIRS : BENT COVERED WIRE, FABRIC CUSHIONS
FILE CABINETS : FOLDED CONSTRUCTION PAPER
PLANTS : COLORED WEEDS
CERAMIC ACCESSORIES

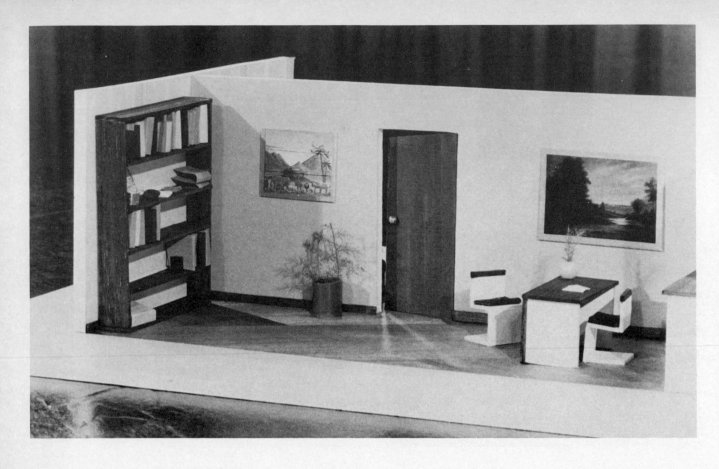

ASSORTED MATERIALS MODEL

FLOORING : WOOD VENEER WALL COVERING
WALL COVERING : WALLPAPER
DESK, CHAIRS AND STORAGE UNIT : SCORED ILLUSTRATION BOARD;
 TOPS AND TRIM, COLORED BALSA WOOD
BOOKS : FOLDED CONSTRUCTION PAPER
PAINTINGS : PICTURES FROM MAGAZINES

Accessorize the model with scaled details:

A piece of coating fabric or felt will occasionally be in the correct scale for a floor covering.

Consider using pin heads, small staples or beads for drawer or door pulls.

Slightly overlapped lines drawn on foam core with a wide-tipped permanent marker will suggest hardwood flooring.

Parts of drawings or photographs cut from magazines can be used as wall enrichments.

Interesting plant forms may be constructed from green areas found in magazine advertisements. Glue two areas together with rubber cement. Cut the leaf shapes. Curve with a pencil. Insert a piece of wrapped florist wire and secure into a base.

Pictures of oriental rugs carefully cut from a magazine and adhered to the hardwood floor will produce the desired effect.

Loose pillows can be easily constructed from scraps of tissue, wallpaper, wrapping or other decorative papers.

Creativity and imagination with colors, textures and materials, plus a quantity of time and patience will bring uniqueness to a successful model.

NEATNESS, CREATIVITY AND PATIENCE ARE ESSENTIAL FOR THE CONSTRUCTION OF A MODEL; SLOPPINESS OR CARELESSNESS IN THE CUTTING OR GLUING OF THE PARTS WILL RUIN THE APPEARANCE OF A MODEL. MODELS REQUIRE MANY HOURS TO CREATE; THEY DO NOT APPEAR 'FULL-BLOWN' OVERNIGHT. BUT WHETHER THE MODEL IS A TEMPORARY 'WORKING' MODEL MADE FROM VERY LIGHT WEIGHT PAPERS OR A VERY METICUOUSLY CONSTRUCTED STRUCTURE, THE PURPOSE OF THE MODEL IS THE SAME: A THREE-DIMENSIONAL VISUAL PRESENTATION OF A DESIGNED SOLUTION.

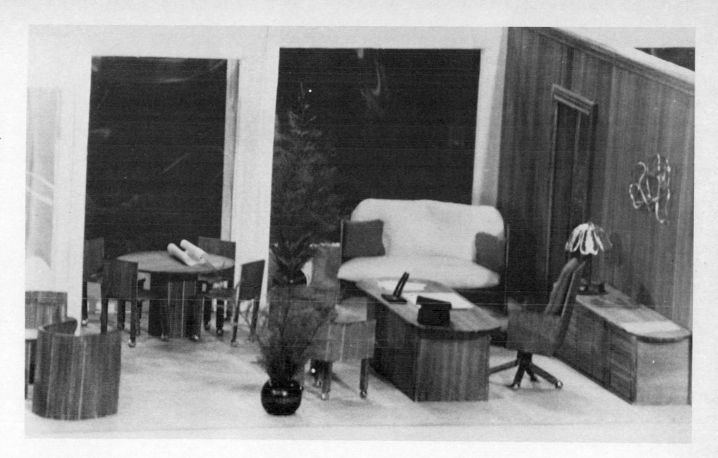

ASSORTED MATERIALS MODEL

WALL PANELLING : STAINED BALSA WOOD
FLOOR COVERING : FABRIC
FURNITURE : SCORED AND STAINED BALSA WOOD
UPHOLSTERY : STUFFED FABRIC
CHAIR CASTERS : BEADS
WALL SCULPTURE : BRASS WIRE

6

axonometrics

AXONOMETRIC OR PARALINE DRAWING IS A SATISFACTORY ALTERNATIVE TECHNIQUE TO A PERSPECTIVE ILLUSTRATION OF AN INTERIOR.

IN A PARALINE DRAWING ALL PARALLEL LINES REMAIN PARALLEL; LINES IN A PERSPECTIVE DRAWING CONVERGE AT THE VANISHING POINTS. AXONOMETRIC DRAWINGS ARE EASY TO CONSTRUCT BECAUSE ALL MEASUREMENTS ARE DRAWN IN A SCALE ON ALL THE AXIS LINES AND ON ALL LINES PARALLEL TO THEM.

THE AXIS LINES DEFINE THE PLANES OF THE COMPOSITION, EACH OF WHICH IS PERPENDICULAR TO THE OTHER ALTHOUGH THE ANGLES FORMED AT THE INTERSECTIONS MAY BE OBTUSE OR ACUTE.

AXONOMETRIC DRAWINGS ARE EFFECTIVE PICTORIAL REPRESENTATIONS. BECAUSE THEY ARE ALWAYS AERIAL VIEWS, THEY CAN ILLUSTRATE HEIGHT, WIDTH AND DEPTH SIMULTANEOUSLY AND CAN COMPLEMENT A SET OF WORKING DRAWINGS.

AXIS LINES

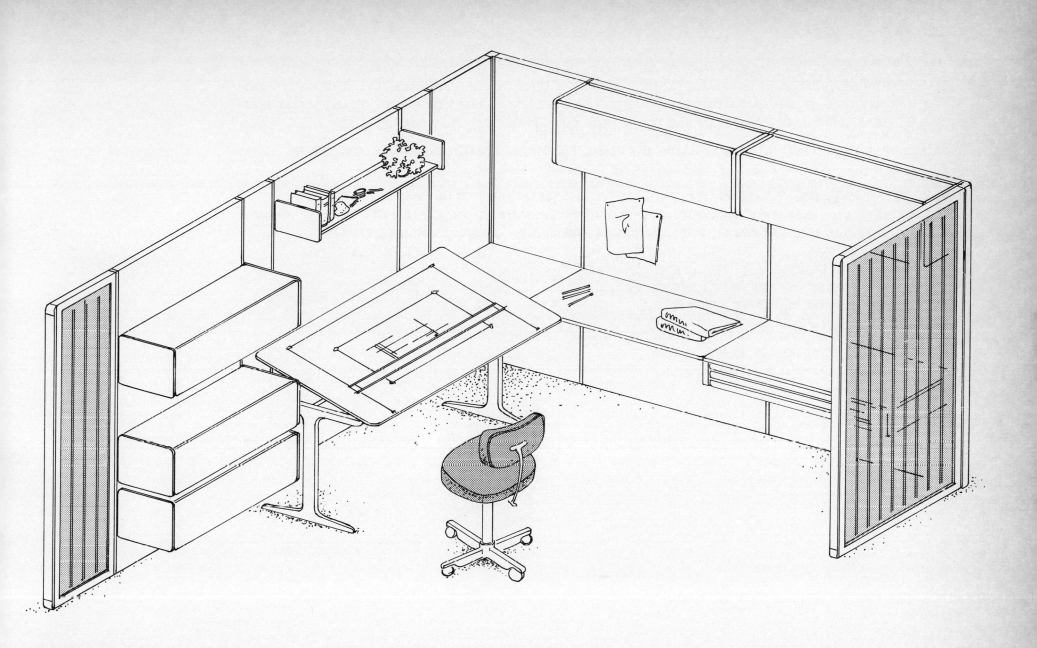

ISOMETRIC

Axonometric drawings are often divided into three general classifications: isometric, dimetric and oblique. Drawings of interiors in isometric are usually turned so that there is a 30° angle on either side of the front corner.

All dimensions are constructed in the scale of the drawing and are foreshortened equally.

Care must be taken in the selection of the walls to be featured. An isometric drawing will present only one view. If important or unique areas are located on opposite walls in the interior, only one area can be shown in detail. There is no opportunity to include both areas, as in a one-point perspective.

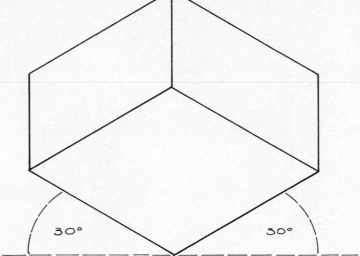

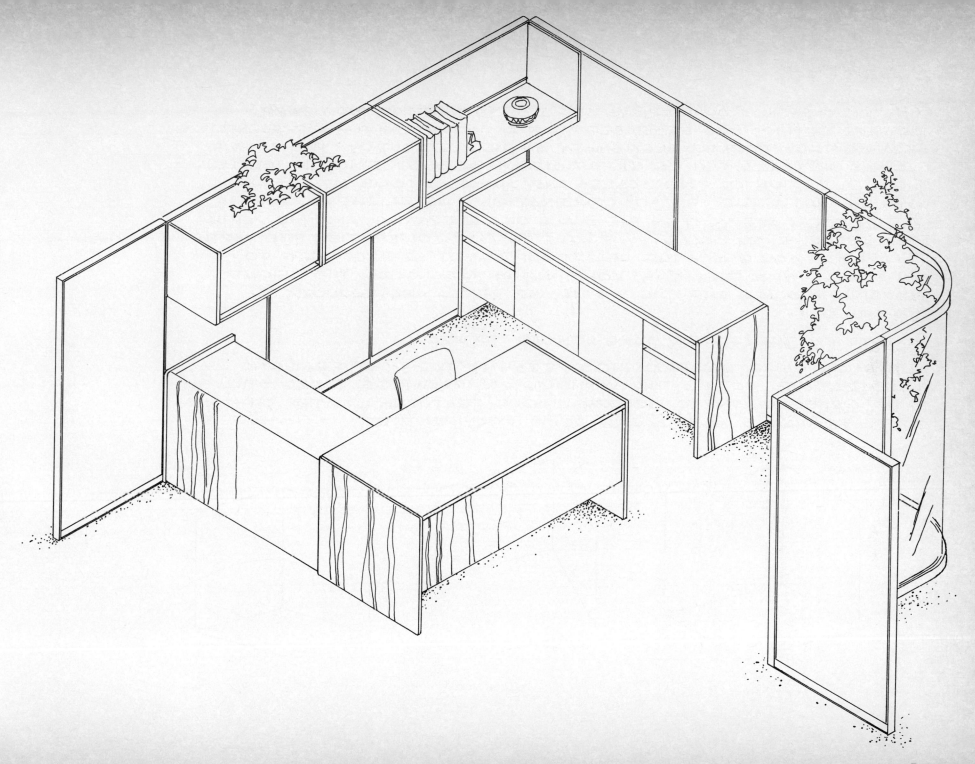

DIMETRIC

Dimetric drawings of interiors are also turned for the viewer. They are often more desirable than an isometric for a presentation because they permit flexibility in their execution. Two of the planes or walls can be emphasized or subordinated through the utilization of two scales and several combinations of angles. With the 15°/30° combination, the height and width of the room are kept in the scale of the drawing, and the depth is reduced to 3/4 scale. With the 15°/60° combination, the width remains in scale and the height and depth are reduced to 3/4 scale. With the 15°/15° combination of angles, the height remains in scale and the width and depth are reduced to 3/4 scale.

Dimetrics, therefore, take longer to draw.

Although dimetric drawings present the most realistic illustrations of all the axonometric drawings, there still is no opportunity to include unique features located on opposite walls as in a one-point perspective.

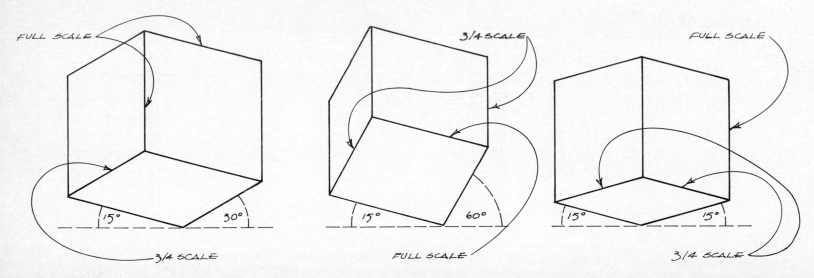

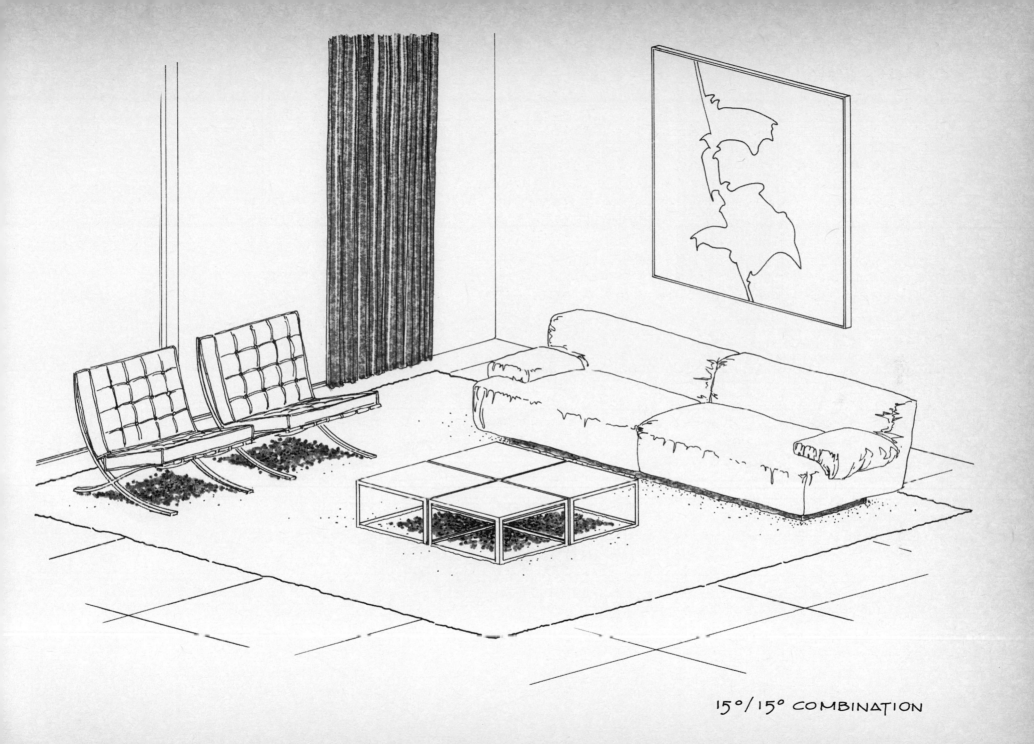

15°/15° COMBINATION

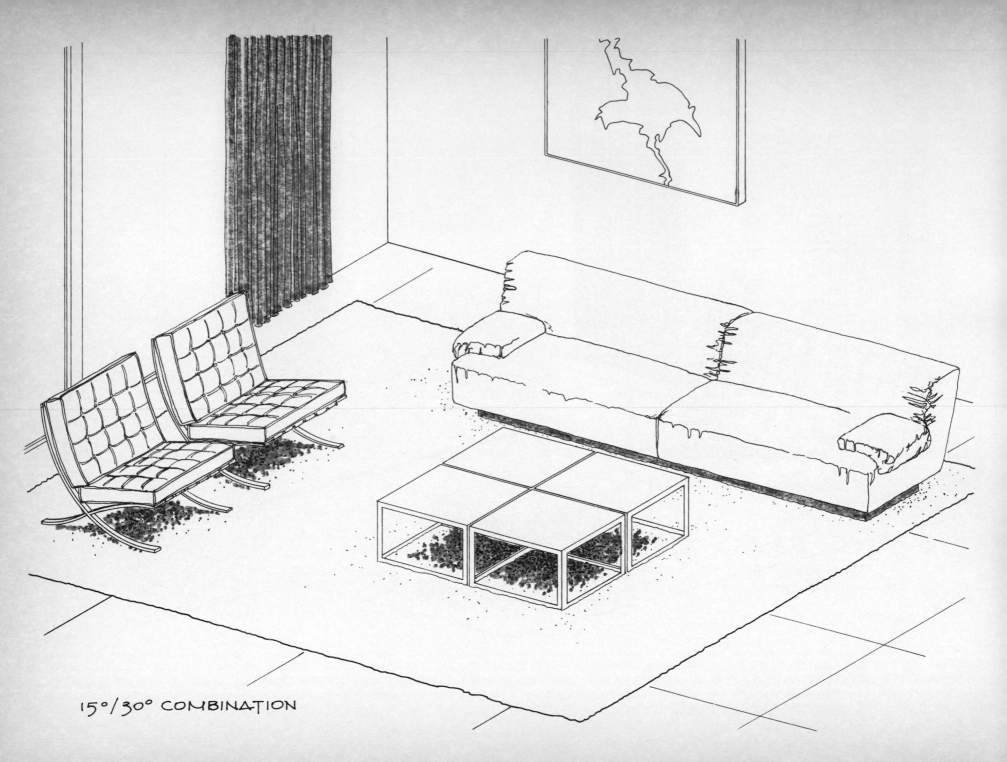

15°/30° COMBINATION

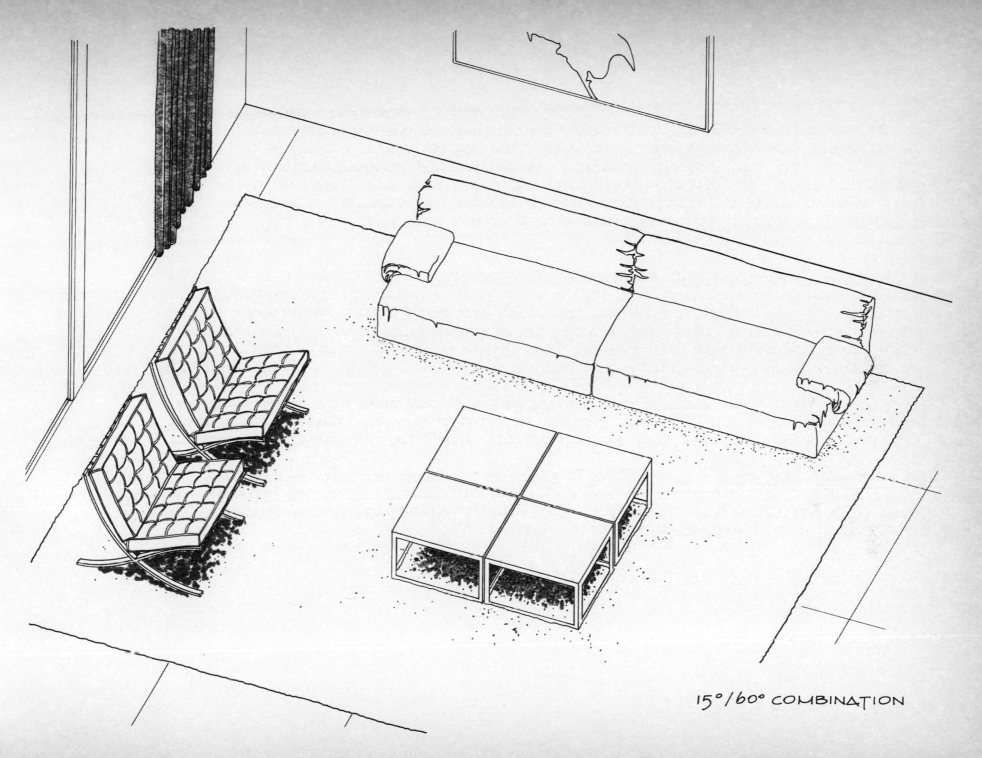

15°/60° COMBINATION

OBLIQUE

IN AN OBLIQUE DRAWING OF AN INTERIOR, THE FRONT PLANE OF THE ROOM
BECOMES A HORIZONTAL SURFACE, PARALLEL TO THE VIEWER, THE
SIDE WALL AND EDGE RECEDE AND THE REAR WALL BECOMES
PARALLEL TO THE FRONT PLANE. THE PLANES PARALLEL TO THE
FRONT PLANE, I.E. THE WIDTH AND HEIGHT, ARE ALL DRAWN IN
THE SAME SCALE. THE RECEDING PLANES, HOWEVER, CAN BE
DRAWN IN A VARIETY OF SCALES DEPENDING ON THE TYPE OF
OBLIQUE DRAWING DESIRED.

IN A CAVALIER OBLIQUE DRAWING THE FRONT, REAR, HEIGHT AND
RECEDING PLANES ARE ALL DRAWN IN THE SCALE OF THE DRAWING.
A CAVALIER OBLIQUE DRAWING IS MOST APPROPRIATE WHEN ANY
DISTORTION OF THE OBJECTS IS NOT OBJECTIONABLE. DISTORTION IS
MOST OBVIOUS IN THE DEPTHS IN THE ILLUSTRATION, THEY APPEAR
TOO LONG, NOT IN CORRECT PROPORTION.

BY ADJUSTING THE SCALE OF THE RECEDING PLANES IN A CAVALIER
OBLIQUE TO 3/4 OR 2/3 THE SCALE OF THE DRAWING, THE PROPORTIONS
OF THE ILLUSTRATION CAN BE IMPROVED AND THE DRAWING BELIEVABLE.

A CABINET OBLIQUE DRAWING IS DRAWN BY CHANGING THE SCALE OF
THE RECEDING LINES TO 1/2 SCALE. NOW, HOWEVER, THE DEPTHS IN
THE ILLUSTRATION MAY APPEAR TOO SHORT AND THE SPACE TOO
SHALLOW, NOT IN CORRECT PROPORTION.

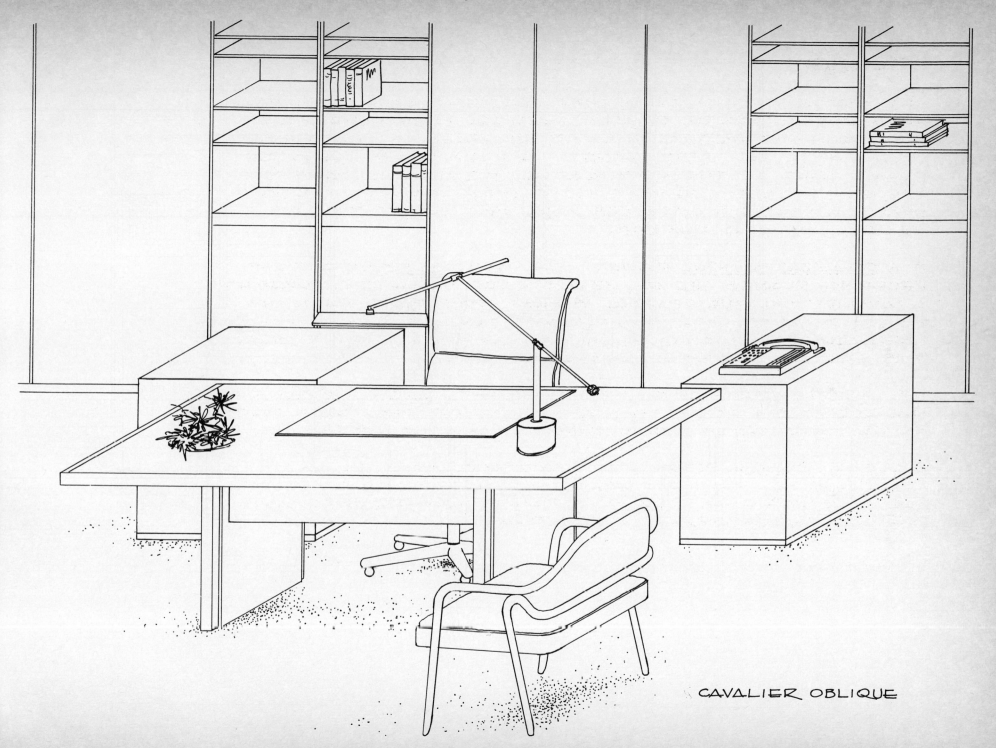

CAVALIER OBLIQUE

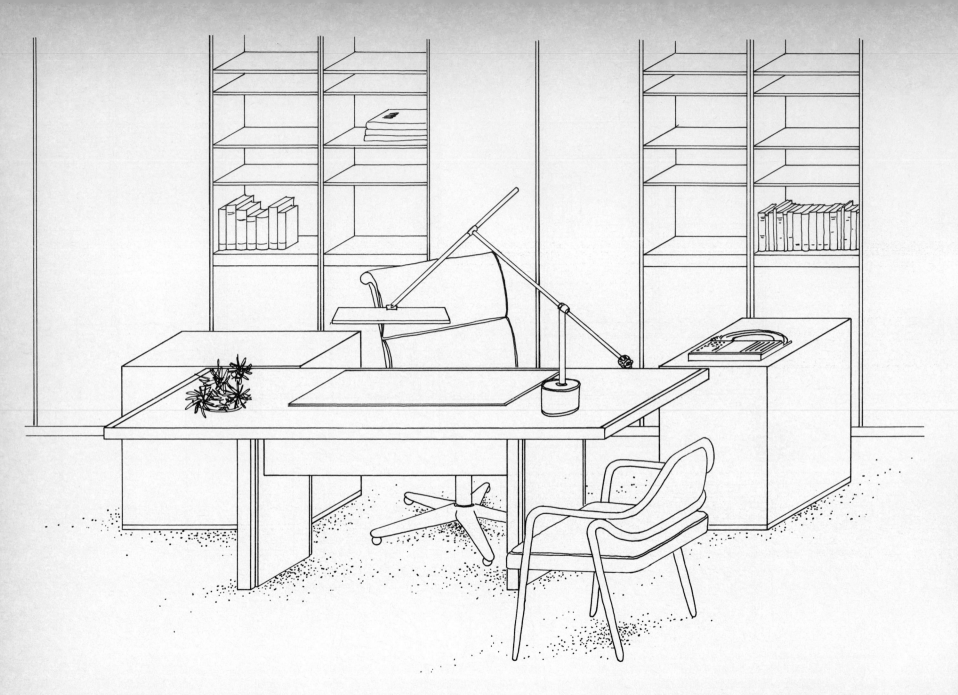

ADJUSTED OBLIQUE

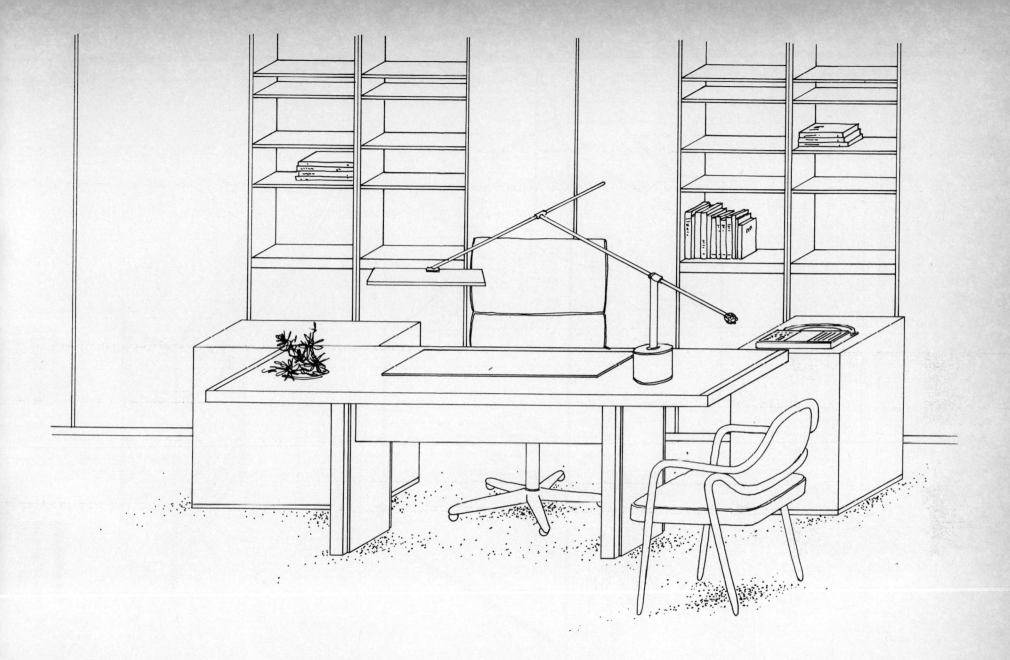

CABINET OBLIQUE

181

A PLAN OBLIQUE DRAWING CAN BE READILY MADE WHEN THE PLAN OF THE INTERIOR TO BE ILLUSTRATED IS AVAILABLE. DRAW THE PLAN IN AN APPROPRIATE SCALE. TURN THE PLAN SO THAT THE ANGLES ON EITHER SIDE OF THE CLOSEST CORNER ARE 45°. BOTH WALL PLANES WILL BE PRESENTED EQUALLY. IF ONE WALL IS TO BE EMPHASIZED AND THE OTHER SUBORDINATED, THE ANGLES SHOULD BE 30°/60°.

THE ILLUSION OF DEPTH IS ACHIEVED BY ADDING VERTICAL LINES IN 3/4 SCALE OF THE DRAWING FROM THE CORNERS OF ALL PIECES OF FURNITURE AND ARCHITECTURAL FEATURES ON THE PLAN.

ADD TEXTURES AND DETAILS AND COMPLETE THE DRAWING.

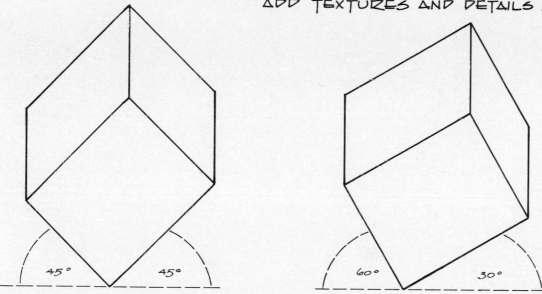

AXONOMETRIC DRAWINGS ARE USED TO BEST ADVANTAGE WHEN THE LARGEST DIMENSION OF THE INTERIOR OR THE MOST COMPLEX SET OF PLANES ON ONE WALL ARE DRAWN IN FULL SCALE. THIS TECHNIQUE SHOULD LESSEN THE EFFECTS OF DISTORTION COMMON TO ALL AXONOMETRIC DRAWINGS.

resources

IDEA NOTEBOOK or FILE

DESIGNERS RELY ON RESOURCES: FURNITURE CATALOGS, FABRIC COLLECTIONS, INDIVIDUALS OR COMPANIES WHO CAN PERFORM A VARIETY OF SERVICES, ETC.

AN ADDITIONAL RESOURCE MIGHT BE A COLLECTION OF INDEXED LOOSE-LEAF BINDERS, OR FILE DRAWERS, CONTAINING AN ASSORTMENT OF PHOTOGRAPHS, ARTICLES, BROCHURES OR OTHER PUBLISHED MATERIALS THAT CAN STIMULATE THE THOUGHT PROCESS OR PROVIDE A SPECIFIC ANSWER TO A DESIGN-RELATED QUESTION.

THE FILE SHOULD BE CONSTANTLY UPDATED WITH NEW MATERIALS, NEW IDEAS, NEW SOLUTIONS.

THE SPECIFIC ORGANIZATION OF THE FILE IS LEFT TO THE DISCRETION OF THE USER, BUT THE FOLLOWING OUTLINE IS A WORKABLE ARRANGEMENT.

RESIDENTIAL:

INTERIORS AND EXTERIORS OF CONTEMPORARY, TRADITIONAL OR HISTORIC HOMES.

PLANS OF HOMES, INCLUDING UNDERGROUND OR SOLAR-HEATED RESIDENCES.

SPECIFIC ROOMS WITHIN THE HOME: LIVING ROOM, DINING ROOM, FAMILY ROOM, WORKROOM, KITCHEN, BEDROOM, BATH, OUTDOOR LIVING AREAS, SUN ROOMS.

LAMPS AND LIGHTING.

STORAGE SOLUTIONS, CABINETS, BUILT-INS.

WINDOW AND FLOOR TREATMENTS.

ACCESSORIES

FURNITURE
UPHOLSTERED, WOOD, LAMINATED, METAL, WITH
SPECIFICATIONS, IF AVAILABLE.

ARCHITECTURAL DETAILING
FIREPLACES, DOORS, PANELLING, RECESSED AREAS.

COMMERCIAL:

OFFICES
OPEN OR CLOSED SYSTEMS, EXECUTIVE, COMPUTER
WORKSTATIONS, CONFERENCE, SECRETARIAL AREAS.

BANKS, HOSPITALS AND SCHOOLS

RETAIL STORES, PRODUCT SHOWROOMS

HOTELS AND RESORTS
GUEST ROOMS, CONFERENCE ROOMS, PUBLIC SPACES.

LIGHTING SOLUTIONS

SIGNAGE AND GRAPHICS

PLANTS
TYPES, SIZES, LIGHT REQUIREMENTS FOR GROWTH.

WINDOW, FLOOR AND WALL TREATMENTS

FURNITURE AND ACCESSORIES

ILLUSTRATIONS:

RESIDENTIAL AND CONTRACT

PEN AND INK

MARKER

WATERCOLOR, TEMPERA

MIXED MEDIA

SIZES

Successful illustrations include objects that look believable. Believability is the result of the knowledge and presentation of the correct size of objects drawn to scale.

Included on the following pages are both typical and specific dimensions for articles found in both residential or contract interiors and for a group of furniture classified as 'classics of contemporary furniture'.

These listings are not all inclusive. Become familiar with specific furniture catalogs, <u>ARCHITECTURAL GRAPHIC STANDARDS</u>, and texts on space dimensions and requirements for further data.

TYPICAL DIMENSIONS

ARM CHAIR	W	D	H	AH	SH
	18" – 27"	19½" – 32¼"	27½" – 34¼"	24¾" – 26"	16" – 19"
	AV. 23"	AV. 23"	AV. 30½"	AV. 25"	AV. 17¾"
SIDE CHAIR					
	16" – 23½"	18½" – 32¼"	28¼" – 35"		17" – 19"
	AV. 20"	AV. 22"	AV. 31"		AV. 18"
ALL-UPHOLSTERED LOUNGE CHAIR					
	25¼" – 40"	25½" – 40"	25" – 39½"	20½" – 25"	12¼" – 18"
	AV. 30"	AV. 29"	AV. 30"	AV. 22½"	AV. 15½"
SOFA					
	48" – 112"	28½" – 37"	22" – 35"	20½" – 29"	14" – 18"
		AV. 30"	AV. 30"	AV. 22½"	AV. 16"
END/SIDE TABLES RECTANGULAR					
	21" – 48"	19" – 28"	17" – 28"		

	W	D	H
SQUARE	15" - 32"	15" - 32"	17" - 28"
ROUND		16" - 30" D.	18" - 22½"

LOW TABLES

	W	D	H
RECTANGULAR	28" - 86"	15½" - 24"	12" - 18"
SQUARE	36" - 42"	36" - 42"	15" - 17"
ROUND		30" - 42" D.	15" - 16½"

CONFERENCE / DINING TABLES

	W	D	H
RECTANGULAR	30" - 60"	60" - 240"	28" - 29"
BOAT SHAPED	CENTER 36" - 72" END 34" - 48'	72" - 240"	28" - 29"
SQUARE	36" - 60"	36" - 60"	28" - 29"
ROUND		42" - 96"	28" - 29"

BEDS

TWIN	39" x 75", 80", 84"
DOUBLE	54" x 75", 80", 84"
QUEEN	60" x 80" OR 84"
KING	76" x 80" OR 84"

MATTRESS
 INNERSPRING 5½" - 6½" H
 FOAM 4" - 7½" H
BOX SPRING 5½" - 9" H

AVERAGE HEIGHT OF BED 13",
<u>PLUS</u> HEIGHT OF FRAME ABOVE FLOOR.

	W		H		D

WINDOWS
 DOUBLE HUNG

	W		H
	30" – 38"	×	38"
	26" – 42"	×	42", 50" OR 54"
	21" – 46"	×	58"
	26" – 46"	×	66"
	34" – 46"	×	70"
	42" – 46"	×	78"

ALL WIDTHS IN 4" INCREMENTS

 CASEMENTS
 24", 48" AND 72" × 36", 41", 48" OR 60"
 24" AND 48" × 72"

 PICTURE WINDOWS
 45", 70" AND 94" × 37", 50", 60" OR 74"

 OTHER TYPES AND SIZES OF WINDOWS AVAILABLE

DOORS
 INTERIOR
 24", 30" OR 36" × 80"

 EXTERIOR
 30" OR 36" × 82"

DESKS
 SINGLE PEDISTAL

	W	H	D
	45" – 84"	28" – 29¾"	24" – 36"
	AV. 60"	AV. 29"	AV. 30"

 DOUBLE PEDISTAL

	W	H	D
	55" – 84"	28" – 29¾"	30" – 39"
	AV. 60"	AV. 29"	AV. 30"

 SECRETARIAL

	W	H	D
	45" – 72"	28" – 29¾"	30" – 32"
	AV. 60"	AV. 29"	AV. 30"

 RETURN

	W	H	D
	15" – 20"	25" – 26¾"	23" – 48"
	AV. 18"	AV. 26"	AV. 36"

W	D	H	SH	CONTEMPORARY CLASSICS
				THONET
				BENTWOOD CAFE CHAIR
16"	20"	35"	18"	
				CORBUSIER ARM CHAIR
21¼"	22"	30½"	18"	
				HOFFMANN
				KUBUS CHAIR
36"	30½"	28½"	17½"	
				CABINETT ARM CHAIR
26¾"	27"	30"	17½"	
				CABINETTE TWO-SEAT SOFA
49½"	27"	30"	17½"	
				CABINETTE TABLE
	34" DIA.	25"		
				FLEDERMAUS SIDE CHAIR
19½"	18"	30"	18½"	
				FLEDERMAUS SETTEE
47½"	18"	30"	18½"	
				FLEDERMAUS TABLE
	26" DIA.	26"		
				ARMLOEFFEL CHAIR
26"	20"	38"	17½"	27⅝" AH
				RIETVELD
				RED - BLUE CHAIR
25¾"	32¾"	34½"	13"	
				SCHROEDER TABLE
19¾"	20"	23¾"		
				ZIG-ZAG CHAIR
14¾"	17"	28¾"	16½"	
				RIEMERSCHMID
				ARM CHAIR
22¾"	22½"	30"	18"	

	W	D	H	SH	
MACKINTOSH					
ARGYLE CHAIR	20"	18"	53½"	18½"	
WILLOW CHAIR	37"	16"	46⅞"	15¾"	
HILL HOUSE LADDERBACK SIDE CHAIR	16"	13⅛"	55½"	16¾"	
INGRAM HIGH BACK CHAIR	18½"	17½"	59¼"	17¾"	
BREUER					
WASSILY CHAIR	30¾"	27"	28½"	17"	22¾" AH
CESCA SIDE CHAIR	18¼"	22⅝"	31¾"	18¼"	
CESCA ARM CHAIR	22⅝"	22⅝"	31¾"	18¼"	27¼" AH
LOUNGE CHAIR	25½"	31½"	32½"	14½"	
LACCIO TABLES	22"	19"	18"		
	54"	19"	14"		
MIES VAN DER ROHE					
BARCELONA CHAIR	30"	30"	30"	17"	
BARCELONA TABLE	40"	40"	17"		
BARCELONA COUCH	78"	39"	15½"		
BARCELONA STOOL	23"	22"	14½"	14½"	
BRNO ARM CHAIR	23"	23"	31½"	17½"	25¾" AH
MR SIDECHAIR	19½"	27¼"	31"	17½"	
MR ARM CHAIR	21"	32½"	31"	17½"	25½" AH

	W	D	H	SH	
	23 5/8"	25 1/2"	25"	15 3/4"	**LE CORBUSIER** — BASCULANT CHAIR
	30"	27 1/2"	26"	17"	GRAND CONFORT
	22 1/2"	63"	ADJUSTABLE		CHAISE
	90"	33 1/2"	27" – 29"		TABLE
	23"	23 1/2"	28 3/4"	19"	ARMCHAIR
	18 1/2" DIA.		19 3/4"		STOOL
					AALTO
	13 3/4" DIA.		17 1/4"		STOOL
	24"	23 5/8"	31 1/2"	16 1/2"	ARM CHAIR
	23 5/8"	33 1/2"	25 1/4"	13"	SCROLL CHAIR
	35 1/2"	19 3/4"	22 1/4"		TEA TROLLEY
	31 1/2 SQUARE		17 1/4"		Y-LEGGED TABLE
	15" DIA.		17 1/4"		FAN LEGGED STOOL
	35 1/2 SQUARE		22" OR 28"		FAN LEGGED TABLE
					WEGNER — CHINA CHAIR
	21 1/2"	21 1/2"	32 1/4"	18"	
	24 1/2"	20 1/2"	27 1/4"	17 1/2"	CLASSIC CHAIR
	30"	29"	41"		PEACOCK CHAIR

	W	D	H	SH	
JACOBSEN					
EGG CHAIR	34"	31"	42"	14½"	
EGG CHAIR OTTOMAN	22"	16"	14½"		
SWAN CHAIR	29"	27"	29½"	15"	22" AH
SWAN SOFA	57"	29"	29½"	15"	
EAMES					
DSX SIDE CHAIR	18½"	22"	31¼"	18"	
DAX ARM CHAIR	24⅞"	24"	31"	17⅝"	
MOLDED PLYWOOD CHAIR	22¼"	25⅜"	27⅜"	15¼"	
MOLDED PLYWOOD DINING CHAIR	19½"	21½"	29½" – 29⅜"	18" – 19"	
ALUMINUM GROUPING ARM CHAIR	22½"	23¼"	33½"	18½"	
TILT, SWIVEL RECLINING ARM CHAIR	26"	31¼"	39½"	16"	
OTTOMAN	21½"	21⅛"	18"	18"	
ROSEWOOD LOUNGE	32½"	32¾"	33⅜"	15"	
OTTOMAN	26"	21"	15"	15"	
CHAISE	75"	17½"	28¾"	20½"	
SOFA	72½"	29⅞"	34⅞"	15⅞"	
NELSON					
COCONUT CHAIR	40"	33¾"	32½"	13¾"	
SOFA	87"	32¼"	29¾"	15½"	

Item	W	D	H	SH	AH
SAARINEN					
WOMB CHAIR	40"	34"	35½"	16"	20½" AH
OTTOMAN	25½"	20"	16"		
WHITE PEDISTAL SIDE CHAIR	19½"	22"	32½"	18½"	
WHITE PEDISTAL ARM CHAIR	26"	23½"	32"	18½"	25⅜" AH
SMALL SIDE TABLE		16" OR 20" DIA.	20½"		
COFFEE TABLE		36" DIA.	15"		
OPEN BACK SIDE CHAIR	22¼"	20¼"	32"	18¾"	
OPEN BACK ARM CHAIR	26"	24"	31"	18"	26¼" AH
BERTOIA					
SIDE CHAIR	21"	22½"	30"	18"	
DIAMOND CHAIR	33¾"	28"	30½"	17"	
PLATNER					
ARM CHAIR	26½"	22"	29"	19"	25½ AH
EASY CHAIR	40¾"	36½"	39"	17½"	21" AH
LOUNGE CHAIR	36½"	25½"	30½"	18½"	25" AH
OTTOMAN		24½" DIA.	15"		
COFFEE TABLE		36" OR 42" DIA.	15"		

8

bibliography

ATKIN, WILLIAM W. ARCHITECTURAL PRESENTATION TECHNIQUES. NEW
 YORK: VAN NOSTRAND REINHOLD, 1976.

BALL, JOHN E. ARCHITECTURAL DRAFTING. RESTON, VIRGINIA:
 RESTON, 1980.

BARTSCHI, WILLY A. LINEAR PERSPECTIVE. NEW YORK: VAN
 NOSTRAND REINHOLD, 1981.

BROMMER, GERALD F. DRAWING: IDEAS, MATERIALS, TECHNIQUES.
 WORCESTER, MASSACHUSETTS: DAVIS, 1972.

BURDEN, ERNEST E. ARCHITECTURAL DELINEATION. NEW YORK:
 McGRAW HILL, 1971.

 VISUAL PRESENTATION: A PRACTICAL
 MANUAL. NEW YORK: McGRAW HILL, 1978.

CHING, FRANCIS D. K. ARCHITECTURE, FORM, SPACE AND ORDER.
 NEW YORK: VAN NOSTRAND REINHOLD, 1979.

 ARCHITECTURAL GRAPHICS. NEW YORK:
 VAN NOSTRAND REINHOLD, 1975.

 BUILDING CONSTRUCTION ILLUSTRATED.
 NEW YORK: VAN NOSTRAND REINHOLD, 1975.

CHOATE, CHRIS. ARCHITECTURAL PRESENTATION. NEW YORK:
 REINHOLD, 1971.

CHOMICKY, YAR G. WATERCOLOR PAINTING. ENGLEWOOD
 CLIFFS, NEW JERSEY: PRENTICE-HALL, 1968.

COLE, REX V. PERSPECTIVE FOR ARTISTS. NEW YORK: DOVER,
 1976.

COOPER, T. HEATON. MODERNIZED PICTORIAL PERSPECTIVE. WASHINGTON, D.C.: GRAPHIC ARTS, 1947.

D'AMELIO, JOSEPH. PERSPECTIVE DRAWING HANDBOOK. NEW YORK: TUDOR, 1964.

DESCARGUES, PIERRE. PERSPECTIVE. NEW YORK: ABRAMS, 1977.

DIEKMAN, NORMAN AND JOHN PILE. DRAWING INTERIOR ARCHITECTURE. NEW YORK: WHITNEY LIBRARY OF DESIGN, 1983.

DOYLE, MICHAEL E. COLOR DRAWING. NEW YORK: VAN NOSTRAND REINHOLD, 1981.

DUBERY, FRED AND JOHN WILLATS. PERSPECTIVE AND OTHER DRAWING SYSTEMS. NEW YORK: VAN NOSTRAND REINHOLD, 1983.

DUNCAN, ROBERT I. ARCHITECTURAL GRAPHICS AND COMMUNICATION, 2ND EDITION. DUBUQUE, IOWA: KENDALL-HUNT, 1982.

EVANS, LARRY. ILLUSTRATION GUIDE FOR ARCHITECTS, DESIGNERS AND STUDENTS. NEW YORK: VAN NOSTRAND REINHOLD, 1982.

FAULKNER, RAY AND SARAH FAULKNER. INSIDE TODAY'S HOME. NEW YORK: HOLT, RINEHART AND WINSTON, 1968.

GILL, ROBERT W. RENDERING WITH PEN AND INK, REVISED. NEW YORK: VAN NOSTRAND REINHOLD, 1984.

GOLDSTEIN, NATHAN. THE ART OF RESPONSIVE DRAWING. ENGLEWOOD CLIFFS, NEW JERSEY: PRENTICE-HALL, 1973.

GOODCHILD, JON AND BILL HENKEN. BY DESIGN. NEW YORK: QUICK FOX, 1980.

GRAPHIC DESIGN IN ARCHITECTURAL RENDERINGS, COMPILED FROM
 INTERNATIONAL COMPETITIONS. WEST BERLIN:
 VERLAG INTERBUCH BERLIN.

GUPTILL, ARTHUR L. DRAWING WITH PEN AND INK, REVISED
 EDITION. NEW YORK: REINHOLD, 1946.

 RENDERING IN PENCIL. EDITED BY SUSAN
 E. MEYER. NEW YORK: WATSON-GUPTILL, 1977.

HARTMANN, ROBERT R. GRAPHICS FOR DESIGNERS. AMES,
 IOWA: IOWA STATE UNIVERSITY PRESS, 1976.

HOHAUSER, SANFORD. ARCHITECTURAL AND INTERIOR MODELS-
 DESIGN AND CONSTRUCTION. NEW YORK: VAN NOSTRAND
 REINHOLD, 1971.

JACOBY, HELMUT. NEW TECHNIQUES OF ARCHITECTURAL
 RENDERING, 2ND EDITION. NEW YORK: VAN NOSTRAND
 REINHOLD, 1981.

JAMES, JANE H. PERSPECTIVE DRAWING, A DIRECTED STUDY.
 ENGLEWOOD CLIFFS, NEW JERSEY: PRENTICE-HALL, 1981.

JANKE, ROLF. ARCHITECTURAL MODELS. NEW YORK: HASTINGS
 HOUSE, 1981.

JONES, FREDERIC H. INTERIOR DESIGN GRAPHICS. LOS ALTOS,
 CALIFORNIA: WILLIAM KAUFMANN, 1983.

KAUTSKY, THEODORE. PENCIL BROADSIDES. NEW YORK:
 REINHOLD, 1947.

 WAYS WITH WATERCOLOR. NEW YORK:
 REINHOLD, 1953.

KEMNITZER, RONALD B. RENDERING WITH MARKERS. NEW YORK:
 WATSON GUPTILL, 1983.

KLIMENT, STEPHEN. (EDITOR). ARCHITECTURAL SKETCHING AND RENDERING.
TECHNIQUES FOR DESIGNERS AND ARTISTS. NEW YORK:
WHITNEY LIBRARY OF DESIGN, 1984.

KONIG, FELIX. PERSPECTIVE IN ARCHITECTURAL DRAWINGS. NEW
YORK: VAN NOSTRAND REINHOLD, 1984.

LANING, EDWARD. THE ACT OF DRAWING. NEW YORK: McGRAW-HILL,
1971.

LASEAU, PAUL. GRAPHIC THINKING FOR ARCHITECTS AND DESIGNERS.
NEW YORK: VAN NOSTRAND REINHOLD, 1982.

LEACH, SID DELMAR. TECHNIQUES OF INTERIOR DESIGN RENDERING
AND PRESENTATION. NEW YORK: ARCHITECTURAL
RECORD, 1978.

LIEBING, RALPH AND MIMI PAUL. ARCHITECTURAL WORKING
DRAWINGS, 2ND EDITION. NEW YORK: JOHN WILEY
AND SONS, 1982.

LOCKARD, WILLIAM K. DESIGN DRAWING, REVISED EDITION. NEW
YORK: VAN NOSTRAND REINHOLD, 1982.

MARTIN, C. LESLIE. ARCHITECTURAL GRAPHICS, 2ND EDITION.
NEW YORK: MACMILLAN, 1970.

DESIGN GRAPHICS, 2ND EDITION. NEW
YORK: MACMILLAN, 1968.

MULLER, EDWARD J. ARCHITECTURAL DRAWING AND LIGHT
CONSTRUCTION, 2ND EDITION. ENGLEWOOD CLIFFS,
NEW JERSEY: PRENTICE-HALL, 1967.

PANERO, JULIUS AND MARTIN ZELNICK. HUMAN DIMENSION AND
INTERIOR SPACE. NEW YORK: WHITNEY LIBRARY
OF DESIGN, 1979.

PATTEN, LAWTON AND MILTON L. ROGNESS. ARCHITECTURAL DRAWING, 3RD EDITION. DUBUQUE, IOWA: KENDALL-HUNT, 1977.

PILE, JOHN. DRAWINGS OF ARCHITECTURAL INTERIORS. NEW YORK: WHITNEY LIBRARY OF DESIGN, 1967.

PITZ, HENRY C. PEN, BRUSH AND INK. NEW YORK: WATSON-GUPTILL, 1949.

PORTOR, TOM AND ROBERT GREENSTREET. MANUAL OF GRAPHIC TECHNIQUES. NEW YORK: CHARLES SCRIBNER'S SONS, 1980.

RAMSEY, CHARLES AND HAROLD SLEEPER. ARCHITECTURAL GRAPHIC STANDARDS, 7TH EDITION. NEW YORK: JOHN WILEY AND SONS, 1981.

RATENSKY, ALEXANDER. DRAWING AND MODELMAKING. NEW YORK: WHITNEY LIBRARY OF DESIGN, 1983.

REZNIKOFF, S. C. SPECIFICATIONS FOR COMMERCIAL INTERIORS. NEW YORK: WHITNEY LIBRARY OF DESIGN, 1979.

RICHARDSON, JOHN ADKINS, FLOYD W. COLEMAN AND MICHAEL J. SMITH. BASIC DESIGN, SYSTEMS, ELEMENTS, APPLICATIONS. ENGLEWOOD CLIFFS, NEW JERSEY: PRENTICE-HALL, 1984.

SHOOK, GEORG AND GARY WITT. PAINTING WATERCOLORS FROM PHOTOGRAPHS. NEW YORK: WATSON GUPTILL, 1983.

STOUTSENBERGER, LEO. CONTROLLED WATERCOLOR PAINTING. CINCINNATI, OHIO: NORTH LIGHT, 1981.

TIMESAVER STANDARDS FOR ARCHITECTURAL DESIGN DATA. NEW YORK: McGRAW HILL, 1974.

WAKITA, OSAMU. PERSPECTIVE DRAWING. DUBUQUE, IOWA: KENDALL-
HUNT, 1978.

WALKER, THEODORE D. PERSPECTIVE SKETCHES. WEST LAFAYETTE,
INDIANA: PDA PUBLISHERS, 1972.

WALTERS, NIGIL V. AND JOHN BROMHAM. PRINCIPLES OF PERSPECTIVE.
NEW YORK: WHITNEY LIBRARY OF DESIGN, 1970.

WANG, THOMAS. PENCIL SKETCHING. NEW YORK: VAN NOSTRAND
REINHOLD, 1977.

PLAN AND SECTION DRAWING. NEW YORK: VAN
NOSTRAND REINHOLD, 1977.

SKETCHING WITH MARKERS. NEW YORK: VAN
NOSTRAND REINHOLD, 1981.

WATSON, ERNEST W. HOW TO USE CREATIVE PERSPECTIVE. NEW
YORK: REINHOLD, 1955.

WEIDHAAS, ERNEST. ARCHITECTURAL DRAFTING AND DESIGN, 4TH
EDITION. BOSTON, MASSACHUSETTS: ALLYN AND BACON, 1981.

WHITE, EDWARD T. A GRAPHIC VOCABULARY FOR ARCHITECTURAL
PRESENTATION. TUCSON, ARIZONA: ARCHITECTURAL
MEDIA, 1972.

WHITE, GWEN. PERSPECTIVE. NEW YORK: WATSON GUPTILL, 1968.

WHITNEY, EDGAR A. COMPLETE GUIDE TO WATERCOLOR PAINTING.
NEW YORK: WATSON GUPTILL, 1965.

WOLCHONOK, LOUIS. DESIGN FOR ARTISTS AND CRAFTSMEN. NEW
YORK: DOVER, 1953.